GEORGIA
A State History

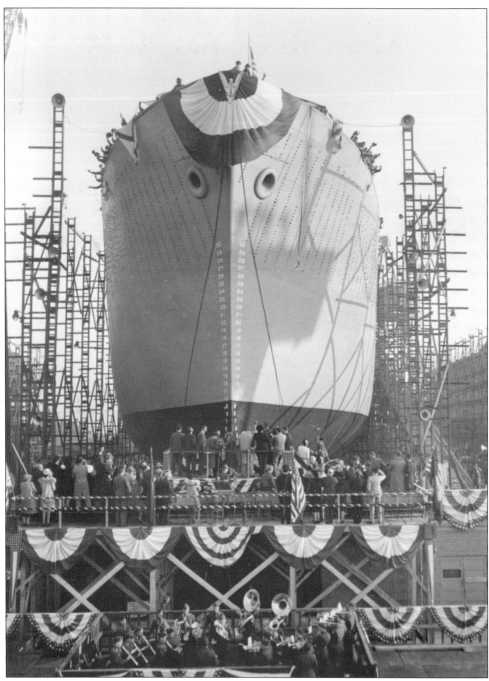

The Liberty ship James Oglethorpe *launched in Savannah in 1942.*

THE
MAKING OF AMERICA
SERIES

GEORGIA
A State History

BUDDY SULLIVAN
in association with
THE GEORGIA HISTORICAL SOCIETY

ARCADIA
PUBLISHING

Published by Arcadia Publishing
Charleston, South Carolina

Printed in the United States of America

Library of Congress Control Number: 2009941863

For all general information contact Arcadia Publishing at:
Telephone 843-853-2070
Fax 843-853-0044
E-mail sales@arcadiapublishing.com
For customer service and orders:
Toll-Free 1-888-313-2665

Visit us on the Internet at www.arcadiapublishing.com

Front cover: *The State Capitol at Atlanta*.

CONTENTS

ACKNOWLEDGMENTS

THIS VOLUME HAS BEEN PREPARED AND WRITTEN as an informal overview of the history of Georgia. Paradoxically, most of the research and source documentation were expedited amid the formality and the august academic environment of Hodgson Hall at the Georgia Historical Society. The holdings of this venerable and remarkable repository of three centuries of Georgiana form the essence of this book, as will quickly be ascertained from the endnotes accompanying each chapter, in which many of the diverse array of collections of the Society are cited. In many of the notes, background is provided on the source of a particular collection. So in some ways, this is also a story of the holdings of the Georgia Historical Society from which this overview of Georgia has evolved.

Jewell Anderson Dalrymple, John Albert, Coby Linton, Valerie Frey, and Linette Neal of the library staff at Hodgson Hall were of great help in locating materials and retrieving collections during the compilation process. Susan Dick, the GHS director of library and archives, and Mandi Johnson, visual materials archivist, were of immeasurable assistance in the painstaking task of locating, cataloging, and processing the images from GHS's visual collections that grace the pages of this volume. Dr. Stan Deaton, director of publications for GHS, is the finest editor any author could have. I am indebted to Stan for his advice, counsel, and keen eye for detail. Any writer worth their salt knows that the secret to any success they may achieve lies in having a good editor.

The end result of all this collaboration and teamwork would not have been possible without the guiding energy and support of Dr. Todd Groce, executive director of the Georgia Historical Society, under whose dynamic leadership the Society has evolved in the last seven years. It was Todd who first encouraged me to undertake this project under the auspices of the Society, and his counsel, support, and helpful suggestions along the way have proven invaluable. This bold new publishing effort in every sense reflects the kind of leadership Todd has given the Society and the dissemination of history in our state in general.

Grateful appreciation is extended to the following for assistance in identifying and securing original photographs not contained among the archival collections of the Georgia Historical Society, and for permission to use their materials: John Sylvest and Sara Saunders, Atlanta History Center; David Stanhope, the Jimmy

Carter Library and Museum; Johari Pollock, Tricia Harris, and Flecia Brown, the King Center; Mary Ellen Brooks and Nelson Morgan, Hargrett Rare Book and Manuscript Library, University of Georgia Libraries; Ed Jackson, Carl Vinson Institute of Government, University of Georgia; Gail Miller DeLoach, Georgia Department of Archives and History; Mary McKay, Richard B. Russell Library for Political Research and Studies, University of Georgia Libraries; and Tamera Reub, United States Olympic Committee.

~ Buddy Sullivan
August 2002

All illustrations, except where noted, are from the collections of the Georgia Historical Society.

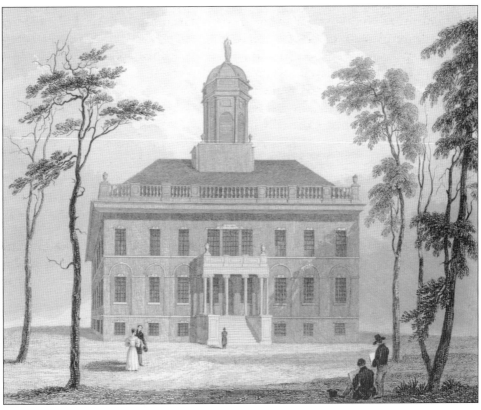

City Hall in Augusta, c. 1831.

INTRODUCTION

ANYONE TRAVERSING MODERN-DAY GEORGIA will find a land that both resembles and stands in stark contrast to the image of the state in popular culture. From the towering skyscrapers and massive traffic jams of Atlanta to the moss-draped oaks and quiet, ancient squares of Savannah, the state seems to the visitor a paradox in itself, comfortably straddling both the Old and the New South. Somehow, in that uniquely southern way, the past and the present seem to merge into one. Georgians may not live in the past, to paraphrase the historian David Goldfield, but the past clearly lives in Georgians.

That past has diverged from the nation's and given Georgia and its people a distinctive culture and character. Some of the best, and the worst, aspects of American and southern history can be found in the story of what is arguably the most important state in the South. Yet, just as clearly, Georgia has not always followed the road traveled by the rest of the nation and the region. Explaining the common and divergent paths that make us who we are is one reason the Georgia Historical Society has collaborated with Arcadia Publishing to produce *Georgia: A State History*.

Georgia's early years foreshadowed the journey that lay ahead. Alone among the 13 original colonies, Georgia served as an outpost of Spain's new world empire and became the battleground where Spanish dreams of conquering and colonizing the Atlantic coast came to an ignominious end. Unlike the other colonies, Georgia was not created for riches or religious liberty. Instead, it was founded by a British aristocrat for the seemingly incongruous purposes of establishing both a military buffer and a humanitarian society where slavery was initially outlawed. The state's conservatism during the crises of the Revolution and the Civil War was remarkably different from the radicalism of South Carolina, its neighbor to the north.

Later, during the Civil Rights struggle of the 1960s, Georgia once again followed its own course, quietly desegregating its public facilities and, for the most part, rejecting the violent opposition to black equality demonstrated in neighboring Alabama and Mississippi. Georgia would go on to embrace the creed of the New South so enthusiastically that what had been the weakest and most undeveloped colony in the eighteenth century would be transformed by

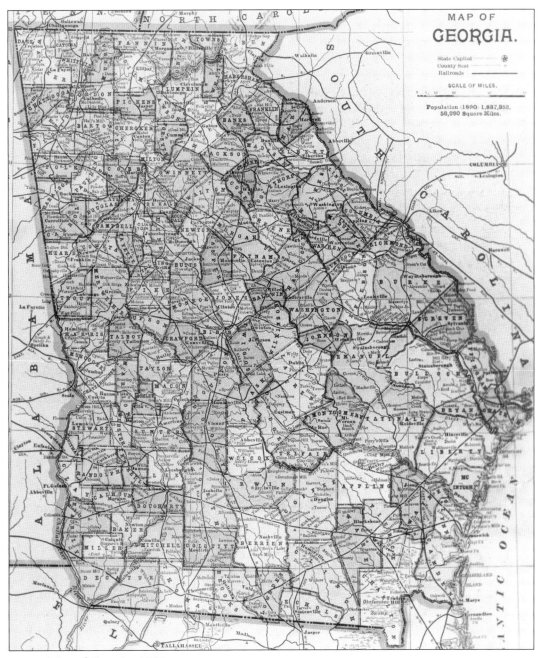

Map of Georgia, 1890.

the dawn of the twenty-first into the richest, most urbanized, and technologically advanced state in the region.

Despite these differences, however, the story of Georgia is typically southern. The growth of the Cotton Kingdom, the devastation of the Civil War, the political campaigns of the Solid South, the racial oppression of Jim Crow, and the economic rebirth and revitalization of the post–World War II era are all part of both the Georgian and southern experience. Indeed, from the invention of the cotton gin on a plantation near Savannah to the emergence of the urban goliath of Atlanta, one could tell the story of the South through the lens of this single state.

It is the compelling story of this unique and yet typically southern people that the Georgia Historical Society seeks to tell. Founded in 1839 with the mission to collect, preserve, and share the history of the state for the enlightenment and enjoyment of its citizens, the society early on amassed an amazing collection of Georgia-related materials, including records and documents, maps, portraits, rare books, and artifacts. Simultaneously, it launched an ambitious publications program designed to make history accessible to all Georgians. Since its first book appeared in 1840, GHS has published over 100 volumes of edited primary sources, monographs, photographs, essays, and lectures related to Georgia history.

The antebellum state capitol at Milledgeville.

Buddy Sullivan's history of Georgia is the most recent in a long and distinguished line of publications offered by GHS that take our collections out of the archives and place them in the hands of the public. The first full-length history of the state produced in nearly a generation, this book is a partnership between the society, Arcadia Publishing, and one of Georgia's most prolific historians. A popular lecturer, veteran journalist, and gifted author of numerous books on various facets of Georgia history, Sullivan is well-suited to tell the story of the state's journey through time. His lively account traces the development of Georgia's politics, economy, and society, relating the stories of the people, both great and small, who shaped our destiny. In the process, he explains to us the foundations of modern Georgia.

This book will be indispensable reading for all Georgians, both old and new. Natives will gain a clearer sense of who they are and newcomers will have a better understanding of the land they now call home. Buddy Sullivan's history of the state opens a window on our rich and sometimes tragic past, revealing to all the fascinating complexity of what it means to be a Georgian.

~ W. Todd Groce, Executive Director
Georgia Historical Society

1. Two "Forgotten" Centuries

RECENT SCHOLARSHIP HAS DEMONSTRATED fairly conclusively that the land that was to become the state of Georgia was the scene of the first European attempt to establish a permanent colony in the present-day United States. In the fall of 1526, Lucas Vasquez de Ayllon, a Spanish official and sugar planter from the island of Hispaniola, founded the colony of San Miguel de Gualdape on the southeastern coast of the future United States, quite possibly in the vicinity of Sapelo Sound in present-day McIntosh County, Georgia. In the context of western hemisphere exploration and colonization, it must be emphasized that Ayllon's colony appeared a mere 34 years after Columbus made landfall in the lesser Antilles, 39 years before the Spanish settlement at St. Augustine (regarded as the first permanent European settlement on the United States mainland), 81 years before the arrival of the English at Jamestown, and fully 207 years prior to Oglethorpe's landing at Savannah in 1733. Over 500 Spanish colonists accompanied Ayllon and, although the effort was not a success due to attrition caused by disease and troubles with the local Native Americans, it nonetheless served as the precursor of later Spanish attempts to explore the region.[1]

Further Spanish explorations of the section that was to include Georgia were those of Hernando de Soto and Tristan de Luna. The former led an expedition from the Gulf of Mexico through upper Florida and much of Georgia in 1540. In northwestern Georgia, de Soto encountered—with violent consequences—the Coosa Indian chiefdom along the Etowah River.

In the fall of 1565, Pedro Menendez de Aviles established St. Augustine on the upper east coast of Florida. A year later, Menendez began expanding his interests northward along the coast. He developed a series of missions on the barrier islands from St. Augustine northward to the Savannah River where resident Native American populations were indoctrinated in Spanish religion, culture, and farming techniques. Jesuit and, later, Franciscan priests conducted evangelical activities on the sea islands of Georgia. Governed from St. Augustine, the missions were largely self-sufficient, particularly in that section of the middle and upper coast comprising the Guale chiefdoms. The name Guale (pronounced "Wall-ie") came from the Spanish appellation for the island of Guale, present-day St. Catherines Island.

Here, about 1570, the Spanish established the principal Franciscan mission of the coast, called Santa Catalina de Guale.[2] Other Franciscan missions were located on Sapelo Island (San Jose de Sapala), St. Simons Island (Santo Domingo de Asao and San Simon), and Cumberland Island (San Pedro de Mocama). These missions interacted with Guale Indian populations on the islands and at the larger Guale towns, representing various chiefdoms on the mainland: Tupiqui, Espogache, Tolomato, and Talaxe, among others.

In 1597, a Native American revolt, known as the Juanillo Rebellion, precipitated by increasing resentment over the Spanish dominance of the region, resulted in the massacre of five Franciscan friars. Following a brief abandonment of the missions, peaceful relations with the Guale were reestablished and Spanish missionary activities resumed by 1603. This effort was solidified by a *visitacion* by the Roman Catholic bishop of Cuba in 1606.

There followed half a century of relatively peaceful activity by Spain along the Guale coast, a period in which Spanish military and evangelistic hegemony reached its peak. However, beginning in 1670 with the establishment of Charles Town and the new English colony of South Carolina, increasing troubles between England and Spain, based largely on commercial considerations in the region, led

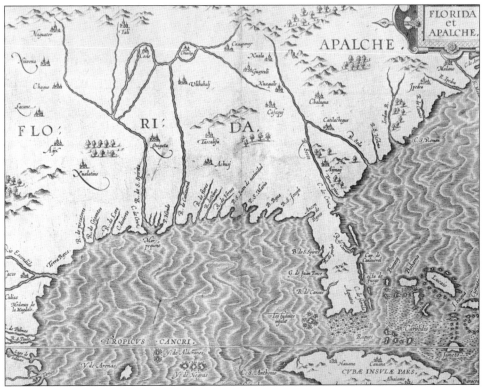

Sixteenth-century Spanish map of "La Florida," encompassing what would later become the southeastern United States.

to the eventual decline of the Spanish missionary presence in Georgia. In 1680, an English force with Native American allies attacked Santa Catalina, the primary mission at St. Catherines Island. The mission was moved to Sapelo, the next island to the south, where it was active for another six years. Following further raids, Spanish officials in St. Augustine ordered the deactivation of missions north of the St. Marys River in 1686.

Nothing now remains of any of the Spanish missions and few references to them are to be found in the eighteenth-century English colonial records for

THE SPANISH MISSION MYTH

In the early 1930s, in an effort to attract tourists and land developers, the numerous tabby oyster shell ruins along Georgia's coast were promoted as the remains of Spanish missions from the sixteenth and seventeenth centuries. Regional "boosterism" and the romantic appeal of thick-robed Franciscan friars preaching to the Guale Indians against the backdrop of tabby convents found their way into such prominent publications as the *Atlanta Constitution* and *National Geographic*. Spanish mission scholars, such as Herbert Bolton, Mary Ross, and John Tate Lanning, published authoritative books attributing Georgia's coastal tabby ruins as evidence of the lost missions. They identified the tabbies at St. Marys as the Mission of Santa Maria, those at Elizafield plantation on the Altamaha River as the ruins of Mission Santo Domingo, and the remains at Sapelo Island as Mission San Jose.

For generations, these tabby ruins had, in local lore, been identified as the remains of nineteenth-century sugar mills and plantation structures. The Georgia Society of the Colonial Dames of America engaged its own team of scholars to dispel the "Spanish mission myth." Local historian Marmaduke Floyd of Savannah, along with James A. Ford of the Smithsonian Institution, conducted a series of historical and archaeological investigations, the result of which proved conclusively that the coastal tabbies were indeed the ruins of antebellum sugarhouses and cotton barns.

Floyd and Ford published their findings in 1937 in a seminal work edited by E. Merton Coulter, *Georgia's Disputed Ruins*. The exhaustive documentation accumulated by Floyd is on deposit among the manuscript holdings of the Georgia Historical Society. Floyd's research centered on the contemporary writings of Sapelo Island planter Thomas Spalding, the leading proponent of the use of tabby as a building material on the Georgia coast during the antebellum period. As early as 1816, then later in the 1830s in the *Southern Agriculturist*, Spalding described his extensive use of tabby and provided detail on his "formula" for making tabby, utilizing equal measures of oyster shell, sand, water, and lime (obtained from the ash residue of burnt shell). Spalding built his Sapelo Island sugar works of tabby, then his family residence and other plantation structures. His methods were adopted by many contemporary tidewater planters.

Tabby structures based on the Spalding method were built from *c.* 1810 until *c.* 1860 along the coast from South Carolina to northeastern Florida. The ruins of many of these structures remain on the coastal sea islands as well as the adjacent mainland, particularly in McIntosh and Glynn Counties.

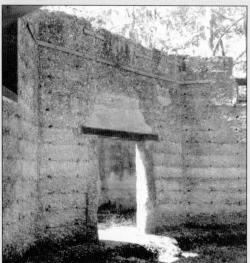

Tabby remains of Elizafield plantation sugar mill, Glynn County.

Georgia. For this reason, historians paid scant attention to the mission era until recent years when careful scrutiny of official Spanish records in Europe led to a renewed interest in the "lost" 200 years. In 1981, an archaeological team led by David Hurst Thomas located the site of Mission Santa Catalina de Guale on St. Catherines Island. A systematic investigation of the rich yield of sixteenth- and seventeenth-century artifacts and several building foundations beneath the soil have led to a greater understanding of both the Spanish missionary culture and the resident Guale and Timucuan Indians to which the friars ministered.

The archaeological evidence at St. Catherines Island, Parris Island, and other mission sites has translated into a greater understanding of the Franciscan presence on the Guale coast during the two lost centuries. Clearly, life was difficult for those on station at the remote, isolated barrier island missions, as well as for the resident Guale Indians. Infectious diseases took a heavy toll on Native Americans and Europeans alike, and epidemics of smallpox, typhoid, and measles were not uncommon. This was particularly so among the Guale, who had no immunity or resistance to these heretofore unknown diseases. Out of about 1,000 Guale who inhabited St. Catherines Island and its environs when the Spaniards arrived in 1570, only a handful remained at the end of the mission era on the Guale coast 116 years later.

The accumulation by the Spanish and subsequent archaeological discovery of numerous religious artifacts at the Santa Catalina mission testifies to the intense effort by the Franciscans to impose Catholicism on the native people. Evidence on these sites also demonstrates the difficulty of the Spanish to adapt to their landscape environment; wheat residue found at St. Catherines was likely imported from Spain or perhaps St. Augustine, since surviving records indicate little success in the cultivation of this important Spanish dietary staple on the Guale coast. More is being learned about the lives of these far-flung missionaries as interest in the lost 200 years increases among archaeologists and historians.

For 35 years following the abandonment of the missions, the coast of Guale lay at the center of increasing dispute between the English in South Carolina and the Spaniards in Florida. The stretch of coast between Beaufort and Amelia Island, known as the "debatable land," came to represent the linchpin of a growing commercial struggle between England, Spain, and France. To protect their interests, Carolina merchants centered at Charles Town sponsored John Barnwell and his rangers to establish a permanent outpost, Fort King George, near the mouth of the Altamaha River in 1721. The English built a cypress blockhouse and stationed troops there for several years to deter the Spaniards from potential encroachments toward Carolina. The unhealthy Altamaha delta region took a far greater toll on them than did their Spanish adversaries, however, and the English abandoned Fort King George in 1727.

2. THE COLONY UNDER THE TRUSTEES

THE CONCEPT FOR THE ESTABLISHMENT of a new English colony between South Carolina and Spanish Florida may reasonably be said to have begun as early as 1717 when Scotsman Sir Robert Montgomery proposed (to no result) his ambitious "margravate of Azilia" on the coast that would become Georgia. By 1729, the British Board of Trade was advocating an extension of South Carolina further southward, below the Savannah River, for protective purposes against Spanish Florida. South Carolina had become an important commercial enterprise with productive rice plantations along the coast from Georgetown to Beaufort, and a burgeoning slave and sugar trade with British colonies in the Caribbean.

At the same time, James Edward Oglethorpe, member of Parliament since 1722, was heading a committee to investigate deplorable conditions in English debtor prisons. Among the recommendations of Oglethorpe's committee was the release of thousands of "debtors" to form the basis of a new colony. This action would serve the additional purpose of providing a military buffer for South Carolina in response to the increasingly antagonistic Spanish authorities in St. Augustine. Thus, in 1730, a concerted "Georgia movement" had begun with Oglethorpe, John Viscount Percival, James Vernon, and others forming the corporation that came to be known as the Georgia Trustees. By 1732, the Trustees' proposal had received the blessing of King George II, the latter approving the settlement of lands between the Savannah and Altamaha Rivers. The Trustees honored the king's support by giving their venture his name—Georgia.[1]

There has been much written by earlier generations of Georgia historians regarding the philanthropic ideals upon which the new colony was founded. In actuality, few debtors were among the first settlers of Georgia. The Trustees, philanthropy notwithstanding, had two primary motives for the colony, one being to claim the disputed land along the coast between South Carolina and Spanish Florida, and the other being purely economic: the mercantilistic prospects (and profits) offered by the establishment of agricultural ventures and their attendant trade outlets with English possessions in the Caribbean basin. There was a great deal of emphasis placed upon silk production in the new colony, although this

effort had met with little success in Virginia and the Carolinas earlier. They also viewed the semi-tropical climate of coastal Georgia as ideal for the cultivation of a variety of spices and the production of wine.

Oglethorpe himself accompanied the first group of 114 settlers to America, these being recruited through the Trustees' vigorous promotional campaign. (Another 500 colonists followed a year later.) The ship *Ann*, transporting the first colonists, sailed from London in November 1732 and arrived at Charles Town two months later. Proceeding to Beaufort, Oglethorpe quickly selected high ground at Yamacraw Bluff on the Savannah River, 16 miles inland from the Atlantic Ocean, as the site of a settlement. It is likely that Colonel William Bull, royal governor of South Carolina and an experienced surveyor, had considerable input in the selection of the site of Savannah. Chief Tomochichi of the local Yamacraw Indians, through interpretation provided by trader John Musgrove and his Native American wife of mixed descent, Mary Musgrove, gave Oglethorpe his approval for the settlement. Oglethorpe and the colonists, accompanied by Bull, landed at Savannah on February 12, 1733, and plans were immediately put in motion for the building of a town on the high bluff.1717[2]

Oglethorpe and Bull laid out the new town of Savannah to be centered around a series of squares, likely modeled after eighteenth-century London grid patterns. The squares were to be surrounded by 40 lots, each 60 by 90 feet. These groupings

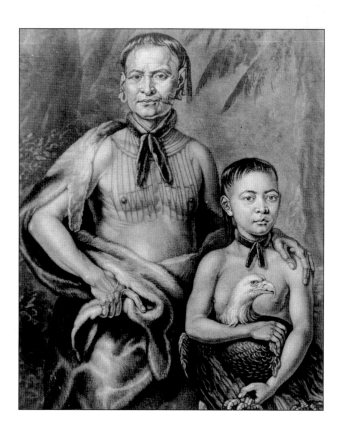

Tomochichi, chief of the Yamacraw Indians, and his nephew Toonahowi.

were comprised of two wards, north and south of the square, each with ten-lot sections called tythings. To the east and west of the squares were Trust lots for public use. This unique town plan incorporated a "Common" on three sides—for defensive purposes—with the river on the fourth (north) side. The Georgia Trustees envisioned a utopian land-use and land-grant system in their provision of lots in Savannah and the surrounding area. Peter Gordon noted the following in his diary for March 1, 1733:

> The first house in the square was framed and raised, Mr. Oglethorpe driving the first pin. We are now divided into different gangs and each gang had their proper labor assigned to them, so that we proceeded in our labor much more regular than before [with] a set of shingle makers and a sufficient number of Negro sawyers who were hired from Carolina to be assisting us.

Savannah's ward system was expanded as the town grew. By the early nineteenth century, the Common had been expanded to include two wide boulevards on the east and west sides.[3]

Oglethorpe had received training as a military engineer both in England and on the Continent; thus, he was acutely aware of the need for the establishment of

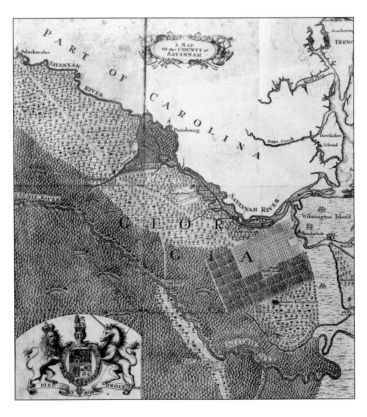

"A map of the county of Savannah," 1735.

Noble Jones of Wormsloe
(1702–1775).

proper defenses. In this regard, he immediately fortified an inland outpost at Fort Argyle on the Ogeechee River to protect the southern and western approaches to Savannah, and a tidewater defensive work—the Thunderbolt fort on Augustine Creek—to guard Savannah's eastern flank.[4] Establishment of good relations with the local Creeks was critical to the early success of the colony and Oglethorpe proved to be a capable diplomat. "Afterwards [Tomochichi] fixed a lighted pipe of tobacco . . . and presented it to Mr. Oglethorpe, who having smoked several whiffs they then presented it to the other gentlemen," wrote Gordon in his diary for March 7, 1733. Later, to solidify his position, Oglethorpe signed a formal peace treaty with many of the chiefs of the Lower Creek Nation and, on a return to England in May 1734, he presented Tomochichi and his nephew Toonahowi to the royal court.

The unusual nature of the new Georgia colony was exemplified by the diversity of the cultures allowed entry by the Trustees. Roman Catholics were denied admission to the colony for fear of possible Spanish spies providing intelligence to St. Augustine, where Spanish officials viewed the developments in Georgia with

increasing concern and resentment. On the other hand, after initial opposition, Oglethorpe received approval to allow Jews into Savannah and they made significant contributions to the early development of the colony.[5]

Lutheran Salzburgers, under the leadership of John Martin Bolzius, also had a positive impact. They came to Georgia from Austria to escape religious persecution. Upon their arrival at Savannah in the spring of 1734, Oglethorpe helped the Salzburgers establish their own settlement on the river about 25 miles above Savannah (present-day Effingham County). Later arrivals of Salzburgers increased their number to more than 1,200 by 1741. The Salzburgers were extremely independent of the other Georgia colonists, due primarily to language differences, and they constructed an impressive brick church at Ebenezer, regarded as the finest church existing in the early years of the colony.[6]

The benevolence of the Georgia Trustees toward its debtor colonists did not come without its conditions. A new settler arriving in Georgia at the Trustees' expense was expected to be physically able both to farm the land and to fight potential Spanish and Native American adversaries. He or she had to agree to an indentured servitude of three years to the colony, which included planting mulberry trees for the cultivation of silkworms and planting no more than 50 acres of land for his own purposes. Typical of the proprietary nature of the new colony was the granting and distribution of land with stringent conditions attached, chief among which was the Trustees' ban on slave ownership, since slaves might represent a threat to the government. Oglethorpe and the Trustees also placed a prohibition on the importation and sale of rum with the view that consumption of "spirituous liquors" would lead to laziness and thus retard the new colony's growth.

The various restrictions, coupled with envious observations of their energetic neighbors in South Carolina, who were allowed to buy and sell their land at will, own slaves to work their prosperous rice plantations, and imbibe rum, not surprisingly led to resentment among many of the Georgia colonists. Georgia was a poor colony from the beginning and, by 1737, conditions had worsened to the point of serious food shortages in Savannah. Complaints arose about the performance of Thomas Causton, the keeper of the Trustees' public store in Savannah, and Noble Jones, the colony's surveyor. Rumblings of discontent grew, along with idleness on the part of some.

William Stephens wrote the following in December 1737:

> It was necessary to break through this stubborn knot of ill-designing people and restore unity as far as possible. The colony would be better off without them. . . . I not only found [an] abundance of lots untouched and many which had little done upon them but, which was yet worse, divers improvements that had been made [were] now going to ruin again, the land overrun with rubbish and seeming to be wholly given up and abandoned.

A vocal and growing group of malcontents, led by Peter Gordon and Thomas Stephens, petitioned the Trustees for better representation and a repeal of the ban on importation of slaves, among other demands. The appeals went unheeded. Oglethorpe, true to his military training, advocated strict enforcement of discipline as the only method to ensure the survival of the colony with concurrence by the Trustees.[7]

MILITARY EXPANSION AND THE WAR OF JENKINS EAR

From the outset of the 13th colony's founding, military considerations increasingly became the primary rationale for Georgia's continued existence. The growing animosity from Spain over what it viewed as England's provocative incursions southward along the coast of Guale established the necessity of increased English military support from London. Savannah's growing port and

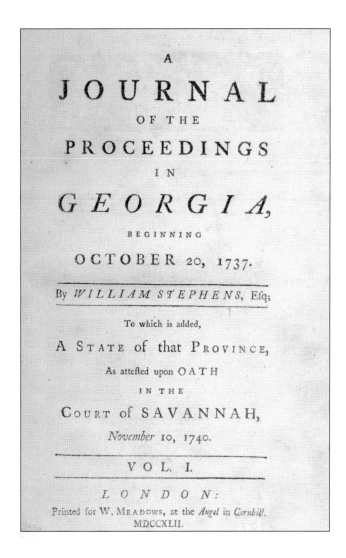

"A Journal of the Proceedings in Georgia, Beginning October 20, 1737," by William Stephens, published in London, 1742.

the influential economy of Charles Town and South Carolina clearly required military protection.

In early 1736, Oglethorpe made several strategic moves to solidify his tenuous position on the coast south of Savannah. In January of that year, a contingent of Highland Scots from the region of Inverness, recruited under Oglethorpe's auspices by George Dunbar and Hugh Mackay, established a fortified settlement near the mouth of the Altamaha, not far from old Fort King George. First known as New Inverness, the Scots' town soon came to be known as Darien. Family clans, including McIntosh, McDonald, and Cuthbert, settled here. The primary role of Darien in the formative years of the colony was largely military in nature, for the Highland Scots were regarded as some of the finest fighting men in Europe.[8]

In March, Oglethorpe himself led British forces down the inland waterway and selected a defensive position on the western side of St. Simons Island, not far from Darien, for a fortification and town, both of which he named Frederica in honor of Frederick, Prince of Wales, the son of George II. Soldiers and craftsmen, in addition to a number of women and children, set about erecting permanent homes and businesses. By 1738, Frederica had become one of the strongest military posts in British North America, providing a strong defensive bulwark for the protection of Savannah 75 miles up the coast.

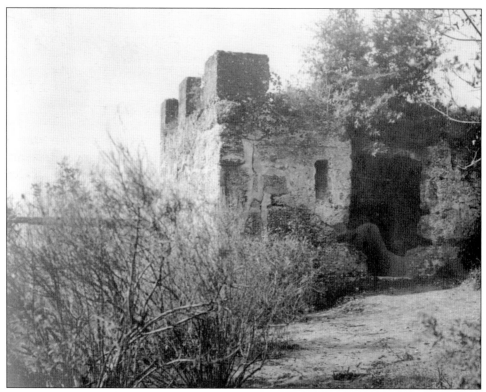

Ruins of the King's Magazine at Fort Frederica.

The Georgia colony during the War of Jenkins Ear, 1743.

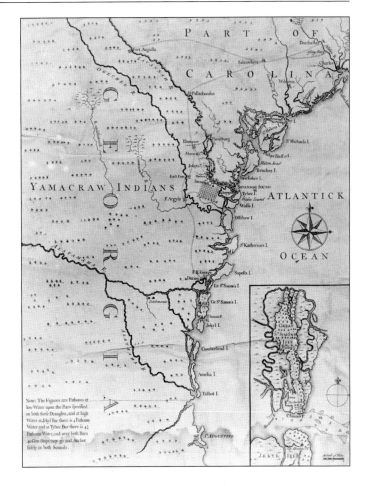

At the same time, Oglethorpe placed two military outposts on each end of Cumberland Island: Fort St. Andrew on the north and Fort William on the south. British forces also reconnoitered further south on Amelia Island and even placed a small outpost not far from the mouth of the St. Johns River on Fort George Island. These developments caused consternation among the Spanish authorities at St. Augustine and vehement protests soon followed. The Spaniards argued that the English had extended their outposts far below the Altamaha River, a stream originally delineated as the southern boundary between the Georgia colony and the "debatable land" between it and Spanish Florida. Oglethorpe parlayed with Antonio de Arredondo, Spanish diplomat from St. Augustine, at Jekyll Island in the summer of 1736, agreeing only to abandon his outpost on Fort George Island. However, as the Spaniards did not seriously protest the British presence on Cumberland and Jekyll, Oglethorpe resolved to maintain his presence on both islands. These were important to the English strategy, for each served as buffers and early-warning posts for the primary military contingent at St. Simons. By late 1738, Oglethorpe had over 600 troops stationed at Fort Frederica, a factor that

inevitably played a large role in the eventual outbreak of hostilities in the region between England and Spain.

Another important strategic ploy by Oglethorpe was to encourage improved relations with the Lower Creeks. His peace treaty with the Creeks in the Treaty of Coweta, completed near the Chattahoochee River in present west-central Georgia in August 1739, was critical in light of later developments in the difficulties with Spain. Although Oglethorpe was not able to engage the Creeks as military allies, he nonetheless extracted from them a promise not to ally themselves with Spain.

To no one's surprise, open hostilities between England and Spain broke out in late 1739. Largely a commercial war over disputed trade venues in the Caribbean and the southeastern American coast, Spain's immediate intent was to dislodge the English from the "debatable land" for good. Oglethorpe took the early initiative in the so-called War of Jenkins Ear by dispatching a force of 900 British troops and 1,100 Native Americans to assault the Spanish stronghold at St. Augustine, defended by a force of about 800 under Governor Manuel Montiano. A siege lasting into the summer of 1740 proved fruitless for the British, however. After a force that included a large contingent of Darien Scots was attacked and defeated at Fort Mose north of St. Augustine in June, Oglethorpe decided to abandon his siege, retreating back north to Frederica where he entrenched his forces for an expected counterattack.[9]

Strangely, the Spaniards hesitated and did not press their momentum. The delay proved costly. Oglethorpe, withstanding strong criticism both in Georgia and London for his failure at St. Augustine, gained valuable time to acquire reinforcements for his St. Simons outposts and, when the Spaniards finally did attack in July 1742, the British were ready. The invasion of Georgia from Havana, by way of St. Augustine, was comprised of 50 Spanish ships and 3,000 grenadiers, a force which greatly outnumbered the British. However, at Bloody Marsh on the south end of St. Simons, a contingent of British regulars from Frederica and Highland Scots from Darien surprised and defeated an advance party of Spanish. Fearing envelopment by what they mistakenly assumed to be superior forces, the Spanish retreated back to Florida. Georgia was saved and was never threatened with invasion thereafter, although a peace treaty was not signed until 1748.

THE END OF THE PROPRIETARY ERA IN GEORGIA

With the end of the war with Spain and the permanence of the Georgia colony assured, the Trustees saw little need for a continued strong military presence in the region. Those who remained in the colony began to acquire land grants with the aim of developing agrarian pursuits. Nevertheless, many people began to depart the colony, seeking slave ownership and the agricultural prosperity offered by Carolina. In 1743, fewer than 300 people remained in Savannah. When Oglethorpe's regiment was deactivated in 1749, only 150 people elected to remain at Frederica. In the late 1740s, the future of Georgia did not look promising.

Restrictions of property ownership and sale had been considerably relaxed and the ban on rum had been lifted in 1742. However, it was not until 1750, when

the Trustees removed the prohibition on slave importation, that the possibilities for the colony begin to brighten.[10] Fee-simple transfer of land for new settlers in the colony, along with the legalization of slavery, gave rise in Georgia to the development of rice and indigo plantations on the South Carolina model.

Slavery had been the central divisive issue since the colony's founding in 1733. One segment of the population, comprised largely of Savannah settlers, petitioned

JAMES EDWARD OGLETHORPE

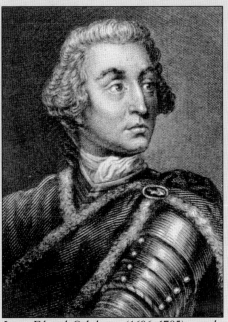

James Edward Oglethorpe (1696–1785) was the founder of Georgia.

The impact of Oglethorpe upon the eventual success of the Georgia colony can hardly be overestimated. It was Oglethorpe's discipline, patience, and perseverance that accounts for his being, more than any other individual, the primary factor in the survival of Georgia in the critical first ten years of the colony.

Oglethorpe was born December 22, 1696 in Godalming, Surrey, England. He received military training early in life and served on the Continent with Prince Eugene of Savoy. By 1722, he had been elected to Parliament, assuming the seat in the House of Commons held previously by his father and older brothers.

Oglethorpe developed strong sympathies for the poor and oppressed peoples of England and his chairmanship of a parliamentary committee to investigate the conditions of English jails led to his major role in the creation of the Georgia colony. Oglethorpe's idea that debtors could better serve the realm outside rather than within the terrible conditions of the jails became the bedrock upon which the new colony would be launched. Oglethorpe correctly reasoned that a second chance in life in a new colony and the individual self-sufficiency evolving from hard work and a period of servitude to the Georgia Trustees would create useful citizens and benefit the British empire in North America.

Because of his inclination toward egotism, his rigorous enforcement of discipline, and his resistance to change in his original concepts, Oglethorpe received criticism on both sides of the Atlantic during the difficult formative years of Georgia. His relentless perseverance and his certainty that his methods were correct nevertheless proved to be the underlying factors in the continuance of the colony. Oglethorpe was not known for being an efficient administrator, but his willingness to personally endure hardships alongside his fellow Georgia settlers earned him the steadfast loyalty of many in the colony, particularly his Scottish Highland recruits at Darien.

After Bloody Marsh and his defeat of the Spanish invasion attempt, Oglethorpe made a second, unsuccessful, attack on St. Augustine in 1743. Later that year, he returned to England to face charges brought against him by one of his military subordinates. He was exonerated in a court martial, but, interestingly, Oglethorpe never returned to Georgia. He spent much of the remainder of a long life in London, gradually having less involvement in the affairs of the colony he founded. Oglethorpe fought on the Continent during the Seven Years War, after which he actively supported the movement for independence in the American colonies, and continued to be interested in events in Georgia during the Revolution. He lived long enough to see independence achieved by the colonies and died June 30, 1785.

for slavery to advance the colony's economic prospects. A petition by the Highland Scots of Darien in 1739, followed by another from the Salzburgers at Ebenezer, strongly opposed the importation of slaves into Georgia. The Trustees endorsed similar sentiments. They objected to slavery not only from a moral perspective, but also because it contradicted the Trustees' vision of a Georgia settled by a work-conscious yeomanry of small farmers.

The outlook was much different by 1750 when the ban on slavery was lifted. Economic realities dictated that, in order for Georgia to have a chance to rival the neighboring Carolinas and Virginia for trade and commerce, slavery must be allowed to enable the development of large-scale plantation-style agriculture. These considerations, with the consequent pressure for change, diminished the Trustees' power. Slavery, necessary and attendant to the pursuit of a plantation culture, came to be seen as the most effective antidote to Georgia's economic lassitude. The way was now open for settlers to carve rice plantations from the cypress swamps near the mouths of Georgia's freshwater rivers. Rapid importation of slaves into the colony, primarily from South Carolina from whence rice planters began to acquire large tracts of fresh, uncultivated Georgia land, quickly led to blacks far outnumbering whites in the colony.

Finally, with the decline and eventual loss of financial support from Parliament, as well as a gradual loss of interest in the affairs of the colony by many of its members, the Trustees surrendered their charter to George II in 1752. By most measures, the Trustees had failed in their original objectives—few indigent debtors were ever brought to the colony and the expansive mercantile and agricultural prospects envisioned by the Trustees never reached their potential. Only in the acquisition of land, through claim and subsequent conflict, had the Trustees been successful. Nevertheless, it may also be said with little argument that the persistence of the Trustees in the first two decades of Georgia ensured the colony's survival.

3. A Royal Province

JOHN REYNOLDS, THE FIRST of three royal governors of Georgia to be appointed by the king, arrived in Georgia in late 1754. He was not impressed with the state of the colony. A visit to Frederica found the town "entirely in Ruins, the Fortifications entirely decayed and the Houses falling down."[1] Reports to the London colonial office by Reynolds in 1755 indicated a Georgia population reduced to 4,500 whites and 1,850 blacks. Reynolds laid the foundation for royal oversight of the colony with the clear implication that the final authority on all issues lay with the governor and the royal colonial council in London. In Georgia, a Commons House of Assembly was elected, comprised of the larger landowners in Georgia.

Reynolds, concerned about the poor state of the colony's defenses, placed a high—almost unreasonable—priority on the improvement of military facilities, an act that was enthusiastically supported by the Assembly. However, Reynolds soon became encumbered with political troubles and factionalism in the colony, and he was recalled by the British Board of Trade with an attendant lack of financial support from London.

Reynolds's successor was Henry Ellis, who arrived in Savannah in early 1757. Ellis was a man with a scientific bent and an interest in natural history. He proved to be far more effective as a royal governor than his predecessor and succeeded in gaining the loyalty of most members of the Assembly. His earliest impressions of the politics of the colony are worth noting, for they reveal the thoughts of a man who felt somewhat daunted by the task confronting him. The *Colonial Records of the State of Georgia* cite Ellis as reporting the following to his superiors in London in March 1757:

> I found the people here exceedingly dissatisfied with each other and an almost universal discontent arising from the late proceedings and persons in power. Few approached me that were not inflamed with resentment and liberal in invectives urging that I should take some immediate and very violent steps, such as a total change of public officers and the dissolution of the Assembly. . . . I forebore making any material alteration until I should be qualified to act from observation and experience.

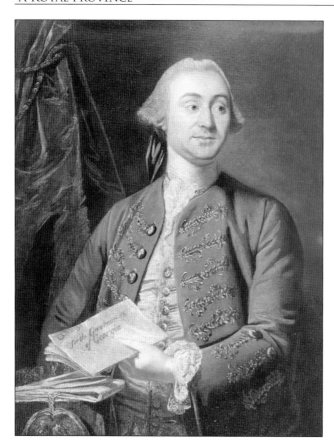

*Sir James Wright
(1716–1785) was the most
efficient and popular of
Georgia's royal governors.*

During Ellis's three years in Georgia, the royal colonial method of government was solidified and, in 1758, the Anglican Church became the established church of the colony. The Commons House of Assembly created eight parishes in 1758. These became separate administrative units accountable to the House and the royal governor. The Assembly established four more parishes in 1765. Parish officials were typically elected by local land owners, usually affiliated with the Anglican Church, and were charged with coordinating the administrative affairs of their section. The colonial parishes evolved into the present system of counties in Georgia during and after the Revolution. The parishes created in 1758 and 1765, with their corresponding counties (established in 1777), were St. Paul's in Richmond; St. George's in Burke; St. Matthew's in Effingham; St. Philip's in Effingham, Chatham, and Bryan; Christ Church in Chatham and Bryan; St. John's in Liberty; St. Andrew's in Liberty and McIntosh; St. James's in Liberty and later in Glynn; St. David's in Glynn; St. Patrick's in Glynn; St. Thomas's in Camden; and St. Mary's in Camden. Bryan and McIntosh Counties were created in 1793 from Effingham, Chatham, and Liberty.

Henry Ellis proved to be a capable diplomat as he negotiated with the Creek to secure Ossabaw, St. Catherines, and Sapelo Islands. A claim on these lands by

Mary Musgrove Bosomworth and her husband, Reverend Thomas Bosomworth, argued through the British courts, was settled in 1759 with the Bosomworths receiving St. Catherines Island, while Sapelo and Ossabaw were retained by the crown and placed for sale at public auction.

Georgia's third and final royal governor, James Wright, assumed office in Savannah in 1760. Wright proved to be the most effective of Georgia's royal governors, universally acknowledged as an honest, efficient administrator who possessed a genuine interest in the improvement of Georgia. Wright was also personally ambitious. He accrued a fortune in Georgia, acquiring huge amounts of land and slaves that enabled him to become a productive rice and indigo planter. Like his predecessors, Wright worried about Georgia's poor defensive posture. He engaged the colonial surveyor, William DeBrahm, to conduct an extensive inspection tour of the colony and make recommendations for the types of fortifications required for defense. Wright also oversaw significant cessions from the Creek by which, through the Treaty of Augusta in 1763, the Georgia colonial boundary was extended further up the Ogeechee River and north and westward

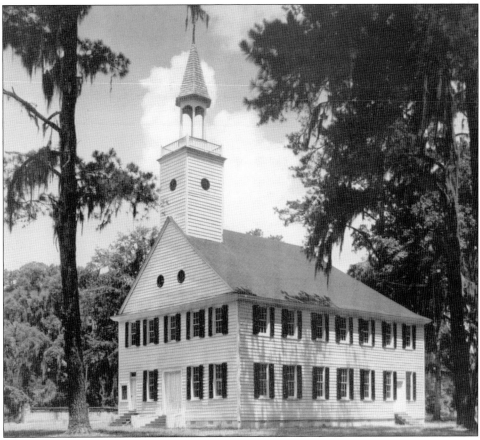

Midway Congregational Church in Liberty County.

from Augusta. By 1773, the colony had acquired from the Creek and Cherokee additional lands amounting to more than 2 million acres in the Broad River valley northwest of Augusta in response to the growing influx of settlers moving into that region from Virginia and the Carolinas.

The late 1750s and the early 1760s were a period of agricultural and commercial expansion of the Georgia colony, as well as increased settlement, expedited primarily through the availability of easily obtainable land. Land grants were awarded under conditions that encouraged settlement in the outlying regions of the colony, particularly along the Savannah River between Savannah and Augusta, and along the coastal tidewater south of Savannah.

In 1752, Puritans from Massachusetts, by way of Dorchester, South Carolina, settled at Midway on the coast below Savannah in what became Liberty County. Members of this community and others founded the new town of Sunbury in 1758 on the Medway River near St. Catherines Island. Sunbury, during the 1760s, became a thriving seaport and, for a time, rivaled Savannah in terms of commercial importance. The town was laid out on 300 acres in a grid with 496 lots, a Common of 100 acres, and 3 squares. Settlers built a customs house and other facilities to

A page from the account book of Savannah merchants James Read and James Mossman from 1765 and 1766.

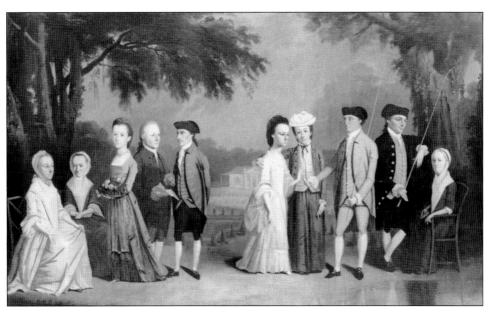

Savannah merchant Edmund Tannatt and his family, c. 1760.

serve the shipping trade. A merchant and planter class made Sunbury the center of economic, cultural, and social life in St. John's Parish.

Also during this period, large tracts of land were granted in the Altamaha River delta and along the lower Ogeechee, Newport, and Sapelo Rivers as colonial authorities sought to encourage the development of large-scale agriculture.[2] Beginning in 1754, another new town was laid out and grants of land were awarded at Hardwicke on the lower Ogeechee River in what later became Bryan County. Hardwicke was surveyed for 600 lots in 335 acres, but the town was not a success due to its proximity to Sunbury and Savannah.

During the 1760s and in the years leading up to the American Revolution, Georgia experienced economic prosperity for the first time. Following the introduction of slavery in 1750, Georgians began to grow rice in increasing quantities on plantations on the Savannah, Ogeechee, and Altamaha Rivers. Georgia planters adopted the South Carolina method of tideflow rice cultivation, utilizing the lower reaches of these freshwater streams and alternating tides from the Atlantic for the irrigation of their fields. Indigo cultivation was also adopted from South Carolina. Slaves brought into Georgia to work large rice tracts acquired by prosperous South Carolinians, such as Jonathan Bryan and Henry Laurens, introduced a new culture to the colony. Other substantial land owners included Governor James Wright, who owned 11 plantations and 523 slaves; James Habersham, with more than 10,000 acres and almost 200 slaves; and John Graham with 25,000 thousand acres. By 1773, Georgia contained over 120,000 acres under cultivation, chiefly in the staple crops of rice and indigo and provision crops such as corn, peas, and wheat. In concert with the growing

dominance of plantations in the economic life of the colony, there gradually developed the culture, religion, and language of African slaves imported through Charles Town and Savannah. The Carolina lowcountry Gullah speech patterns of mixed West African dialects and English evolved into the Geechee speech of tidewater Georgia.

In 1754, Georgia shipped about 1,900 tons of commodities on 52 vessels clearing the Savannah harbor. By 1770, export tonnage clearing the colony had increased to 10,500 tons on almost 150 ships from Savannah.[3] In 1772, 56 vessels departed Sunbury with cargoes of Georgia rice, indigo, and lumber. The growth of the tidewater rice industry is revealed in the steady increase in exports; in 1755, Savannah exported 2,200 barrels of rice, a figure that grew to almost 20,000 by 1770. The early 1770s demonstrated the great reliance on naval store exports to the colony's growing economy. Georgia shipped over 2 million feet of lumber in 1772, in addition to large quantities of barrel staves, shingles, and pitch. Meanwhile, Georgians cultivated silk with measured success, chiefly at the industrious Ebenezer Salzburger settlement on the Savannah River. Silk exports reached a high of 2,000 pounds in 1767. Imported commodities, primarily from the West Indies, included cargoes of sugar, rum, and molasses.

Savannah's commercial prosperity from 1760 to 1775 reached new heights and would not be surpassed until the early nineteenth century. The export firm of Harris and Habersham constructed seagoing shipping facilities on the Savannah waterfront to handle the increased trade.[4] Another mercantile concern and counting house was managed by Thomas Raspberry, whose letter book sheds considerable light on the economic conditions of Savannah in the 1760s, as well as information on the people in the local merchant class.[5]

Up the Savannah River on the fall line where the Appalachian plateau meets the upper reaches of the coastal plain, the growing town of Augusta had become the leading commercial center and Indian trading post on Georgia's colonial frontier. Originally laid out by James Oglethorpe in a plan resembling Savannah's, Augusta began in the first years of the colony as a frontier military and trading outpost. Oglethorpe also constructed a road between Augusta and Savannah to open both land and water communication routes between the two towns. By 1745, Augusta boasted five warehouses to accommodate trade with the region's Native Americans. The establishment and rapid growth of St. Paul's Church in 1750 lent a sense of permanence to Augusta. By 1773, prominent merchants and Indian traders, such as Andrew McLean and Lachlan McGillivray, among others, helped make Augusta the commercial center of the colonial frontier.[6] These developments did not escape the notice of Governor Wright, who wanted to open the region around Augusta to new settlers, eventually negotiating cessions of lands from the local Cherokee and Creek.[7]

Other colonial towns developed slower. Darien, near the mouth of the Altamaha, had seen its Scottish population decimated during the War of Jenkins Ear and the town was slow to recover. Lachlan McIntosh, a son of John Mohr McIntosh,

BARTRAM'S TRAVELS THROUGH GEORGIA

William Bartram (1739–1823) is recognized as one of America's first early naturalists. As a young man, he accompanied his father John Bartram, a respected botanist from Philadelphia, on travels through Georgia and East Florida. From 1773 to 1777, William conducted an extensive survey of the American southeast, much of it in Georgia, as he identified, catalogued, and sketched the flora and fauna of the region. Bartram synthesized his natural investigations while adding commentary on the geography and people of the region in his definitive *Travels,* published in 1791.

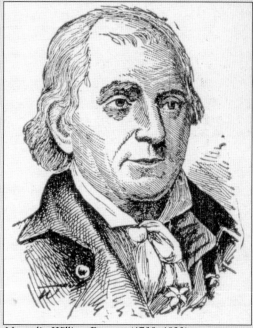

Naturalist William Bartram (1739–1823).

The flowering evergreen shrub, perhaps the most significant finding by the Bartrams on their 1765 expedition, was discovered on the north bank of the Altamaha River, west of Darien near Fort Barrington. It was named *Franklinia alatamaha* by John Bartram in honor of Benjamin Franklin. The plant has also been variously described as the Lost Gordonia, or Franklinia. William found the plant again in 1773 on a return to the Darien area, but since that time, the Franklinia has never again been found in its native habitat. The plants now in existence are generally recognized to have come from those taken by John Bartram to his gardens in Philadelphia.

William Bartram in his *Travels* became one of the first naturalists to write of "Ouaquaphenogaw"—the Okefenokee Swamp, that vast, marshy wetland in lower southeast Georgia, which teems with wildlife. Bartram writes both affectingly and engagingly of the alligator, that "terrible monster [which] when they bellow in the Spring Season they force the water out of their throat . . . & a steam or vapour from their Nostrals like smoke."

William Bartram's powers of observation and his keen perception and understanding of his surroundings came together in both his artistic depictions and his written observations. Few of his contemporaries possessed the insights on the significance of the natural surroundings. He wrote, "Let us rely on Providence, and by studying and contemplating the works and power of the Creator, learn wisdom and understanding in the economy of nature, and be seriously attentive to the divine monitor within."

one of Darien's 1736 founders, executed a Crown survey of the town in 1767 and enlarged upon Oglethorpe's original foursquare town plan. Darien did not prosper, however, until the early years of the nineteenth century when it took advantage of increased river trade from the interior of Georgia.

Brunswick was Georgia's third "public town" (after Savannah and Hardwicke), meaning it was designed as a port of entry and government center. Brunswick was laid out in 1771, the last town founded by the British in their North American colonies before the Revolution. It had an ideal deep-water harbor much nearer the sea than Savannah and was situated on the Turtle River, a tidal stream. George McIntosh surveyed the original town and it was laid out in the familiar Savannah plan, with 383 acres for the town proper and 2,024 acres for the Common. The

Revolution disrupted Brunswick's development and not until the early 1830s did the town begin to grow and prosper.

Another town, Wrightsborough, was founded in 1769 in St. Paul Parish (Augusta) and was surveyed by a North Carolina Quaker, Joseph Maddock. Governor Wright supported the town named for him, and he intended it to be an important military buffer and commercial entrepôt on the colony's western boundary. William Bartram visited Wrightsborough before the Revolution and noted that the town had 200 families, all Quakers.

Georgia clearly prospered as a royal colony, particularly in light of the uncertainty of the colony's future in the final years of Trusteeship. In 1752, when the Trustees surrendered their charter, the population of the colony was about 2,100 inhabitants, of whom 420 were black. By 1760, with migration of new settlers from South Carolina and other colonies, Georgia's population had increased five-fold, to about 10,000, about one-third of which comprised the colony's slave force. On the eve of the Revolution, in 1773, the population had more than tripled to 33,000, including 15,000 slaves. The majority of slaves by this time were utilized on the tidewater rice and indigo plantations. A plantation aristocracy in Georgia had its beginnings during this period, from the 1760s to the Revolution.

With the growth of commerce, the influx of new settlers, and development of a tidewater planter class, Georgia gradually began to achieve some of the rudimentary trappings of sophistication already in place in her more established sister colonies to the north. The colony's first newspaper, the *Georgia Gazette,* began in Savannah in 1763, edited by James Johnston. Prominent Savannah families, encouraged by Governor Wright and the Assembly, began to promote cultural events to offer some relief from their active business enterprises.[8] And while the Church of England enjoyed official status as the established church of the colony, many clergymen— among them John J. Zubly of the Independent Presbyterian Church in Savannah, John Osgood of the Congregationalist Church at Midway, and John M. Bolzius at Ebenezer—worked actively on behalf of other denominations.[9] Georgia's nascent prosperity, however, would soon be threatened by the storm clouds of revolution that gathered ominously on the horizon. There were darker days ahead.

4. THE AMERICAN REVOLUTION AND STATEHOOD

DURING THE DECADE OF THE 1760s, as unrest against England grew in the 13 colonies, two distinct political factions evolved in Georgia. One, steadfastly loyal to King George III, was an older generation of colonists, chief among whom were Noble Jones and James Habersham. The other group was comprised of the sons of the older conservatives; Noble Wymberly Jones, John Habersham, James Habersham Jr., and Lachlan McIntosh were among those advocating independence.

Despite these deep divisions, Georgia was slower than the other colonies to embrace the push toward independence and revolution. This reluctance was rooted largely in age and distance. The colony was the newest of the 13 and, thus, more reliant on England; it was furthest removed from the earliest flashpoints of discontent in the New England colonies, such as Boston. By 1770, however, some issues began to come to a head even in Georgia. Royal governor James Wright had increasingly acrimonious relations with the Commons House of Assembly. The situation further deteriorated in the spring of 1771 when Wright refused to accept the choice of Noble W. Jones as speaker of the House. Jones had become one of Georgia's most radical and outspoken leaders in opposition to England's management of its colonies.[1]

Wright's staunchest ally was James Habersham, president of the colonial council. Attesting to this confidence was Wright's appointment, while in England from 1771 to 1773, of Habersham as acting governor. Once in office, Habersham, like Wright, also rejected Jones as House speaker and ultimately dissolved the assembly, an action severely criticized by Presbyterian clergyman John Zubly of Savannah.[2] When representatives from the colony's parishes met in defiance of Wright at Peter Tondee's tavern in Savannah in August 1774, Georgia was irrevocably committed to the growing movement of resistance to parliamentary authority. Though Georgia elected no representatives to the First Continental Congress in Philadelphia, the colony did elect three delegates to the Second Continental Congress the following January: Noble W. Jones, Archibald Bulloch, and John Houstoun (all from Christ Church Parish). However, since only five of

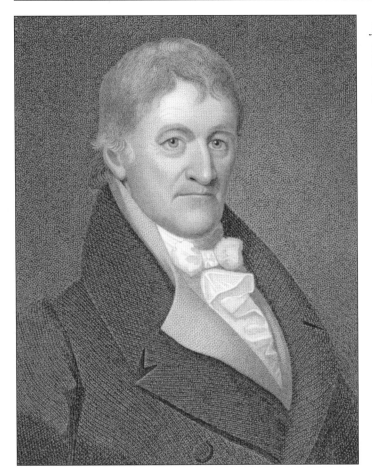

Joseph Habersham (1751–1815) was a leader in Georgia's independence movement.

Georgia's twelve parishes were represented at this gathering, the three delegates declined to attend the proceedings in Philadelphia.

Wright's tenuous hold on the Commons House further eroded throughout 1775. Upon receiving the news of open rebellion erupting in Massachusetts at Lexington and Concord, Georgia further defied royal authority when a group led by Noble W. Jones and Joseph Habersham robbed the public magazine at Savannah of 600 pounds of gunpowder.[3] In July 1775, the rebels formed the Georgia Council for Safety to manage the rapidly deteriorating situation between the colony and Britain. This group included some of the leading Whigs of the Georgia independence movement: Samuel Elbert, William Young, William LeConte, George Walton, Joseph Habersham, William Ewen, John Cuthbert, Edward Telfair, John Morel, Francis Harris, and Joseph Clay, among others.[4] The council was the foundation of a new revolutionary government and had powers of authority for Georgia when the provincial congress was not in session.

Events moved quickly in 1776; Governor Wright fled the colony in February after his arrest by the Council of Safety completed the collapse of royal

authority in Georgia.[5] By the spring of 1776, Georgia was fully committed to the Revolutionary movement. The final break came in July, when Georgia's three congressional delegates—George Walton, Button Gwinnett, and Lyman Hall—joined their colleagues from the other colonies in the formalized acceptance of separation from Britain by signing the Declaration of Independence (see sidebar).

Four provincial congresses managed Georgia's affairs from early 1775 until June 1777, when Georgia adopted the first state constitution. Also in 1777, Georgia's colonial parishes were replaced by the creation of the state's first eight counties, named for English politicians who supported the American movement toward independence: Chatham, Richmond, Glynn, Effingham, Camden, Burke, and Wilkes, in addition to another named for Liberty. Button Gwinnett

This extract from minutes "At a Meeting of the Council of Safety, Monday, Jany. 8, 1775," includes the names of George Walton, Edward Telfair, Noble W. Jones, Samuel Elbert, Button Gwinnett, and Jonathan Bryan.

THREE GEORGIANS FOR INDEPENDENCE

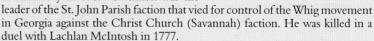

Georgia's three representatives in the Continental Congress who signed the Declaration of Independence in Philadelphia on August 2, 1776—Button Gwinnett, Lyman Hall, and George Walton—rank among the better-known names in Georgia's history. But just who *were* the men behind the names? Like many other colonial leaders, these Georgians sacrificed their personal fortunes for the cause of liberty and were only a step ahead of the hangman's noose after being denounced as traitors by the British government.

Button Gwinnett (1735–1777), perhaps the most famous (partly because of the rarity of his signature), came to Georgia from his native England in 1765. Soon after his arrival in Savannah, he purchased St. Catherines Island where he planted indigo and other crops and built a residence. Gwinnett also had a home in nearby Sunbury, then a thriving port town and the business center of St. John Parish. He began his career in Revolutionary politics when he was elected to the Commons House of Assembly in 1769. Gwinnett was the

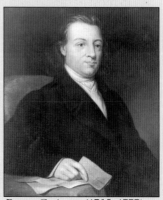

Button Gwinnett (1735–1777).

leader of the St. John Parish faction that vied for control of the Whig movement in Georgia against the Christ Church (Savannah) faction. He was killed in a duel with Lachlan McIntosh in 1777.

Lyman Hall (1724–1790) was born in Connecticut and studied theology and medicine before moving to Charles Town in 1757, where he began a medical practice. In 1760, Hall migrated to Georgia and built a home at Hall's Knoll in St. John Parish near Midway, settled several years earlier by Puritans from Dorchester, South Carolina. Hall cultivated rice and tended to the medical needs of the surrounding region. Like his neighbor Button Gwinnett, Hall joined in Georgia's Revolutionary movement and was twice elected as a representative to the Continental Congress.

Lyman Hall (1724–1790).

George Walton (1750–1804), a native of Virginia, arrived in Savannah in 1769 to study law under the guidance of Henry Yonge. Walton was admitted to practice before the provincial court in 1772 and, by 1775, he had developed one of the most prosperous law firms in the colony. In the latter year, Walton became actively involved in the Revolutionary movement, was elected secretary of the provincial assembly, and was selected as a delegate to the Continental Congress in early 1776.

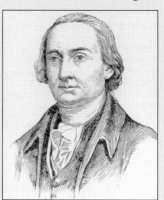

George Walton (1750–1804).

returned from Philadelphia and became president of the Georgia provincial congress in early 1777 after the death of the first president, Archibald Bulloch. As the radical Whigs assumed control of government during 1776 and 1777, many of Georgia's loyalists began an exodus to British East Florida. The confiscation and banishment acts of 1777 and 1778 resulted in the further legalized expulsion of loyalists (Tories) from Georgia with the attendant acquisition of considerable amounts of loyalist property. Most of the loyalists moved to St. Augustine, where many formed military brigades to engage in raids against Georgia for the remainder of the war.[6]

Although unified in the effort to gain independence, Georgia's Whig political leaders found themselves as susceptible to disagreement and controversy as those in most of the other rebelling colonies. One of the influential Darien Scots, Lachlan McIntosh, was a conservative who became a brigadier general and commander of the Continental forces in Georgia, a position that had been sought by Gwinnett. Contentious relations between Gwinnett and McIntosh were aggravated by Gwinnett's charges of treason against McIntosh's brother George. The political controversy ended in a duel between Gwinnett and McIntosh in Savannah in May 1777. Though both were wounded, Gwinnett's injuries were fatal and he died three days later. Amid this controversy, McIntosh departed Georgia and served two years under General George Washington in Pennsylvania and the Northwest territories.[7]

Militarily, there were no events of significance in Georgia until 1778. Various contingents of Georgia Whig forces made three unsuccessful attempts to capture St. Augustine in 1776 and 1777, all doomed to failure by a combination of poor organization and communications, bad weather, and troubles evolving from Native American raids on the frontier. In December 1778, British forces under General Augustine Prevost and Colonel Archibald Campbell recaptured and occupied Savannah. By January 1779, Sunbury and Augusta had also fallen to the British, and Governor Wright returned to Savannah to resume royal authority over the state.

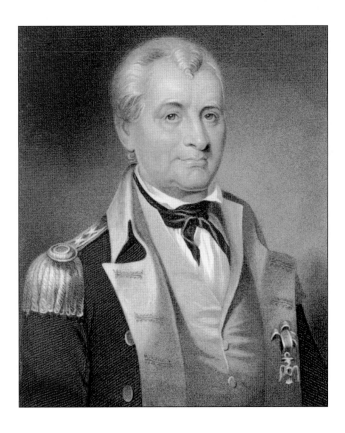

General Lachlan McIntosh (1727–1806) was commander of Georgia's forces during the Revolutionary War.

With the British in control of the upper Georgia coast and much of the Savannah River, events in the backcountry became the focus of the colonists' continued war effort. Whig forces from North Carolina forced a British withdrawal from Augusta down the Savannah River toward Ebenezer. The Battle of Kettle Creek in Wilkes County in February 1779 solidified the Whigs' hold on the Georgia interior as militia troops led by Elijah Clarke, John Dooly, and Andrew Pickens defeated a large British Tory force. This action was neutralized soon after by an American defeat at Briar Creek. General Benjamin Lincoln, the new Continental commander in the South, then began raising forces to mount an offensive against the British aimed at retaking Savannah.

Prospects for success at Savannah received a fortuitous lift when, in September 1779, a large French naval force transporting 4,000 troops under Count Charles Henri d'Estaing arrived off Tybee Island. Working in concert with Generals Lincoln and McIntosh (who had returned to Georgia), d'Estaing made plans for an all-out assault on Savannah. Despite a numerical advantage in forces, however, the French and Americans made the fatal mistake of delaying their attack until October 9. Prevost, utilizing slave labor, had time to strengthen Savannah's perimeter defenses. He also received reinforcements from nearby Beaufort, South Carolina under Colonel John Maitland. Thus, the combined Franco-American force was

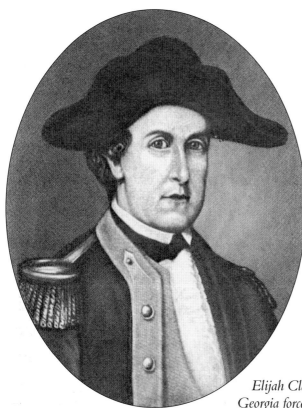

Elijah Clarke (1733–1799) was a leader of Georgia forces in the backcountry.

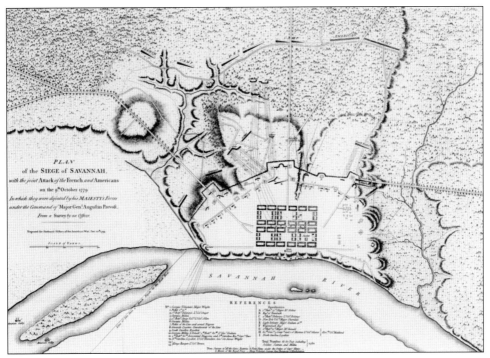

This British engraving depicts the Battle of Savannah on October 9, 1779.

repelled by the British defenders in one of the bloodiest actions of the Revolution. The allies lost 750 men killed and wounded, while British battle deaths numbered only 18. Among the American combatants killed were Count Casimir Pulaski and Sergeant William Jasper, both of whom were later honored with monuments on Savannah squares.[8] Meanwhile, Savannah and the neighboring coast remained firmly in British control until the final withdrawal of the Wright government in the summer of 1782.

The inability of the British to subdue the Georgia backcountry in 1779, however, gave the Whigs continued encouragement militarily, but political factionalism prevented a cohesive effort. With Savannah occupied by the British, Augusta had become the administrative center for Georgia. Their opposing groups maneuvered for political control, one led by George Walton and an executive council, and the other called the Supreme Executive Council. In early 1780, Georgia's Whig government called for a new assembly to meet at Augusta, subsequently electing Richard Howley as governor. The assembly also moved Georgia's capital to Augusta, relocating the direction of state affairs away from the coast for the first time since the colony's founding almost 50 years earlier. Nevertheless, with many of Georgia's forces called to the defense of Charleston (which fell to the British in May 1780), the English seized the opportunity to take Augusta and Georgia's Whig government there collapsed.

For the next year and a half, Whig and Tory militia forces fought for control of the backcountry. Georgia troops, led by Elijah Clarke, John Twiggs, Benjamin Few, James Jackson, and John Dooly, eventually linked with Continental forces under the command of General Nathanael Greene, appointed by Washington to organize a new southern offensive against the British. The combined forces recaptured Augusta in June 1781 and expelled the British from the surrounding frontier soon after. Joseph Clay arrived in Augusta later that summer to lead a reorganization of state government with a new assembly composed of representatives from each county.[9] Nathan Brownson was elected governor and, as the war neared its end, Georgia Whigs laid plans for the formation of a permanent government. During the first part of 1782, General Anthony Wayne led the revitalized Whig forces that drove the Tories back down the Savannah River corridor into Savannah itself. Many Tories eventually joined the Whig cause as the outcome of events became clearer. The British evacuation of Savannah in July 1782 removed the last remaining royal forces from Georgia. Colonel James Jackson led the American forces triumphantly into the liberated city. Fifty years after Georgia's founding, royal authority had ended forever.

The Revolution in Georgia was over and with it came the changing dynamics of political affairs in the state. With independence assured in 1782 and a new state government formed in Augusta, it had become clear that the political focus of Georgia had made a gradual and permanent shift from the coast to the interior.

STATE GOVERNMENT AND STATEHOOD

Events moved rapidly following the cessation of fighting. The Georgia Assembly intensified the sale of confiscated Tory property while awarding considerable amounts of land in recognition of those who had served the Revolutionary cause. Nathanael Greene, Anthony Wayne, Elijah Clarke, and James Jackson were among those rewarded with plantations. Greene and Wayne received valuable Savannah River rice land. Governmental administration briefly resumed in Savannah before moving again to Augusta in 1785. In 1796, Georgia selected a new town, Louisville, near the Ogeechee River, as the state capital before finally settling upon Milledgeville in 1807.

During the years immediately after the war—the Confederation period—the Assembly attempted to mitigate the Indian question in the interior. The influx of new settlers into Georgia after the Revolution, primarily from Virginia and North Carolina, brought a heavy demand for land, increasing the necessity for interior expansion with the resultant expulsion of the Creek, who occupied the region between the Ogeechee and Ocmulgee Rivers.

With its frontiers vulnerable to Native American attacks, Georgia, for the most part, energetically supported the concept of a central national government as it joined the loosely aligned states of the Confederation and participated in the creation of the national constitution in 1787. The Georgia Assembly elected William Few, Abraham Baldwin, William Pierce, George Walton, William Houstoun, and Nathaniel Pendleton as its representatives to the Constitutional

Noble Wymberly Jones (1723–1805) was the leader of Georgia's opposition to British rule.

Convention, which convened in Philadelphia that summer. Baldwin was probably the most active Georgia delegate and made the greatest contribution to the final document that emerged from that convention. He also served on the Convention's Committee of Style and his copy of the Constitution is now owned by the Georgia Historical Society.

Georgia ratified the new United States Constitution on January 2, 1788, the fourth state to do so. In 1789, Georgia elected Few and James Gunn as its first United States senators, while then-governor George Mathews, James Jackson, and Abraham Baldwin were elected to the new House of Representatives.

During this period, events proceeded toward the establishment of a new and permanent form of state government as well. In May 1789, Georgia ratified a new state constitution, modeled upon the new federal Constitution. The Georgia constitution called for a two-house state legislature (senate and house of representatives), with each county to have representation based on population.

5. Expansion into the Interior

THE FOUR DECADES FOLLOWING THE END of the Revolution saw the expansion of Georgia into the interior until, by the early 1830s, the state had reached the limits of its present boundaries. With independence came the gradual influx of new settlers into Georgia from neighboring states, as well as the former colonies to the north, particularly New England. The first United States census in 1790 recorded Georgia's population as 82,548. The years following statehood were accentuated by the state's steady acquisition of territories occupied by Native Americans, who in most cases, despite formal negotiations and bargaining, only reluctantly ceded their lands.

From the beginnings of colonization in 1733 through the Revolution, Georgia's settled lands had lain along the Atlantic seaboard or inland along the major river systems that flowed from the interior to the coast—the Savannah, Ogeechee, Canoochee, and Altamaha. In the decades following statehood, white settlement pushed the Native American populations west and north. Boundaries, delineated by rivers, grew between white expansion and the natives with each new territorial acquisition by the government—westward from the Ogeechee to the Oconee, then to the Ocmulgee, the Flint, and finally to the Chattahoochee, the state's eventual western boundary.

Expansion progressed from the coastal zone westward into the coastal plain, a section that comprises more than half the area of present-day Georgia. This region was suitable for agriculture with porous, sandy soils dominated by distinctive regions known as the "rolling wiregrass country" and the "pine barrens." In addition to farming, these areas were conducive to harvesting pine timber for lumber and naval stores, including the extraction from pine trees of such commodities as rosin, which, when distilled into turpentine, opened a new array of economic possibilities for south Georgia.

Above the Coastal Plain was the Piedmont, a region dominated by heavier soils, stands of hardwood trees, hilly plateaus, rocky slopes, and red clay. The higher land separating the Coastal Plain and the Piedmont is known as the Fall Zone, so named because of the flow of rivers that descend from the high interior to

lay bare the old rock strata of the Piedmont, the lowermost point of the ancient Appalachian system.

The Fall Line extends gradually southwestward across the middle of Georgia, from Augusta on the Savannah River to Milledgeville on the Oconee, to Macon on the Ocmulgee to Columbus on the Chattahoochee. The industrial development of these important cities in the nineteenth century was predicated upon their situation on the Fall Line at the head of navigation of their respective rivers.

LAND FRAUDS AND THE "INDIAN QUESTION"

In 1785, about four-fifths of the land occupied by Georgia in its present boundaries comprised territory under Native American control. In response to the growing demand for land occasioned by increased settlement of the interior, local and state officials typically awarded property on the headright system, particularly in the areas now comprising much of southeast and eastern Georgia. A new settler would often be awarded irregularly shaped tracts of land staked out by a land surveyor. This system eventually reflected a patchwork-quilt pattern of lands within newly created counties based on cleared fields, fence lines, roads, and the trails and streams that passed through a tract.

Between 1804 and 1832, Georgia held public lotteries on a periodic basis to distribute the huge expanses of land between the Oconee and Chattahoochee Rivers. Land lotteries accounted for roughly three-fifths of western Georgia. The distribution of lottery land reflected the ideals held in the previous century by the Georgia Trustees who wished to see a frontier populated by industrious small yeoman farmers. Also as envisioned by the Trustees, several towns were planned

The boundaries of the new state of Georgia in 1790.

and laid out in the lottery lands in advance of their actual settlement, particularly those in the Fall Line region.

At the end of the Revolution, there were about 35,000 Native Americans living in Georgia, primarily the Creek in the south and west and the Cherokee in the north. These peoples were gradually pushed out as Georgia's population increased from 162,000 in 1800 to almost 700,000 by 1850. The "Indian question" dominated Georgia politics in the early decades of the nineteenth century. Indeed, the protection of settlers from Native Americans underlay the immediate ratification of the federal constitution by Georgia in 1788.

The prelude to the chain of events that ultimately led to the finalization of Georgia's present boundaries was the Yazoo Land Fraud of 1794 and 1795. Four Yazoo land companies acquired from the state of Georgia about 40 million acres in an area comprising the future states of Alabama and Mississippi. Bribes and other political chicanery resulted in the incredibly low selling price of $500 million for this land. The majority of state legislators were involved in the fraud as they received stock in the Yazoo companies. A huge public outcry followed and, in 1796, voters turned out of office many of the legislators involved in the frauds. James Jackson resigned his U.S. Senate seat to return home to oppose

This extract from the letterbook of Indian agent Benjamin Hawkins (1754–1816) was published as "Sketch of the Creek Country in the Years 1798 and 1799."

the Yazoo frauds and the newly elected state assembly quickly repealed the Yazoo Act.[1]

In 1798, Benjamin Hawkins, an agent for the federal Bureau of Indian Affairs, began conducting surveys of the western Georgia lands occupied by the Native Americans.[2] This was the precursor to an agreement reached in 1802 between Georgia and the United States that resulted in the cession to the federal government (for $1.25 million) of all the Georgia lands west of the Chattahoochee River extending to the Mississippi. Additionally, the federal government agreed to sanction the removal of all Native American claims to Georgia lands east of the Chattahoochee. Alexander McGillivray, working on behalf of the Creek, created continuing obstacles in an effort to prevent, or at least delay, white expansion into the interior. Nevertheless, he ultimately proved unable to block the outright acquisition, in 1804, of the Creek lands between the Oconee and Ocmulgee Rivers by the federal government for the state of Georgia.[3]

In 1813 and 1814, General John Floyd, 900 Georgia militia, and Native American allies from Fort Hawkins on the Ocmulgee, near the later site of Macon, joined General Andrew Jackson's Tennessee and Kentucky forces to quell an uprising of the Upper Creek in Alabama. Georgians aided Jackson in the decisive victory over the Creek at Horseshoe Bend in January 1814. However, more controversy followed when the Treaty of Fort Jackson, which ended the Creek War, allowed the Creek to retain possession of their Georgia lands between the Ocmulgee and Chattahoochee Rivers.

Further complications arose from a treaty in 1821 at Indian Springs in present-day Butts County between the federal government and the Creek. The Creek were allowed to retain possession of lands ceded to the state of Georgia. William McIntosh, the Coweta chief of the Lower Creeks, came under criticism from many of his subordinate chiefs for giving away too much land. Georgians were also unhappy with the arrangement. George M. Troup, who became governor in 1823, sought a quick resolution to the impasse. (Ironically, Troup was the first cousin of McIntosh.) He wasted no time in asserting Georgia's right of claim to the disputed lands. McIntosh and his followers signed a new treaty at Indian Springs in early 1825 that ceded Creek lands in Georgia in exchange for lands west of the Mississippi. Dissenting Creeks subsequently murdered McIntosh for agreeing to this sweeping concession.[4] When President John Quincy Adams nullified this treaty and declared illegal any surveying of the Creek lands by Georgia authorities, Governor Troup defiantly ignored the order and instructed that the lands be surveyed anyway. Georgia and the federal government avoided further confrontation when a series of treaties in 1826 and 1827 formally ceded to Georgia all the land east of the Chattahoochee at a cost of $217,000 to the Creek with a perpetual annuity of $20,000. Meanwhile, plans were established for the removal of the Creek to the western territories.[5]

The prosperous Cherokee of north Georgia were among the last of the large Native American groups to vacate the present boundaries of the state.[6] In 1828, following the discovery of gold at Dahlonega, thousands of prospectors

descended on the region. The Cherokee, without a treaty to protect their claims to their lands, were at a decided disadvantage in their dealings with the state of Georgia and the federal government (see sidebar). Governor Wilson Lumpkin opened the way for surveys of the Cherokee territories and the 1832 lotteries awarded extensive northern lands to Georgians as a means of encouraging new settlers to move into the upper sections of the state. By 1834, settlers from Georgia, Virginia, North Carolina, and South Carolina were moving into the newly-acquired territories.

GEORGIA POLITICS IN THE EARLY REPUBLIC

Political factionalism dominated the Georgia legislature during these years. The question over what to do about the Creek and Cherokee was the most pressing issue facing the state. From 1788 until his death in 1806, James Jackson and members of his faction controlled state politics. Following his death, Jackson's coalition fell apart and rival factions supporting gubernatorial candidates John Clark and George M. Troup (Jackson's protege and successor) waged a series of bitterly contested battles for control of state politics. Clark defeated Troup on the legislative ballot in 1819 and 1821, while Troup defeated Matthew Talbot to become governor in 1823. Troup narrowly won reelection over Clark in 1825 in the state's first popular gubernatorial election.

Troup's confrontations with the federal government over the Indian question exemplified his faction as the party of strong states' rights advocacy in Georgia. Its popularity was solidified in 1827 when John Forsyth was easily elected to succeed Troup. Forsyth was followed by another Troup backer, George R. Gilmer, who won a one-sided election over Joel Crawford in 1829, one of the last holdouts of the John Clark faction. Later, Wilson Lumpkin led the newly emergent Union Party to victory over the Troupites in the 1831 election. Thus, Troup and Lumpkin, two highly competent governors from opposite ends of the Georgia political spectrum, guided the state through the Creek and Cherokee controversies.

During this period, states-righters in Georgia also addressed the increasingly contentious tariff question, an issue that resulted in additional friction between the state and federal governments. Most Georgians opposed the imposition of protective tariffs by the federal government. Neighboring South Carolina, urged on by John C. Calhoun, lobbied for nullification of federal tariff legislation in 1832. Georgians, for the most part in favor of states' rights, were somewhat slower to join the push for nullification since President Andrew Jackson was backing Georgia's effort to remove the Cherokee.

As the Clark and Troup factions lost their former dominance in state politics, the Union and State Rights Parties rose to the forefront. Georgia solidified its place in the federal Union when the Union Party gained control of the state legislature in 1832. The moderate stand of the State Rights Party on nullification helped Gilmer regain the governorship in 1837, but the Panic of 1837 and the subsequent depression led to the Union Party regaining control of the legislature in 1839. Soon after, a new coalition of former State Righters and Troupites formed

George M. Troup (1780–1856) was governor of Georgia from 1823 to 1827. The "apostle of states' rights" also served in the U.S. House and Senate from 1807 to 1818.

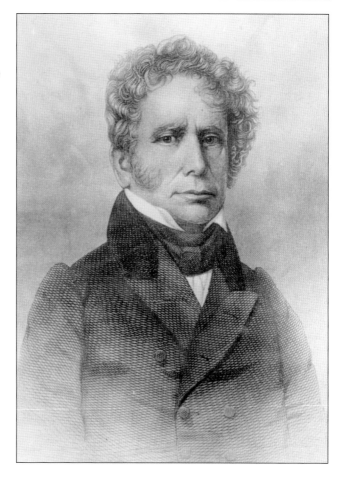

the Georgia Whig Party, while the Georgia Democratic Party emerged behind the former backers of John Clark and the Union Party. During the 1840s and 1850s, these two parties dominated Georgia politics with the Whigs being led by, among others, Alexander H. Stephens and Robert Toombs, and the Democrats by Herschel V. Johnson and Howell Cobb.

COUNTY EXPANSION AND TOWN DEVELOPMENT IN ANTEBELLUM GEORGIA

The gradual cession of Native American lands to the state in the first two decades of the nineteenth century precipitated the rapid creation of new counties and towns. Georgia created 14 new counties during the first decade of the 1800s and added 9 more during the second decade. In the ten years after 1820, no less than 29 new counties were formed, giving the state 82 of its present 159 counties by 1830.

Following the Revolution, the Georgia legislature quickly moved to expand upon the original eight counties that had been designated in 1777. It established two new tidewater counties in 1793—Bryan from Chatham and Effingham,

NORTH GEORGIA'S CHEROKEES AND THE TRAIL OF TEARS

In the mountainous sections of north Georgia, a unique Native American culture grew and prospered in the first third of the nineteenth century, thriving upon a high degree of innovation and self-sufficiency.

The Cherokee Indians of this region of Georgia established their own civilized nation largely based on European customs. Sequoyah (George Guess, *c.* 1776–1843) created the Cherokee syllabary, an alphabet and writing system based on symbols for word sounds. Sequoyah's alphabet enabled many of the Cherokee to become literate. In 1828, the Cherokee began a new bilingual newspaper, the *Cherokee Phoenix.* It was published weekly until 1834 when its printing press was confiscated by the state of Georgia because of the paper's editorials protesting the Cherokee removal from north Georgia. The Cherokee nation had a well-established court system, a formal constitution, and a representative form of government centered on the capital town of New Echota. It is no exaggeration to say that the Cherokee underwent the most remarkable adaptation to white culture of any Native American people during this period.

Many Cherokee became successful farmers with comfortable homes, cultivated fields, and large herds of livestock. An 1826 census of Cherokee property in north Georgia revealed holdings of 1,560 slaves, 22,000 cattle, 7,600 horses, 46,000 swine, 2,500 sheep, 762 looms, 2,488 spinning wheels, 172 wagons, 2,942 plows, 10 sawmills, 31 grist mills, 62 blacksmith shops, 8 cotton gins, 18 schools, and 18 ferries. Chief John Ross lived in a $10,000 house designed by a Philadelphia architect. Many Cherokee were far more prosperous than their white neighbors in north Georgia.

While the Cherokee had a strong sense of independence, they realized the importance of maintaining an accommodation with white American authorities. After the Creek War of 1813 and 1814, the Cherokee, by treaty, reluctantly ceded large amounts of their land. Two important events in 1828 marked the beginning of the end for the Cherokee in Georgia: the election of Andrew Jackson as President and the discovery of gold deposits on Cherokee land in north Georgia. With Jackson's support, Congress passed the Indian Removal Act in 1830. Jackson also refused to enforce the Cherokee protection treaties.

The Cherokee had little or no legal protection. Their only alternatives were to go to war with the Americans or to fight removal through the courts. The Cherokee won two important cases, *Cherokee Nation* v. *Georgia* (1831) and *Worcester* v. *Georgia* (1832), but the legal victories proved meaningless. The leading Chief John Ross was arrested, the offices of the *Cherokee Phoenix* were burned, and the mansion of the wealthiest Cherokee, Joseph Vann, was confiscated by the Georgia militia.

Cherokee Phoenix *masthead.*

Ross worked to prevent the removal of his people from Georgia, but the December 1835 Treaty of New Echota, with its subsequent ratification by the Senate, sealed the fate of the nation. The treaty forced the cession of all Cherokee lands in exchange for $5 million, 7 million acres in the Oklahoma territory, and an agreement to move within two years.

In 1838, federal troops under General Winfield Scott occupied the Cherokee lands and forced the Cherokee out of their homes to begin the long trek westward without adequate shelter or food. Led by John Ross from north Georgia to Oklahoma, over 4,000 Cherokee perished from hunger, exposure, and disease during the forced march on foot. Many of those who died had to be left unburied along the road westward. This journey became known among the Cherokee and other removed tribes as the "trail where they cried," hence the name Trail of Tears.

and McIntosh from Liberty. Other new counties in the eastern part of the state included Franklin (1784), Washington (1784), Greene (1786), Columbia (1790), Elbert (1790), Montgomery (1793), Screven (1793), Warren (1793), Bulloch (1796), Jefferson (1796), Lincoln (1796), Tattnall (1801), and Emanuel (1812).[7]

The Treaty of Fort Jackson in 1814 resulted in the cession of extensive Creek lands in south Georgia. In 1818, the legislature divided this section into three extremely large counties across the bottom tier of the state—Early, Irwin, and Appling Counties—which sprawled west to east from the Chattahoochee River to the Okefenokee Swamp. They were bounded on the north by the Ocmulgee and Altamaha Rivers and on the south by the Florida line. From these three counties, the various counties of the south Georgia Wiregrass region evolved over the ensuing 100 years. The earliest counties created from this lower tier were Decatur in 1823, Ware in 1824, and Thomas and Lowndes, both in 1825.

In southwest Georgia, the creation of Dooly County in 1821 gave rise to another group of counties in the 1820s and 1830s, including Lee (1825), Randolph (1828), and Sumter (1831). Cession of Native American lands from the end of the Revolution to 1840 allowed the state to create a large tier of Piedmont counties above the fall line and, as the frontier expanded into the Piedmont, a flurry of new counties emerged; 39 were created in the 1850s to give Georgia 132 altogether on the eve of the Civil War. The western and northern counties evolved, of course, behind the rapid expansion of population into former Indian lands. The subdivision of the larger counties was based upon economic considerations, railroad development, and the establishment of towns with the attendant civic pride energized by local politics. Georgia, by 1860, had many more counties than the other states in the South.

The creation of new counties brought the development of "county seat towns," some of which evolved as "academy towns." In 1783, the Georgia legislature enacted laws to promote education and the creation of county academies. The state awarded land to counties that in turn sold the properties with the revenues designated to support a local academy. The first towns to benefit from this legislation were Augusta (Richmond Academy), Washington, and Waynesborough. Sunbury Academy was established in 1786, while Chatham Academy (Savannah) and Glynn Academy (Brunswick) began in 1788.

Courthouse towns laid out after the Revolution were Greensborough (Greene County) and St. Marys (Camden). Washington, in Wilkes County, began in 1783 on 100 acres that included a town common and 1-acre lots for residents.[8] Funds derived from the sale of these lots were set aside for a courthouse, a county jail, and an academy. Greensborough and Waynesborough (Burke County) were planned on a decidedly larger initial scale, each with about 200 town lots.

Some towns were founded largely on commercial and industrial considerations. A good example is the trading town of Petersburg, authorized by the legislature in 1786 to be established at the juncture of the Broad and Savannah Rivers in the portion of Wilkes County that became Elbert County in 1790. Petersburg began as a center for the storage and inspection of tobacco, an important staple crop in the

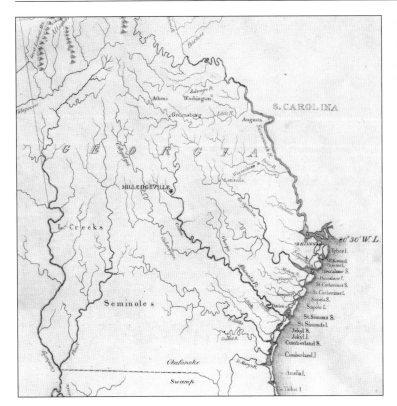

This map of Georgia shows rivers and early towns in 1822.

eastern uplands of Georgia in the early nineteenth century. After the 1830s, with the demise of tobacco as a primary cash crop, Petersburg entered a steady decline and eventually became a ghost town. The site of the former town now reposes on the bottom of Lake Russell.[9]

Many of the county seat towns in Georgia created from the 1790s through the first three decades of the nineteenth century followed a concept similar to that of Washington in Wilkes County—a freestanding central square, usually containing the courthouse, with surrounding streets and buildings on four sides that entered the square from the corners. Several towns adopted the "Washington plan": Warrenton (Warren County), Lexington (Oglethorpe County), Sandersville (Washington County), Crawfordville (Taliaferro County), Madison (Morgan County), Lawrenceville (Gwinnett County), Gainesville (Hall County), and Eatonton (Putnam County). Watkinsville, founded in 1802 as the first seat of Clarke County, also incorporated a Washington-style town plan.

Madison became one of the Piedmont's wealthiest towns and certainly one of its most architecturally appealing. Many of Madison's signature antebellum homes have survived to the present day. Lawrenceville, laid out in 1820, was unusual at the time in that the courthouse square was not situated on a rise, but actually sat on a lower elevation than the streets entering the square from the north. Nearby Gainesville was also developed in 1820, but on a more ambitious plan than

Lawrenceville. Gainesville initially featured wide streets, a central court square 200 feet by 200 feet, and a grid of 75 town lots. Another town in this section, Fayetteville (Fayette County), features the oldest standing courthouse in the state, completed in 1825. In the lower Piedmont section of Georgia, two other towns adopted the Washington plan—Forsyth, founded in 1822 as the seat of Monroe County, and Thomaston, established as the seat of Upson County in 1825. These were followed by Newnan (Coweta County) in 1827; Hamilton, in 1828, incorporated as the seat of Harris County; and LaGrange in Troup County.

Forsyth, Newnan, Thomaston, and LaGrange later became important textile mill towns and each features outstanding examples of antebellum residential architecture that has survived to the present day. LaGrange was the most elaborately planned town of this group, somewhat similar to Gainesville, with a courthouse square bisected with ranges of crossing streets and blocks. LaGrange became a cotton and railroad center, and the home of the LaGrange Female Academy, founded in 1831 as one of Georgia's first institutions of higher education for women.[10]

In southwest Georgia, Americus began as a railroad and cotton shipping center, in 1832, and the seat of Sumter County. It was developed on the Washington plan, as was Lumpkin (1828) in Stewart County. In an unusual development, Americus later sold its central square. In the late nineteenth century, the large brick Windsor Hotel was built on one half of the square and the post office on the other.

In the pine barren-wiregrass of south Georgia, several county seats developed on the Washington plan: Thomasville (Thomas County) in 1826; Bainbridge (Decatur County) in 1829; and Newton (Baker County) and Irwinville (Irwin County) in 1831. Bainbridge was situated to take advantage of the navigational potential of the Flint River, near the point where that river joined with the Chattahoochee to form the Apalachicola, which flowed into the Gulf of Mexico. Thomasville became an important cotton, lumber, and naval stores town during the antebellum period.

The Washington plan was modified somewhat in 1795 by the layout of Sparta as the seat of Hancock County. Sparta's plan featured the courthouse square in an acropolis setting—situated on a rise, or elevation, with entering streets running up to the center of the square.[11] Sparta-plan towns also included Lincolnton (Lincoln County), Dublin (Laurens County), Danielsville (Madison County), and Jefferson (Jackson County). Decatur, founded in 1823 as the seat of DeKalb County, followed the Sparta plan with the courthouse square on a rise and the town's two main streets entering the square from opposite sides. In southwest Georgia, Blakely, established in 1821 as the Early County seat, was one of the few towns in that section to follow the Sparta plan. Founded by Nelson Tift in 1836, Albany was laid out as a shipping center on the Flint River and quickly developed as an important point for the transfer of cotton downriver to Apalachicola on the Gulf.[12]

Other towns diverged from the pattern established by Savannah, Augusta, Washington, and Sparta. They adopted instead a layout that became common

to many courthouse towns of Georgia. These towns featured a courthouse at the center of a circle, with the circle's arc expanding as the town grew. Perry, established as the Houston County seat in 1823, followed a plan that determined that the town limits were to encompass all the land lying within a circle extending a quarter of a mile from the center of the courthouse site. Perry and Houston County later became one of the leading cotton-producing areas of Georgia.

Rome, seat of Floyd County in the northwest, upper Piedmont, is a good example of a town that developed around navigable rivers. Founded in 1834, Rome was laid out on a peninsula at the confluence of the Etowah and Oostanaula Rivers and built around several hills. Subsequent development spread outward in all directions from the town's core. Rome was designed specifically with commercial and industrial considerations in mind, a vision that proved highly beneficial, as the town became the major transportation and industrial link between upper Georgia and Tennessee, as well as an important shipping center for the Coosa Valley.

Another town that developed during this period also had a classical name— Athens. Situated in northeast Georgia, Athens was originally laid out on 633 acres on a bend of the Oconee River in 1801. The town was selected as the permanent site for the state's land-grant college, endowed in 1784 by the Georgia legislature. Josiah Meigs oversaw the construction of buildings and the development of a curriculum to educate the young men of the state and succeeded the college's first president, Abraham Baldwin. Known for many years as Franklin College

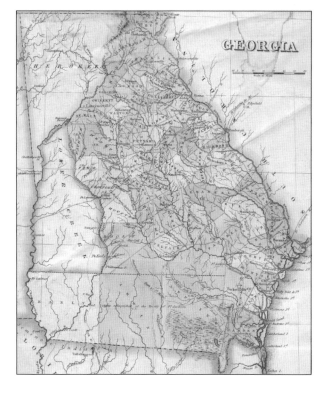

Georgia in 1827, prior to the Cherokee and Creek removal.

Thomas County courthouse in Thomasville.

(for the first permanent building on the campus), the institution evolved into the University of Georgia. The university has always been the dominant feature of Athens, in ways that far transcended just its educational and architectural identity. Athens also capitalized on its location on the shoals of the Oconee by utilizing water power to develop textile mills, endeavors further amplified by the arrival of the railroad in 1840.[13]

GEORGIA'S "GOLD RUSH"

Although rumors of gold attracted Europeans to the north Georgia mountains as early as the 1540s, not until 1828 did the metal begin to be "discovered" in anything beyond minimal amounts. In that year, Benjamin Parks found gold in the section of Habersham that later became White County and, by 1829, mining operations had begun in Habersham County. Intensified searches for gold that year yielded additional finds in Lumpkin and Union Counties. News of these discoveries brought gold seekers by the thousands into the north Georgia hill country, at that time still occupied by the Cherokee nation.

Reports soon filtered out that over 300 ounces of gold a day were being produced from a region extending from near the town of Blairsville southward to Cherokee County, where some of the most extensive mining operations were conducted. Dahlonega and Auraria, in Lumpkin County, became the center of gold production in north Georgia.

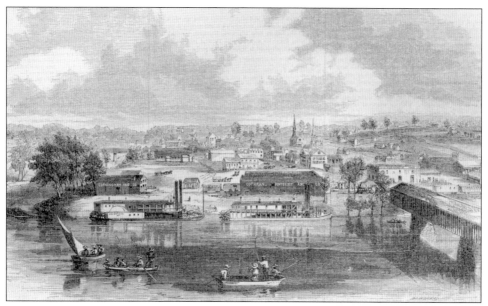

By the late antebellum era, the city of Rome had become a major commercial hub in Northwest Georgia.

Auraria, just south of Dahlonega, became Georgia's first real "boom town," developed solely on the premise of gold. The powerful Bank of Darien, one of the leading financial institutions in the southeastern United States, had a branch office in Auraria. The town also had a post office, a local gold mining newspaper, and a hotel owned by John C. Calhoun, then Vice President. With gold finds declining by 1840, Auraria disappeared almost as quickly as it began, becoming a virtual ghost town.

In 1838, the federal government established a federal mint at Dahlonega in response to the increased importance of gold production in the region. The greatest activity at the Dahlonega Mint occurred in the 1840s with the deposits of north Georgia gold. The mint also had gold deposits from several other states, including California. Gold mining activities in north Georgia, however, were already in decline by the late 1830s and were reduced even more following the discovery of gold in California in 1848. The West Coast discoveries prompted many of the north Georgia gold hunters to depart for the San Francisco region to try their luck. In 1861, the Dahlonega Mint closed, but in its 24 years of operation, it produced almost 1.4 million gold coins, with a face value of $6.1 million. This figure represented only a portion of the total gold mined in north Georgia in the three decades prior to the Civil War. The mint building at Dahlonega later served as a repository for the Confederate Treasury during the war.

Gold mining continued in Georgia on a small scale, aided by the introduction of hydraulic mining in 1858. Mining continued after the Civil War, but steadily

An antebellum view of Franklin College (now the University of Georgia) in Athens.

declined again after 1900, although some gold activities continue to the present day. Perhaps the most visible and lasting legacy to the Georgia gold rush is the gold dome of the Georgia state capitol building in Atlanta. Gold from Dahlonega was pounded into thin sheets and installed atop the capitol in 1958.

FALL LINE TRADING TOWNS

Two "trading towns" were begun by the state in the 1820s, both on the Fall Line at the head of navigation of major rivers—Columbus on the Chattahoochee and Macon on the Ocmulgee. Georgia's other two important Fall Line towns, Augusta and the state capital at Milledgeville, were also at the head of navigation on important waterways, the Savannah and Oconee Rivers, respectively.[14] All four Fall Line towns became important shipping points from which inland-grown cotton was transferred to ports on the Atlantic Ocean and the Gulf of Mexico. The establishment of these towns at the head of important rivers, long before the emergence of railroads in Georgia, was no accident. These sites were initially selected to accommodate the shipment of cotton to points downriver and later, in the case of Augusta and Columbus, water power provided the basis for industrial development.

Milledgeville was laid out as a government center by the Georgia legislature in 1804 and the state capital officially moved there from Louisville for the 1807 legislative session. Milledgeville was unique in that its town plan evolved around four very large squares, each serving a particular governmental or civic purpose—statehouse, governor's residence, state penitentiary, and local cemetery. The siting of Milledgeville on the Oconee River was designed to encourage the town's growth

Toccoa Falls in north Georgia during the antebellum period.

as a major cotton shipping market. Regular steamboat service began between Milledgeville and Darien in 1819, with the latter town becoming, by the 1830s, the leading ocean shipping point on the Atlantic coast for cotton grown inland. With its focus as the center of state government, Milledgeville became one of the wealthiest towns in Georgia.

Augusta's development as an important frontier pre-Revolutionary center with its own town plan has been discussed in Chapter 3. Augusta was an early nineteenth-century tobacco nexus before it became a shipping point for inland-grown cotton and, still later, a major textile producing center, the "Lowell of the South."

Macon was laid out on a large state reserve of 21,000 acres as a trading town on the Ocmulgee River near Fort Hawkins. The first surveys of the town and auction of lots occurred in 1823. Macon was built on a bluff overlooking the Ocmulgee, with land set aside as "public reserves." The site contained a market square, a bridge over the river, and even a residential suburb, Vineville. Situated amidst Georgia's vast interior cotton belt, Macon became a logical shipping

point for that increasingly valuable commodity. The town came into its own during the 1830s—by the end of that decade, Macon shipped over 100,000 bales of cotton (one-third of the state's total) downriver on barges, poleboats, and steamboats to the Atlantic port of Darien. When the railroads arrived in the 1840s, Macon made the gradual transition to an industrial town, eventually becoming the heavy machinery and manufacturing center of the South by the end of the antebellum period. In 1860, as the seat of Bibb County, Macon's population was 7,000 persons, while the town boasted three railroads, six hotels, and two banks.

Columbus was established by the state legislature on December 24, 1827 and laid out by five town commissioners in early 1828 at the Coweta Falls of the Chattahoochee River. The state designated 1,200 acres for a town and common, with the square fronting the river amid 632 building lots of about one-half acre each. By 1833, Columbus had become a thriving trading town with its warehouses filled with cotton earmarked for shipment downriver to the Gulf port of Apalachicola. The falls of the river at Columbus provided unlimited potential for waterpower, and the town rapidly developed as an industrial center with textile mills and an ironworks. Columbus eventually became the second leading textile city in the South.[15]

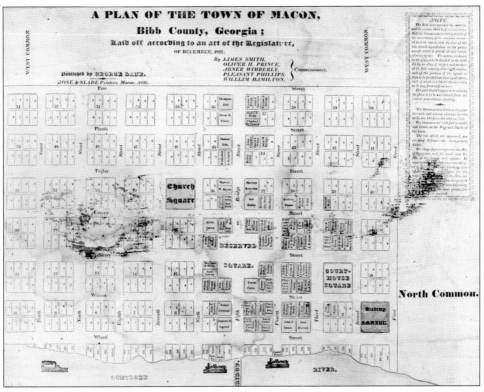

Plan of the new town of Macon as it looked in 1826.

The earliest impressions of the new Fall Line towns are unusually instructive as they come from the pen of Basil Hall, a Scotsman and retired British naval officer, who conducted extensive travels in Georgia in 1828. After visits to coastal rice plantations, Hall embarked upon a stagecoach journey into the western Georgia wilderness. Hall wrote the following on March 27, 1828:

> Macon appeared to be in the South, exactly such a town as Utica or Syracuse in the North, or any other of those recently erected towns in the western parts of the State of New York. . . . The woods were still growing in some of the streets . . . the houses looked as if they had been put up the day before, so that you smelt the saw-mill everywhere. . . . This town of Macon, though founded in 1823, has not yet worked its way to the maps and road-books . . . it [is] thought that the navigation of the river Ocmulgee, on which it stands, might be so improved that a communication could be opened with the sea-coast of Georgia and consequently, that a great portion of the produce of the upper part of the state would find its way to Macon as a depot.

Columbus was even more in its infancy than Macon when Hall arrived there several days later:

> We arrived, fortunately, just in the nick of time, to see the curious phenomenon of an embryo town, a city as yet without a name, or

A view of Columbus in 1844.

any existence in law or fact, but crowded with inhabitants, ready to commence their municipal duties at the tap of an auctioneer's hammer. . . . A gentleman . . . called our attention [to] a long line cut through the coppice wood of oaks. On reaching the middle point, our friend, looking around him, exclaimed in raptures at the prospect of the future greatness of Columbus—"Here you are in the center of the city!"

Railroad development was the premise upon which another new town was founded, although the earliest years of Atlanta were hardly a precursor of its ultimate importance. In the early 1840s, three railroads converged in the Georgia Piedmont at a point that was referred to as Terminus. The Western & Atlantic Railroad came to be an important link for that part of Georgia with Tennessee and points further north.

Terminus began to grow and, in 1843, the little railhead acquired a new name, Marthasville, named in honor of Martha Lumpkin, daughter of the Georgia governor. In 1845, the name was changed again to Atlanta, regarded as a feminine version of Atlantic in deference to the importance of the Western & Atlantic Railroad. By 1851, Atlanta had grown to become a rowdy, boisterous town of over 2,500 citizens, 2 hotels, a number of stores, and, most importantly, facilities for the railroads to acquire wood, water, oil, and supplies, along with attendant maintenance shops and freight depots. Atlanta was unique in its town development as it evolved purely as a transportation center and railroad hub, rather than as a traditional agricultural market center and trading town, as was the case in Columbus, Macon, Augusta, Milledgeville, and Savannah. By the eve of the Civil War, Atlanta's population had increased to 11,500.

6. THE RISE OF KING COTTON AND THE RAILROAD

WITH THE ALMOST CONTINUAL EXPANSION of the boundaries of Georgia during the first half of the nineteenth century came a steady growth and development of agriculture, through improved farming techniques, and transportation to facilitate the shipment and marketing of crops.

Most of Georgia was topographically suited to support varying degrees of crop cultivation. Yeoman farmers migrating into the hilly region of the state's upper Piedmont were the least likely to find adequate fertile lands to grow crops. The upper Piedmont was not suited to the cultivation of cotton, the primary cash crop of the state; thus, settlers in this area owned few, if any, slaves. Instead, they turned to livestock raising and small-scale grain cultivation as their means of livelihood.

In the central and lower Piedmont, conditions were far more suitable for the growth of short-staple cotton. The section of Georgia immediately north and south of the Fall Line saw the most rapid settlement and thus became the scene of the most extensive cotton operations. The red hills south of the Fall Line had some of the state's best soil for cotton and the largest plantations, with large numbers of slaves. The rolling and thickly wooded land west of the Chattahoochee saw far less agricultural development.

Agriculture was also the primary economic mainstay in the fertile limesink section of southwest Georgia, where the rich soil provided valuable cotton land. Further east, the wiregrass country and pine barrens of the southern, coastal plain were not well suited to large-scale agriculture. These flat areas featured soil that drained poorly and was useful only for extensive pine timbering operations after the Civil War. On the coastal tidewater, rice and Sea Island cotton were the major staples.

Rice had been grown on the coast from the time the prohibition against slavery was lifted in 1750, introduced by South Carolina planters migrating into the tidewater, seeking fresh lands, and bringing thousands of west African slaves with them. Shortly after the Revolution, Sea Island cotton began to be cultivated on Georgia's barrier islands, having been grown in the Bahamas by former colonists who had remained loyal to England. Coupled with the effectiveness of a roller

ginning process invented in 1785 by Joseph Eve, Sea Island cotton quickly became the leading staple crop on the tidewater coast.[1] Some coastal planters, such as Thomas Spalding[2] of Sapelo Island and James Hamilton Couper[3] of Hopeton plantation on the Altamaha, diversified their agricultural practices, planting both rice and Sea Island cotton, along with sugarcane. A distinct "tidewater aristocracy" dominated the agricultural economy, politics, and society of the rice coast in Georgia and South Carolina during the antebellum period.[4] The tidewater planters were typically the largest slaveholders of the state. Spalding and Couper were true scientific farmers as they experimented with various crops and grasses, methods of cultivation, and techniques that made them the most successful planters of their day.

During the 1840s and 1850s, Georgia was second only to South Carolina nationally in the production of rice. Its production required both a heavy investment in capital and a large labor force. Rice plantations were highly specialized, few in number, and generally isolated along the coastal tidewater. They were often viewed as rather forbidding places, especially to the novice. Frances Anne Kemble's

This brick rice mill stack is located at Butler's Island in McIntosh County.

reaction was typical. Upon her arrival at her husband's Butler's Island plantation near Darien, in early 1839, she wrote the following:

> the place is one of the wildest corners of creation. The whole island is swamp, a sort of hasty-pudding of amphibious elements, comprised of a huge rolling river, thick and turbid with mud, and stretches of mud banks, scarcely reclaimed from the water; diked and trenched and divided by ditches and a canal, by means of which the rice-fields are periodically overflowed, and the harvest transported to the threshing mill.

Georgia planters followed the Carolina method of tideflow production, utilizing the fertile bottomlands of the freshwater river deltas and the ebbing tides from the nearby Atlantic to irrigate their fields during the planting cycle. Georgia's rice crop reached a peak in 1859 when more than 52 million pounds were harvested and sold to foreign and domestic markets. The centers of rice production were Chatham County in the environs of Savannah; the Ogeechee River on both the Bryan and Chatham County sides; the Altamaha River delta in McIntosh and Glynn Counties; and the lower Satilla River in Camden County. The most consistently successful producer of rice was probably Couper at Hopeton, while the nearby Butler's Island plantation on the Altamaha generally produced the largest amounts on the labor of one of the largest slave forces in the state. Major Pierce Butler, succeeded by his grandsons Pierce and John Mease Butler, worked nearly 1,000 slaves in the cultivation of rice on the Altamaha and Sea Island cotton on St. Simons Island. In 1859, the Chatham County plantations along the Savannah and Ogeechee Rivers, managed by planters such as James F. Potter, James P. Screven, Charles and Louis Manigault, and William H. Gibbons, produced some 25 million pounds, the greatest aggregate of rice in Georgia's history.[5]

GEORGIA'S "COTTON KINGDOM"
Nevertheless, cotton, not rice, would dominate Georgia's antebellum economy. Eli Whitney's invention of the cotton gin at Mulberry Grove plantation near Savannah in 1793 made possible the expansion of upland, short-staple cotton cultivation.[6] The growth of upland cotton in central Georgia was equally profitable both on large plantations or small farms with a spring to late summer (planting to harvest) production cycle. Upland cultivation of cotton increased to 90,000 bales by 1820, an economic consideration that could not be ignored. This was clearly the prime factor that fueled the acquisition of more land by the state of Georgia for farming purposes, with the consequent removal of resident Native American populations.

Cotton became the engine of agricultural prosperity, a factor reflected in the steady population growth of Georgia: in 1820, there were 190,000 whites and 151,000 blacks in the state; by 1840, these figures had increased to 408,000 and

284,000; and by the 1860 census, they had increased to 592,000 whites and 466,000 blacks. Upland cotton production was not the more careful, scientific enterprise practiced by many of the coastal planters. There was much waste, trial, and error. Nonetheless, Georgia had become the largest cotton producer in the world by 1826 when 150,000 bales were marketed statewide, selling at about 29¢ a pound. Despite a downturn in cotton prices, production increased to 326,000 bales by 1839. Production climbed even higher, to half a million bales produced in 1850; by then, Georgia trailed Alabama in world production. Georgia growers reached the peak of the antebellum cotton market in 1859 when they produced 701,840 bales.[7] Houston and Stewart Counties produced the most cotton in Georgia in 1860, each with more than 20,000 bales produced (1859 crop). Other leaders in cultivation were Dougherty, Lee, Sumter, Harris, Troup, Twiggs, Hancock, and Burke Counties.

Georgia's own Margaret Mitchell, in her famous novel *Gone With the Wind*, evoked the essence of the lower Piedmont cotton culture perhaps better than anyone in print:

> All of the world was crying out for cotton, and the new land of the
> County, unworn and fertile, produced it abundantly. Cotton was the
> heartbeat of the section, the planting and the picking were the diastole

Cotton being brought to market at Bay Street in Savannah.

and systole of the red earth. Wealth came out of the curving furrows, and arrogance came too—arrogance built on green bushes and the acres of fleecy white. If cotton could make them rich in one generation how much richer they would be in the next.

The "endless acres" described by Mitchell allude to the largest of the cotton plantations (those worked by a labor force of 30 or more slaves), but in actuality, these comprised only about 7 percent of Georgia's farms in the 1860 agricultural census. Of just over 62,000 farms listed in that census, only 902 had more than 1,000 acres, while 3,600 had acreage of between 500 and 1,000 acres. Nevertheless, it was the economy of "King Cotton" that epitomized antebellum Georgia and the rest of the South. Georgia had more plantations than any other state and Mitchell's allusion to planter "arrogance" was no exaggeration; the planter society of Georgia and the South viewed itself as possessor of a special kind of civilization that was morally and culturally superior to the North, with slavery as the accepted underpinning of that civilization. Several generations of historians have attempted to come to terms with these conditions in antebellum Georgia and the South, with varying degrees of success.

The cotton economy affected the state in a variety of ways. Savannah, with its Bay Street rice and cotton factorages and its waterfront warehouses bulging with thousands of bales, became a more important seaport than ever with its growing connections to international markets.[8] Indeed, Savannah remained the economic and cultural (if not the political) capital of Georgia until well after the Civil War. When railroad construction began later in the nineteenth century, all roads led to Savannah. The city's English Regency architecture by William Jay, its dominant planter and factorage class, and its cultivated, leisurely lifestyle typical of the tidewater country made Savannah the center of society and refinement in Georgia. Savannah was the principal market not only of the Georgia coast, but also for the nearby South Carolina sea islands, Hilton Head and St. Helena, and the prosperous town of Beaufort.[9] "I hear nothing but talk of the price of cotton. Georgians are madly devoted to cotton," one traveler to Georgia wrote in 1827. A visitor to Savannah remarked, "There was a large party at supper, composed principally of cotton manufacturers from Manchester [England], whose conversation operated on me like a dose of opium. Cotton! Cotton! Cotton! was their never-ceasing topic."

Cotton was shipped from the farms and plantations to the interior river towns that had access to the ocean ports—Augusta to Savannah by way of the Savannah River; Milledgeville and Macon to Darien on the Altamaha via the Oconee and Ocmulgee Rivers, respectively; and Columbus and Albany to Apalachicola via the Chattahoochee and Flint, respectively. Broad Street in Augusta was filled with cotton wagons lined up to market the season's crop for eventual shipment to Savannah and Charleston, and from there to the foreign markets.[10] When the Central of Georgia Railroad began construction in 1837 from Macon to Savannah,

The Savannah rice and cotton factorage of Robert Habersham and sons.

cotton suddenly had a much more efficient, and eventually cheaper, method of shipment to the coast.

Cotton fortunes did not come without a heavy price. Prices averaged about 30¢ a pound during the early nineteenth century, but dropped to about 12¢ by the 1850s. The drop in prices brought an attendant rise in operating costs—the price of a prime slave rose from about $300 in 1790 to about $1,800 on the eve of the Civil War. Large planters and small farmers alike incurred increasing debts during the antebellum era, a growing fact of life throughout the southern cotton economy. Cotton planters borrowed heavily to acquire land and slaves, gambling on the success of their crops from year to year. The almost exclusive attention to the cultivation of a single cash staple ultimately exhausted the fertility of the soils of the middle Georgia cotton belt, forcing many planters to acquire newer lands with increasing frequency.

Besides cotton, the most productive crop harvested in antebellum Georgia was corn. All planters cultivated corn as their primary provision crop for the sustenance of farm animals, slaves, and as a household staple. Additionally, they sent a great deal of corn to market, and the income realized from a productive corn crop often proved to be a valuable supplement to the profits brought in by cotton. About 40 percent of the cultivated land in the state was planted in corn with 50 million bushels harvested in 1849. In addition to corn, cotton belt plantations and farms

also devoted considerable acreage to the cultivation of other necessary provision crops for their slave forces and livestock, particularly sweet potatoes, wheat, peas, and other vegetables and fruits.

SLAVERY

Slavery was literally the lifeblood of agricultural achievement in Georgia and the rest of the South. At the time of the Revolution, Georgia had 16,000 slaves, with most engaged in the cultivation of rice and indigo. With the increase in rice production on the coast and the growing dominance of both the Sea Island variety and inland short staple cotton, Georgia's slave population increased to almost 150,000 by 1820 and to 462,000 on the eve of the Civil War. In 1860, Georgia followed only Virginia in the number of slaves and slave owners. Contrary to accounts in some popular literature, agriculture and slavery in Georgia were essentially small-scale, rather than the romantic "moonlight and magnolias" picture painted by many novelists and historians. Most white families in Georgia owned no slaves at all. In 1860, only 41,000 out of 118,000 families (about 35 percent) enumerated in the federal census owned any slaves. Of slave-owning families, the great majority possessed fewer than 30 slaves and, of that group, most owned 6 slaves or fewer.

Surviving plantation accounts and planters' journals consistently record a mundane life bordering on the monotonous for slaves, overseers, and planters' families alike. Journals reveal that the concerns of the planters essentially revolved

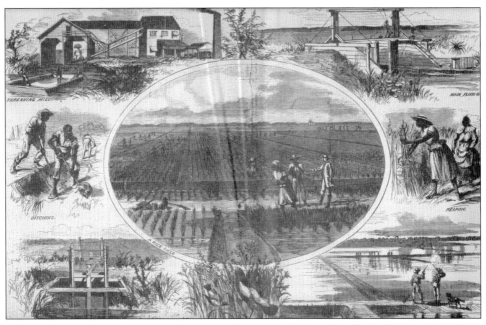

Rice cultivation is portrayed in this group of images, as experienced on the Ogeechee River near Savannah.

around the status of their crops, the weather (which affected the crops), and the health of their slaves. Daily routines typically focused on rail splitting; planting, chopping, picking, moting, and ginning cotton (depending on the time of year); spreading manure, burning the fields, and, in the case of the tidewater rice plantations, repairing tidegates, dikes, and levees; and hoeing the crop between irrigations. Rice production required the largest labor forces and the conditions associated with rice plantations were very difficult. The isolation of these plantations resulted in less contact between the races; thus, the preservation and extension of the slave culture along the coast (Gullah/Geechee) was far more pronounced than on the interior plantations. Despite the intensive labor required in cultivating their crop, rice slaves typically had a higher standard of living and enjoyed more autonomy than the workers on the inland plantations. The coastal slave community was able to retain much of its African culture and preserve an enduring sense of identity.

There was no hard and fast rule on the philosophies of slave management. Planters and their overseers adopted varying approaches. The proper handling of a workforce was directly tied to the degree of efficiency with which a plantation was run, as well as its level of production. "When an equitable distribution of rewards and punishments is observed [the slaves] will conform to almost every rule," Roswell King Jr., a tidewater planter, observed in 1828. "A master does not discharge his duty to himself unless he will adopt every means to promote their welfare. A master or an overseer should be the kind friend, not the oppressor"

In 1860, about 3,500 white Georgians owned 30 to 100 slaves. Another 212 slaveholders owned more than 100 slaves and, of these, only 23 owned more than 200 bondsmen. Black slaves worked primarily as field hands planting, cultivating, harvesting, and preparing for market the crops that formed the basis of Georgia's agrarian economy. Slaves also worked a multiplicity of other tasks, as carpenters, blacksmiths, gristmill and cotton gin operators, drivers, and cooks and servants in the planter's house. Some slaves developed specialized skills, such as that of machinists, and their services were contracted by their owners to other plantations.

On the coastal rice and cotton tracts and the inland cotton plantations, slaves typically worked five and a half days a week, with Saturday afternoon and all day Sunday off. Several days at Christmas were also usually awarded as time off. The more efficiently managed plantations utilized the task system of labor by which slaves were assigned a prescribed amount of work based on their age and physical capabilities. Black drivers, answerable only to the plantation overseer, usually supervised the fieldwork. Slave marriages, though not officially sanctioned by Georgia law, were nonetheless quite common.

A wise slaveowner allowed family units to remain intact to encourage productivity and higher morale than would be realized by splitting families apart at slave auctions. This rule of thumb was clearly not what Pierce Mease Butler had in mind in 1859 when, to pay off mounting debts, he sold almost half his bondspeople—429 slaves—at the Savannah racetrack in the largest auction in Georgia history. A contemporary New York account reported the following:

> The buyers were generally of a rough breed, slangy, profane and bearish, being for the most part from the back river and swamp plantations. The Negroes were examined with as little consideration as if they had been brutes indeed: the buyers pulling their mouths open to see their teeth, pinching their limbs to find how muscular they were. . . .

This auction separated many families, their members dispersed to different plantations and, in some cases, to different states.

Coastal rice planters comprised the early aristocracy of plantation society. A similar class of slaveholders developed in the interior cotton belts. There was a small, but growing, middle class of artisans and skilled yeoman workers in the developing towns of antebellum Georgia. Poorly educated and generally financially insignificant, this class was far below the planter class, but still held a social status and economic station above that of Georgia's so-called white "crackers" and black slaves.

Non-slaveholding families, which comprised a sizeable majority, were typically the small landholding farmers of the poorer class. These "crackers," found in every section of the state, lived generally in the pine barrens and swampy regions of southeast Georgia, in the hill and mountain areas of the Piedmont, and in sections

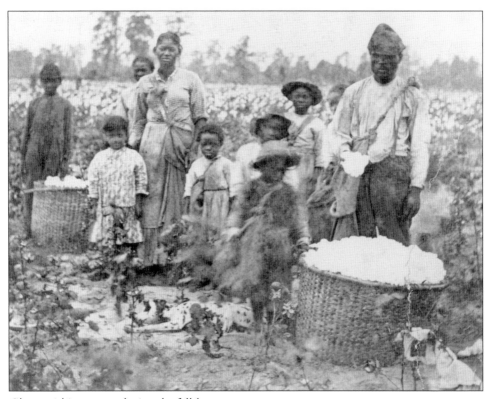

Slaves picking cotton during the fall harvest.

where the soil was not conducive to productive agriculture. They made their living through subsistence agriculture, lumbering, and turpentining.

Frances Anne Kemble observed the following in 1839:

> the scattered white population [of coastal Georgia], too poor to possess land or slaves, and having no means of living in the towns, squat on other men's land until ejected. They are hardly protected from the weather by the rude shelters they frame themselves in the midst of these dreary woods. . . . Their clothes hang about them in filthy tatters and the combined squalor and fierceness of their appearance is really frightful.

A fugitive slave, Charles Ball, reported, " . . . there is no order of men in any part of the United States who are in a more debased and humiliated state of moral servitude than are those white people that inhabit parts of the southern country where the landed property is all, or nearly all, held by the great planters."

In stark contrast to the cotton kingdom to the south, north Georgia was predominantly a land of small farms and villages and few slaves. This beautiful and rugged region is divided by geography into two distinct parts: the Blue Ridge of the east and the Ridge and Valley section to the west. As in other areas, land and

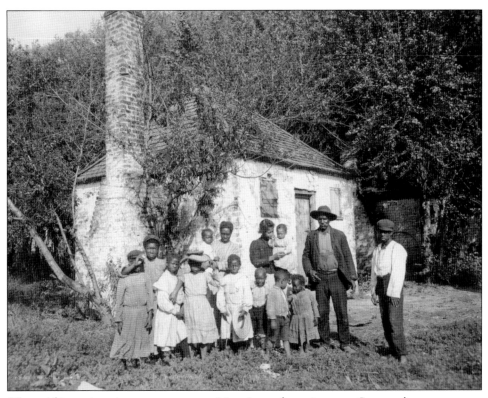

These African-American quarters are at Hermitage plantation near Savannah.

71

trade routes dictated development. Although the soil was thin and rocky at higher elevations, the valleys and coves proved remarkably fertile. With the exception of the Western & Atlantic in the late antebellum period, railroads did not penetrate most of north Georgia until after the Civil War and, as a consequence, the region lacked a cheap and dependable line of communication and trade with the rest of the state. Nevertheless, farmers raised a variety of grain crops, hogs, and other foodstuffs for subsistence, selling the surplus in the markets to the south, which they reached using rivers and roads through the mountain passes. Indeed, despite its image as a remote and isolated region, north Georgia and its farmers participated fully in the state's antebellum economy.

ANTEBELLUM EDUCATION AND RELIGION

The movement to improve education in antebellum Georgia was more pronounced in the more heavily settled sections of the state. State-sponsored county academies, funded by the sale of public lands, were the first step in developing public education in the early years of statehood. In 1821, the state legislature authorized an expenditure of $750,000 to promote a "poor school" fund so that the children of the poorer class of whites could receive basic education.

Nonetheless, in 1850, over 20 percent of adult white Georgians were illiterate. Free education through the poor school fund was not universally embraced by the poor, at least partly because of the dependence on agriculture and the need for every able body to work, particularly in non-slaveholding families. No significant advancement in public education was made in Georgia until after the Civil War.

The antebellum years witnessed rapid growth of the Baptist and Methodist denominations in the interior of the state. Presbyterians, Episcopalians, and Lutherans held the prevailing denominational majorities before and just after the Revolution. But as settlement spread westward, Baptist and Methodist missionaries established solid footholds and large followings in the remote rural sections of Georgia. Many of these were Primitive Baptist congregations established in the sparsely settled wiregrass sections of south Georgia. The state contained 2,393 churches in 1860, of which 1,141 were Baptist and 1,035 Methodist. Presbyterian churches were a distant third with only 125 congregations. Still, the Episcopalian and Presbyterian faiths were heavily represented among the planter class, and these churches continued to exert an influence far beyond their actual numbers.

TRANSPORTATION, INDUSTRY, AND FINANCE IN ANTEBELLUM GEORGIA

The forerunner of rail development in Georgia was the promotion of canals linking the key waterways of the state to facilitate the movement of upland cotton to the seacoast markets. The Savannah-Ogeechee Canal linking those two rivers near the coast was completed in 1831, but the Central of Georgia Railroad superseded this accomplishment less than a decade later. Another

canal built in the late 1830s linked Brunswick with the Altamaha River for the purpose of siphoning off some of nearby Darien's lucrative cotton trade. It was not completed until 1854, however, and by then, most of the inland cotton was moving by rail to Savannah.

By the late 1840s, railroads were connecting all the major cotton markets of the interior of Georgia with shipping points along the rivers and with Savannah on the coast. Railroads began to replace the river steamboats as the primary conveyance of cotton from the plantations.

The completion of the 136-mile Charleston & Hamburg Railroad in 1833 in South Carolina was the catalyst for railroad development in Georgia. The South Carolina rail link to the Atlantic Ocean threatened the diversion of much of Georgia's cotton and other market goods away from Savannah to Charleston. In response, the Georgia legislature, in December 1833, granted charters to three railroads from points in middle Georgia to Savannah. One important line emerged from this group in 1836: the Central of Georgia Railroad and Banking Company that ran from Macon to Savannah (see sidebar). The Central of Georgia was surveyed in 1834 and grading began late the following year. Also that year, the City of Savannah subscribed to 5,000 shares of capital stock, giving it a controlling interest in the railroad. Due to labor and financial problems, the Central was not completed until October 1843. The 190-mile route from Savannah to Macon made the Central the longest railroad in the world under one ownership.[11] Another company, the Georgia Railroad, began construction in 1834 to link Athens and Augusta. The state-owned Western & Atlantic Railroad was chartered in late 1836, but the Panic of 1837 delayed construction until 1843. Construction proceeded until 1851, when the line was completed between Chattanooga, Tennessee, and Atlanta.

The Macon & Western Railroad linked Macon with Atlanta in 1846, in addition to its junction with the Central of Georgia for the link with Savannah. There was also a spur on the Macon & Western from Barnesville a short distance west to Thomaston. Increased cotton production in southwest Georgia led to two more railroads in 1845: the Southwestern Railroad, which by 1860 linked Macon with Albany on the Flint River by way of Americus, and the Muscogee Railroad, from Columbus to Fort Valley to Macon, where it linked with the Central of Georgia. The Muscogee ran into financial difficulties and was eventually absorbed by the Southwestern Railroad, with both railroads later becoming part of the Central of Georgia system and the City of Savannah.

The Atlanta & West Point Railroad was completed in 1853 to link those two towns by way of Newnan and LaGrange. By 1854, the Waynesboro Railroad linked Augusta and Savannah by way of Millen. This line joined the state's two largest private railroads, the Central of Georgia of Savannah and the Georgia Railroad of Augusta. Railroad competition literally came full circle by 1860 with the completion of the Charleston & Savannah Railroad to link the two rival south Atlantic seaports. In south Georgia, the Savannah-owned Savannah, Albany & Gulf Railroad began construction in 1855 and reached its terminus in Thomasville

THE CENTRAL OF GEORGIA RAILWAY

The Central of Georgia, in many ways, merits the distinction as the state's most historic railroad. Not only was it Georgia's first railroad, but its operational lifespan, from 1833 to 1963, makes it Georgia's longest continuously running railroad.

Presidents of the Central of Georgia Railway, 1836–1968.

On December 20, 1833, the Georgia legislature granted a charter to a consortium of Savannah businessmen and civic leaders headed by John M. Berrien to form the Central Railroad and Canal Company. The charter called for the issuance of capital stock in shares of $100 each, amounting to $1.5 million. The City of Savannah subscribed to 5,000 shares and became by far the largest stockholder in the railroad. Shares bought by individuals in Savannah totaled 1,849, while other Georgians purchased 700 shares.

Surveys funded by the City of Savannah were made on a proposed road from Savannah to Macon in 1834, roughly following a westward route along the Ogeechee River to a point near Sandersville, thence to the Oconee River, and finally to the east bank of the Ocmulgee River at Macon. Construction of the Central of Georgia began in 1835. Work proceeded so rapidly that the state legislature authorized doubling the railroad's stock in addition to giving the company banking privileges. In December 1835, the company was organized under a new name, the Central Railroad and Banking Company of Georgia.

By 1839, the depot in Savannah was under construction and the road grading was complete from Savannah to Sandersville, a distance of 133 miles, with track laid for 76 miles. Labor problems plagued construction that year as trouble developed between the African-American slaves used by some contractors and European immigrant laborers employed by others. Work slowed to the point where, by late 1841, grading still had not reached Macon. Further investments in rail and rolling stock, along with shrewd managerial decisions, enabled the completion of track from Savannah to Macon, 190 miles, in October 1843. At that time, the Central of Georgia was the longest railroad in the world under single ownership.

In 1846, the Macon & Western Railroad was completed from Macon to Atlanta, thus completing a continuous line between Savannah and Atlanta. The state legislature approved the consolidation of the Macon & Western with the Central Railroad and Banking Company in 1872.

The Central became *the* railroad of Georgia by expanding its routes and acquiring other lines over the years. One of the most important of these was the Southwestern Railroad, a venture kept solvent in the late 1840s largely by the continuous infusion of Central stock with additional funding from the City of Savannah. The Southwestern completed track from Macon to the Flint River at the new town of Oglethorpe in 1852. Also during this time, the Central absorbed the Muscogee Railroad, which had completed track from Columbus to Macon. Columbus thus had its first rail connection to a seaport (Savannah).

By 1860, the Southwestern had completed 206 miles of track from Macon, southward through Americus and Albany, to Eufaula, Alabama on the Chattahoochee, by way of Dawson, Fort Gaines, and Cuthbert in southwest Georgia. In 1869, the Southwestern Railroad was leased to the Central of Georgia, making it an entity of the Savannah-based system.

The effective direction provided by some of the presidents of the Central was critical to its growth and sustained profitability. These individuals included William Washington Gordon, 1836–1842; Richard R. Cuyler, 1842–1865; William M. Wadley, 1866–1882; Hugh M. Comer, 1892–1900; and Henry D. Pollard, 1931–1942.

After the Civil War, the Central expanded its operations to include a seagoing subsidiary—the Ocean Steamship Company. Until 1872, the railroad was dependent on contracts with northern shipping firms for the shipment of freight by sea from its Savannah headquarters. That year, the Central purchased six steam vessels and, in 1874, Ocean Steamship was created. William M. Wadley negotiated the Central Railway's purchase of the former Vale Royal plantation tract with 271 acres fronting the Savannah River. Docks and warehouses were built and, as the years went by, more modern and capacious steamships were added to the Ocean fleet. Thus, in the latter nineteenth and early twentieth centuries, the Central Railway played an increasingly important role in the growth and development of the port of Savannah.

Besides the Southwestern Railroad, other lines in the state that became acquisitions of the Central of Georgia system were the Augusta & Savannah; the Macon & Northern; the Savannah & Atlantic (known

Central of Georgia train engine.

locally as the "Tybee Railroad") from Savannah to Tybee Island, built in 1887; the Savannah & Western; the Eatonton & Milledgeville; the Upson County Railroad; the Buena Vista & Ellaville Railroad; the Georgia & Florida Railway; the Wrightsville & Tennille Railroad; and the North & South Railroad Company, which operated a line from Columbus to Rome.

The largest and one of the last of the Central Railway's subsidiaries, acquired in 1951 for $3.5 million, was the Savannah & Atlanta Railway. This company began as a short line from Savannah to Springfield (Effingham County) in 1906 before being extended, in 1911, to Waynesboro. In 1915, the railroad extended from Savannah to St. Clair, where it linked to existing lines acquired by the Central. In 1917, the Savannah & Atlanta was a complete route of 141 miles from the coast inland to connections with the state capital.

The Southern Railway Company acquired controlling stock in the Central of Georgia Railway in June 1963. Later, the Southern merged with the Norfolk-Western Railroad, creating the Norfolk Southern Corporation. The Central of Georgia actually still exists today, but only as an operating entity of Norfolk Southern. The original Central of Georgia route from Savannah to Macon is still operated by Norfolk Southern, but most of the other former Central routes have long been abandoned.

Many of the nineteenth- and early twentieth-century Central of Georgia facilities in Savannah are still intact, including the railroad shops, office buildings, storage sheds, the 1853 and 1866 brick viaducts, the passenger depot, and the 1858 passenger train shed, roundhouse, and turntable. All these structures are federally-designated National Historic Landmarks and represent some of the most significant antebellum railroad shops in existence in the United States.

The surviving records of the railroad are voluminous and quite extensive in all aspects of the company's 130-year operations. The records of the Central of Georgia Railway are on deposit at the Georgia Historical Society and constitute the largest single archival collection among the Society's holdings.

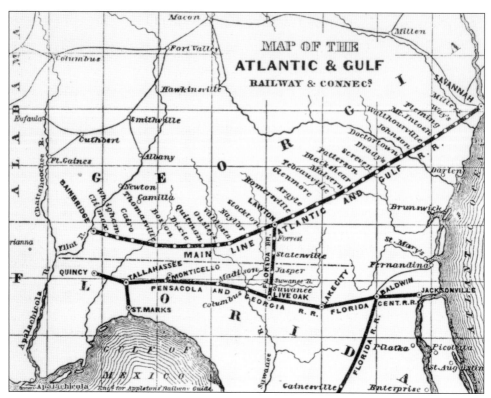

Atlantic & Gulf Railroad map.

in 1861 from Savannah by way of McDonough, several miles from the future site of Waycross. Another line, the Atlantic & Gulf, began construction in 1856 from Brunswick on the coast to a junction with the Savannah, Albany & Gulf at McDonough, 50 miles inland.

In 1861, Georgia had the best railroad system of any of the southern states. Its total track, primarily of the preferable 5-foot-gauge type, comprised 1,400 miles from 18 railroads, second only to Virginia in the South.

Georgia's industrial progress was fueled by cotton, the state's primary agricultural staple. Cotton gins and presses in the middle and southwest Georgia cotton growing regions grew in sophistication and size. The newer towns, particularly Columbus, Macon, Athens, Augusta, and Thomaston, became centers for the expanding cotton markets.[12] Each had the advantage of good river locations, as well as being railroad hubs. Abundant waterpower from their proximity to major rivers also made these towns manufacturing centers. By 1850, there were 40 cotton mills in the state and, ten years later, Georgia led the South in textile manufacturing with over 2,800 workers. Atlanta, meanwhile, had become the railroad center of Georgia by 1860. It had machine shops for railroad maintenance and the state's largest iron rolling mill, which had an annual manufacturing capability of 18,000 tons of rails. In

1860, there were 1,890 manufacturing facilities of all kinds in Georgia, with over 11,500 employees.

Lumbering became another important industry in the prewar period. Yellow pine timber was cut in the interior and floated down the Savannah and Altamaha Rivers to Savannah and Darien, the leading timber-processing centers. Savannah, by 1861, had become Georgia's largest and most diverse industrial center. It led the state in population—22,292 residents in 1860, over one-third of whom were black—and was the primary exporting center for Georgia's industrial goods, including cotton destined for overseas markets. The other population centers of Georgia in 1860 were Augusta (12,493), Columbus (9,621), Atlanta (9,554), and Macon (8,247).

Thus, by the early 1850s, Georgia's economy had expanded to include cotton processing, textile manufacturing, grain milling, and timber processing.[13] Still, industrialization developed slowly, partly because of a lack of adequate capital. There was also a continuing lack of skilled workers prior to the Civil War. Slavery and the availability of cheap white labor discouraged large-scale industrial ingenuity in the 1850s, and the acquisition of industrial machinery proceeded slowly. Only in the river towns where cotton remained king—Columbus, Macon, Augusta, and Athens—did industrialization gain a foothold before the Civil War.

7. The Politics of Secession

GEORGIANS PLAYED A LEADING ROLE on the United States congressional stage in the dramatic events of the 1850s that culminated in the national anguish of 1861–1865. In 1849, the standard bearer of Georgia's powerful Unionist Democrats, Howell Cobb of Athens, became Speaker of the House of Representatives in the midst of a bitter sectional debate. As Speaker, Cobb played an important role in the protracted fight in the House that resulted in approval of the controversial Compromise of 1850. As proposed by Senator Henry Clay, the Compromise provided in part for a stronger federal fugitive slave law and for California to enter the Union as a free state.

The sectional difficulties became increasingly acute. Cobb's moderate Unionist Democrats favored the Compromise in tandem with the former Georgia Whigs, led by Robert Toombs and Alexander Hamilton Stephens. The more radical southern rights proponents lined up in opposition to the Compromise behind John C. Calhoun of South Carolina, who sought to forge a strong southern coalition advocating regional solidarity for slavery and states' rights. In the Georgia delegation, the support for Calhoun was less than enthusiastic, particularly among such leaders as Toombs, Cobb, Stephens, and John Macpherson Berrien. However, influential Georgia Senator Herschel V. Johnson, Governor George W. Towns, former governor Charles J. McDonald, and Henry L. Benning championed Calhoun's efforts for states' rights and eventually became ardent secessionists. To a great degree, the energetic efforts of the Georgia "triumvirate"—Cobb, Stephens, and Toombs—paved the way for passage of the Compromise of 1850 and thus saved the Union, delaying for a decade the cataclysm of civil war.

But the sectional differences were far from resolved. Most southern state legislators and congressional representatives had been at odds with the federal government over tariffs and states' rights issues since the early 1830s. By 1850, the debate had shifted from issues related to the tariff to concerns over restricting the expansion of slavery into the territory gained as a result of the Mexican War in 1844–1846. These constraints, in southern minds, threatened the Missouri Compromise, the fragile balance of power in Congress, and the ultimate continuance of slavery where it already existed. Many Southerners believed that southern honor itself was at stake.

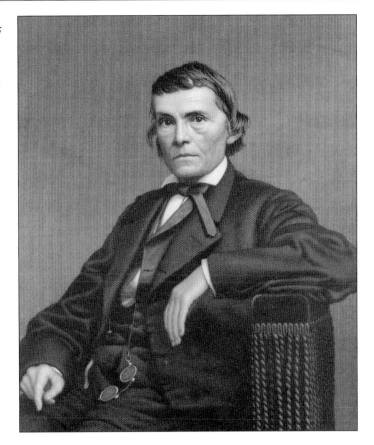

Alexander H. Stephens (1812–1883) was vice president of the Confederate States. He also won election to the Georgia House and Senate and to the U.S. Congress, where he served both before and after the Civil War for 26 years as one of the foremost spokesmen of the South. He was governor of Georgia from 1882 to 1883.

The efforts of the "triumvirate" in the sectional crisis were reflected in the moderate view taken by Georgia voters in the 1850 fall election. Unionists (a coalition of Whigs and Democrats) outpolled the states' rights' faction (extremist pro-secession Democrats) by almost a two-to-one margin. Georgians' loyalty to the Union, despite the bitterness of the congressional debates and the disagreement among the state's own delegation, was perhaps more pronounced than in any of the other southern states. A year later, in Georgia's 1851 gubernatorial election, Unionist Howell Cobb won a solid victory over Southern Rights Party candidate Charles McDonald, who ran on a pro-secession platform. Unionists also won six of Georgia's eight Congressional seats.

During Cobb's term as governor, the immediate sectional crisis passed. As a consequence, the Union Party in Georgia began to disintegrate. The Southern Rights Party adopted a less radical agenda during the early 1850s. Led by Herschel V. Johnson, it adopted broader ties with the national Democrats. Cobb, with a coalition of former Whigs and old-line state Democrats, also joined the national Democratic mainstream. He led the dominant faction of the party in Georgia. The coalition, however, did not include Robert Toombs, who assumed Berrien's former Senate seat, or Alexander H. Stephens. These two continued to

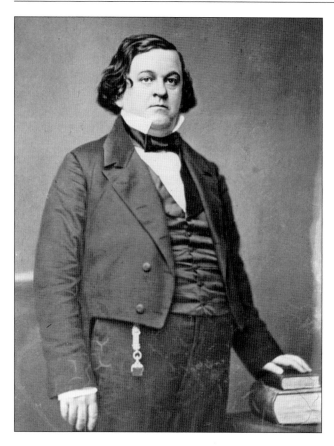

Howell Cobb (1815–1868), Unionist and Georgia governor from 1851 to 1853, also served six terms in the U.S. Congress, acting at different times as Speaker, Secretary of the Treasury, president of the Provisional Congress of the Confederate States, and major general in the Confederate Army.

support the national Whig agenda in the 1852 presidential election. In 1853, the old Southern Righters, under the aegis of Howell Cobb and the new Georgia Democratic Party, won the governorship for Johnson for a four-year term, succeeding Cobb.

National politics careened along under ever-darkening skies. The national Kansas-Nebraska bill generated sufficient controversy in 1854 to lead to dissolution of the old Whig Party and the creation of the American, or Know-Nothing, Party (a faction embraced by such politically prominent Georgians as Benjamin Harvey Hill, John Macpherson Berrien, and Charles J. Jenkins) and the new Republican Party. The Republicans, comprised almost entirely of a coalition of free soil and anti-slavery adherents from the North, opposed the spread of slavery into newly created territories. These developments did not escape the notice of both the national and the Georgia Democrats and served to further solidify the political bonds between Cobb, Stephens, Toombs, and Johnson. Cobb and Johnson each played important roles in the campaign of Democrat James Buchanan, who won the presidency in the 1856 election.

Georgia's 1857 gubernatorial election featured a contest between two young rising stars on the state's political scene. The Know-Nothing Party nominated

Joseph Emerson Brown (1821–1895) was Georgia governor during secession and the Civil War, 1857–1865. The only man to serve four terms as governor, he also served as circuit judge, state senator, U.S. senator, and chief justice of the Georgia Supreme Court.

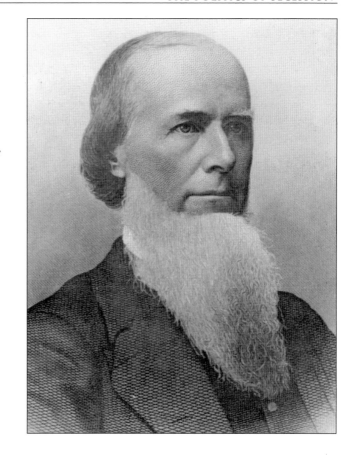

Benjamin H. Hill, 35, while 36-year-old Joseph E. Brown became the standard bearer for the Democrats. Brown won a substantial electoral victory. The Democrats also won six of the state's eight congressional seats and returned Toombs to the Senate for a second term. The election of Brown—a Yale-educated moderate Southerner from northwest Georgia, who was generally Unionist in his views regarding the sectional conflict—marked the beginning of a new political dynasty. Winning reelection in 1859, 1861, and 1863, Brown was a popular governor who enjoyed widespread support among the working classes of Georgians. He championed the cause of public education and promoted legislation that set aside profits from the state-owned Western & Atlantic Railroad to be used for the improvement of schools.

Nationally, the Buchanan presidency of 1857 to 1861 was punctuated by increasing sectional friction over the issues of slavery and states' rights. The slowly dissolving Union, held together to that point primarily by the national Democratic Party, entered a new crisis, entailing intra-party factionalism between the followers of Buchanan and those supporting Stephen A. Douglas. The Democratic convention in Charleston in April 1860 included a polarized delegation of Georgia Democrats. A large number of Georgians backed a slate

81

of delegates who supported favorite-son candidate Howell Cobb. Meanwhile, northern and southern Democrats divided at Charleston over the salient issues of slavery and states' rights. The northern faction supported popular sovereignty, the principle of the individual territories making their own determination as to allow slavery or not. Southern Democrats wanted federal sanction and support of slavery in the territories. Unable to break the impasse, many Southerners walked out of the Charleston convention, and again at a second gathering in Baltimore, thus paving the way for the nomination of Douglas. Many Georgia Democrats joined their fellow Southerners and nominated their own presidential candidate, John C. Breckinridge of Kentucky. Meanwhile, the new Republican Party, with a platform embracing an end to the expansion of slavery, nominated Abraham Lincoln, who had virtually no organized support in the South.

In the 1860 national election, Lincoln won the presidency with slightly less than 40 percent of the national popular vote, while Georgia's popular and electoral votes went to Breckinridge. Thus, the die was cast: Lincoln's election was the final act in the growing momentum that culminated in the secession of southern states from the Union and the creation of the Confederate States of America.

Southerners had divided opinions on the proper course of action. The most vocal group, "immediate secessionists," advocated the quick withdrawal of the slaveholding states from the Union. The other, more moderate group, known as the "cooperationists," counseled for a cautious approach and called for a meeting of the slave states to determine a concerted, unified course.

The immediate secessionists emerged as the prevailing force, a development given additional emphasis when, on December 20, 1860, South Carolina became the first state to secede. This move precipitated a debate, sometimes quite contentious, among Georgia's political leaders as to which course the state should follow. The growing sense of urgency gained momentum when other southern states joined Georgia in the debate over whether to follow South Carolina's example.

Governor Brown, enjoying widespread popular support, advocated secession for Georgia, as did Howell Cobb, Francis Bartow, Robert Toombs, and Cobb's younger brother, Thomas R.R. Cobb, a prominent Athens attorney and rising political star who would lose his life at the Battle of Fredericksburg in late 1862. Taking a more moderate Unionist position were Alexander H. Stephens, Benjamin H. Hill, and Herschel V. Johnson, the latter a former staunch State Righter.

Most Georgia newspapers joined the secession bandwagon and, when Georgians voted on January 2, 1861 for delegates to a convention to debate secession, the outcome was a foregone conclusion, although far from unanimous. It should be noted that the electoral margin was sufficiently close to demonstrate just how divided Georgians were on the issue—50,000 voters supported secession delegates, while 37,000 cast votes for delegates who held a variety of positions ranging from unionism to cooperationists to anti-secessionists. Delegates to the state convention on secession gathered two weeks later in Milledgeville.

After three days of debate, culminating in an emotional speech by T.R.R. Cobb advocating the break from the Union, delegates approved an ordinance of secession by a final vote of 208 to 89. Thus, on January 19, 1861, Georgia formally broke with the Union, following South Carolina, Alabama, Mississippi, and Florida. Governor Brown received approval from the state legislature for an appropriation of funds for development of a Georgia military force. Brown also issued orders for the capture of Fort Pulaski, the large federal fortification at the mouth of the Savannah River, as well as the seizure of the federal mint at Dahlonega and the arsenal at Augusta. Calls were issued for the formation of military units from all sections of the state. By the end of 1861, about 75,000 Georgians were serving in the Confederate Army. Meanwhile, T.R.R. Cobb was primarily responsible for the new state constitution of 1861 that both modernized and streamlined Georgia's government.[1]

The role of two Georgians, Alexander H. Stephens and Robert Toombs, cannot be overemphasized in the southern movement toward secession and the subsequent creation of the Confederate States of America. Both were natives

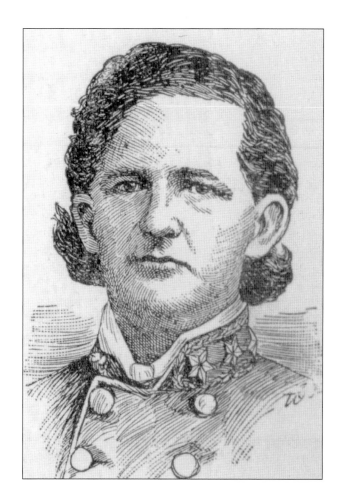

Thomas R.R. Cobb (1823–1862) was a renowned legal scholar and strong proponent of secession. He told his fellow Georgians that they could "make better terms out of the union than in it." He was killed at the Battle of Fredericksburg.

JOHN MACPHERSON BERRIEN AND THE GEORGIA HISTORICAL SOCIETY

The Georgia Historical Society, one of the oldest organizations of its kind in the nation, was founded in Savannah in 1839. One of the Society's founders and its first president, John Macpherson Berrien, played a significant role in national politics and jurisprudence.

Berrien (1781–1856) was admitted to the bar in Savannah in 1799 and soon built the largest law practice in the city, specializing in civil, admiralty, and criminal law. In the early 1820s, Berrien served a term in the Georgia senate and became part of the George M. Troup faction in state politics. Georgia elected him to the Senate in 1824, where he allied himself with Andrew Jackson and the Democratic Party. Berrien became a strong voice in national politics; his passionate oratorical style earned him the sobriquet "the honey-tongued Georgia youth" from Supreme Court Chief Justice John Marshall.

In 1829, Berrien resigned from the Senate and accepted the position of U.S. Attorney General in President Jackson's cabinet. He played a key role in support of Jackson's Indian removal policies. Following a series of disagreements with Jackson, Berrien resigned his cabinet post in 1831 and returned to Savannah, where he resumed his law practice. He also became a prominent Savannah River rice planter and slaveowner at Morton Hall and Oakgrove plantations.

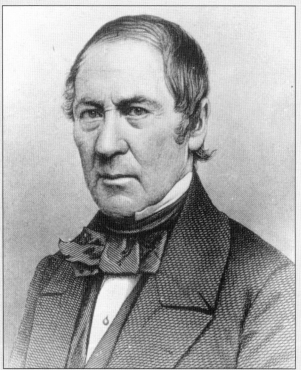

John McPherson Berrien (1781–1856) was a prominent Georgia statesman and jurist, U.S. Attorney General under President Andrew Jackson, and the first president of the Georgia Historical Society.

Berrien energetically supported railroad development in Georgia, a pursuit that coincided with his increased involvement in state politics. Later, as a member of the Whig Party, he was again elected to the Senate in the 1840s and 1850s, and he opposed Henry Clay's Compromise of 1850. Berrien died in 1856 as one of the most prominent, yet perhaps most enigmatic, of antebellum Georgia political leaders. Berrien was described by a contemporary as "stern, cold and proud" and "as aloof as possible from the rough and tumble relations and contests of men." He was a Savannah aristocrat of the eighteenth-century mold and was almost universally unpopular; yet he was one of the most enlightened and intelligent men of his time.

The Georgia Historical Society was incorporated by the Georgia legislature on December 19, 1839, following the efforts of Savannah historian William Bacon Stevens, one of the Society's founders, to consolidate the collections of Georgia Colonial and Revolutionary documents then in the possession of Israel K. Tefft. Stevens, Tefft, and Richard D. Arnold envisioned the

need to gather and preserve the historical documents of Georgia. These papers formed the basis for the history of Georgia compiled by Stevens and published in 1847. The first annual meeting of the Society was held in Savannah on February 12, 1840, the anniversary of James Edward Oglethorpe's landing at Yamacraw Bluff in 1733.

John Macpherson Berrien was chosen as the first president of the Georgia Historical Society, serving in this capacity from 1839 to 1841, then again from 1854 until his death in 1856. Berrien's interest in the history of his state, coupled with the prominent positions that he held in state and national politics, were critical factors in the early development of the Society. Savannah jurist James Moore Wayne served as president of the Society for two terms prior to the Civil War and was, like Berrien, a guiding force in the early development and growth of the organization.

The Society's stated mission of "collecting, preserving and diffusing information related to the history of Georgia" began auspiciously with its acquisition of the extensive collection of books of the Savannah Library Society and the publication, in 1840, of the first volume in its documentary *Collections* series, a publishing effort that has continued to the present day.

The collapse of the Confederacy and the difficult years of Reconstruction marked the darkest hours of the Society. Only the fortitude demonstrated by its presidents during this period—Stephen Elliott (1864–1867), John Stoddard (1867–1868), Edward J. Harden (1868–1873), George W.J. DeRenne (1873–1874), Henry Rootes Jackson (1874–1899), and Savannah historian Charles C. Jones Jr.—prevented the dissolution of the Society.

The Society persevered in the troubling times of the 1870s and crossed an important threshold in 1876 with the dedication of its permanent home at Hodgson Hall. William B. Hodgson became a curator (board member) of the Georgia Historical Society and was greatly involved in the civic and cultural affairs of Savannah soon after his marriage to Margaret Telfair in the years before the Civil War. After his death in 1871, Margaret Telfair Hodgson, his widow, financed and directed the building of Hodgson Hall in his memory for the purpose of permanently housing the collections of the Georgia Historical Society. The structure was completed in 1876 on property donated to the Society by Margaret's sister, Mary Telfair. Hodgson Hall was designed by Detlief Lienau, one of the founders of the American Institute of Architects. It is one of the most distinguished buildings in Savannah, with its vaulted three-story ceiling in the research room and main hall.

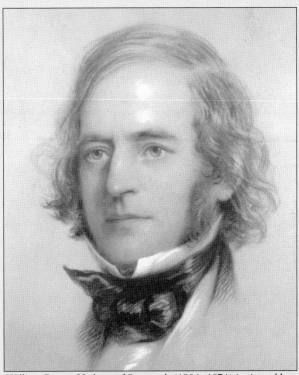

William Brown Hodgson of Savannah (1801–1871) is pictured here as a young man.

of Wilkes County and their interaction featured a friendship and collaboration that was as close as their personalities and physical traits were different. Toombs, descended from a wealthy planter family, evolved from a moderate State Righter into an ardent secessionist. He had a magnetic personality and was an imposing man physically, standing 6 feet tall.[2] Conversely, Stephens was sickly, weighed less than 100 pounds, and looked far older than his age due to his sufferings from rheumatoid arthritis. He was more moderate than Toombs and fervently opposed the dissolution of the Union until matters had gone past the point of no return. Paradoxically, Stephens became vice president of the Confederacy and played a leading role in the formation of the new government of the Confederate States, while Toombs became secretary of state. Stephens and Toombs were especially instrumental in formulating the Confederacy's constitution. As the Civil War progressed and the fortunes of the South ebbed, both Stephens and Toombs became outspoken critics of many of the policies and strategies of President Jefferson Davis and the Confederate States' government.

With the call to arms issued early in 1861, Governor Brown and the Confederate government disagreed over the management of the state's military affairs, a development that continued for the duration of the Civil War. While there was no shortage of manpower, Georgia's war effort lacked adequate supplies and materials. One decided advantage was the industrialization that had begun in several cities during the 1850s. Textile factories and ironworks were converted to the manufacture of cannon, small arms, and uniforms. Columbus and Macon became important Confederate arsenals where foundries manufactured ordnance. An arsenal and gunpowder factory opened in Augusta. Athens had a cannon foundry, while Atlanta and Savannah were important industrial centers and arsenals.[3] The conversion of industry to military production was successful in large part because Georgia contained a more extensive railroad system than any of the other Confederate states. In addition, Georgia, like the other southern states after secession, was forced to become self-sufficient—hundreds of commodities, from furniture to farm machinery, once imported from the North, now had to be manufactured within the state.

Although the state's economy was healthy in 1861 due to the growth of industry and a productive cotton market, inflation soon set in due to the constraints imposed by the war and the heavy taxation necessary for maintaining the military effort. Georgians were in for difficult times and shortages of almost everything, particularly after 1862. The war would come home to Georgia in ways that seemed unimaginable just a year before.

8. CIVIL WAR AND RECONSTRUCTION

THE CIVIL WAR, AS IT EVOLVED IN GEORGIA and the other states that seceded from the Union, was for Southerners an exercise that began with the fervor and religiosity of a holy crusade and ended in futility, devastation, despair, and ultimately total defeat. They approached the war with the conviction that secession was a just and righteous cause, built upon a foundation of states' rights, a defense of slavery, and other time-honored southern institutions. Paradoxically, many religious leaders of the South, who had initially opposed secession but then strongly embraced the Confederate cause once the war began, had to justify a conflict predicated on a fight to maintain a huge portion of its population in human bondage. Not surprisingly, the war took a heavy toll on Georgians in terms of lives lost and property destroyed. About 125,000 Georgians fought for the Confederacy. Of this number, some 25,000 men were killed, including battle casualties and deaths attributed to disease. This toll was reflected in the census of 1870, which revealed that there were 10,000 fewer white men between the ages of 20 and 29 in Georgia than appeared in the 1860 census.

The immediate strategic objective of the North was to blockade the South. This would prevent the importation of food supplies and war materiel, while denying the shipment of cotton and other agricultural commodities to overseas markets—primarily England—the proceeds of which could be utilized by the Confederacy to finance its war effort.[1] President Lincoln's military strategists felt that paralyzing the South economically would quickly induce the Confederacy to sue for peace and rejoin the Union. This strategy, while effective, took much longer to produce the desired results due to the unforeseen (by the North) resiliency and determination of the South.

The war came home to Georgia first by sea. A Union naval force under Admiral Samuel F. DuPont, commander of the South Atlantic Blockading Squadron, overwhelmed two fortifications and a small outgunned Confederate squadron under Georgia's Josiah Tattnall in Port Royal Sound in November 1861. The Federals established a permanent base of operations on Hilton Head Island, South Carolina, after which President Jefferson Davis sent Robert E. Lee to Savannah

Battle flag of the 54th Georgia Infantry, C.S.A. Originally known as a "Hardee Pattern," this style of flag was adopted for use by General William J. Hardee's Corps of the Army of Tennessee early in the war. This is the only existing example of the Hardee pattern belonging to a Georgia regiment.

to organize the defense of the Georgia and upper Florida coasts. Lee, in the few months that he held this command, could do little to stem the Federal naval assault. By the spring of 1862, DuPont's fleet had bottled up the Georgia coast, including the ports of Savannah, Darien, Brunswick, St. Marys, and Fernandina. Many of the island planter families along the coast, fearing Federal naval raids, took refuge at inland locations. Some planters moved their slaves inland and continued agricultural operations on purchased or leased lands in southwest and middle Georgia.

Union forces landed unopposed on Tybee Island in December 1861. They immediately began the supposedly difficult task of neutralizing Confederate-held Fort Pulaski, which guarded the north and south channels of the Savannah River entrance opposite Tybee. DuPont's forces occupied St. Simons Island in March 1862, liberated the plantation slaves, and used the island as a base from which to conduct continuous naval raids on the towns and plantations along the coast for the remainder of the war. One of these attacks resulted in the looting and burning of the undefended and largely abandoned town of Darien near the mouth of the Altamaha River in June 1863. This controversial raid was conducted by elements of the 2nd South Carolina Volunteers under the command of a radical Kansas Jayhawker, Colonel James Montgomery, and the 54th Massachusetts Volunteers, commanded by 25-year-old Colonel Robert Gould Shaw, scion of a Boston abolitionist family. These were the first African-American units to fight under northern command in the war.

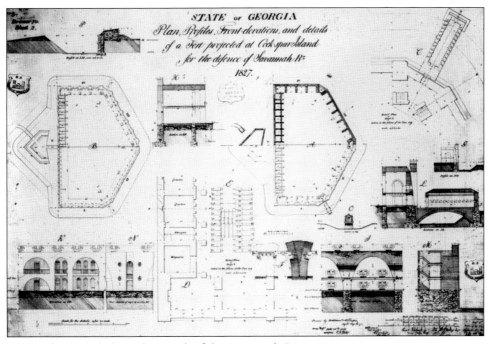

Plans of Fort Pulaski at the mouth of the Savannah River.

A far worse defeat for Georgia, because of its economic implications, was the loss of Fort Pulaski at the mouth of the Savannah River in April 1862. Union artillery placed on Tybee Island reduced Pulaski with such accurate effect that Confederate commander Colonel Charles Olmstead was forced to surrender the fort after a 36-hour bombardment. Five thousand artillery shells fell on Pulaski from a range of 1,700 yards during the short siege, directed by Union General Quincy A. Gilmore. Olmstead received criticism for not holding out longer, but the outcome was never in question, particularly after Union shells breached the fort's 7-foot walls and began falling dangerously close to the powder magazine. This was an important turning point in siege warfare. The Federals used new rifled artillery to neutralize the brick masonry fortification of Pulaski. These types of forts, built along the east coast during the 1830s and 1840s, were thought to be impregnable. With Pulaski's fall and the Savannah River's closure to navigation, Georgia's primary port was forced to rely on rail connections to south Georgia and Charleston to maintain lines of supply and communication.[2]

An earthwork defensive outpost, Fort McAllister, near the mouth of the Ogeechee River in Bryan County, successfully withstood seven Union naval attacks in 1862 and 1863, some of which involved the latest in Union naval ironclad technology. These events were crucial—the defense of Fort McAllister protected the "back door" to Savannah and ensured that the Savannah, Albany & Gulf Railroad, several miles to the west, was kept open. The persistence of McAllister had far-reaching

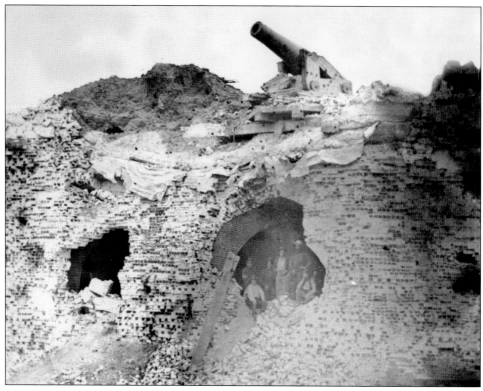

The breached wall at Fort Pulaski after the Union artillery barrage in 1862.

implications, particularly for the critical resupply of besieged Charleston by rail up the coast from Savannah.[3]

However, Admiral DuPont's boast, "I will cork up Savannah like a bottle," was no exaggeration. Savannah's outlet to the sea was cut off and only an occasional blockade runner was able to elude the Federal warships offshore, slipping through with valuable cargoes of cotton destined for the anxious English textile mills. The most famous of these were the fast steamers *Fingal* and *Bermuda,* both of which transported Savannah cotton and rice to the British Isles in late 1861 and returned safely with cargoes of military supplies.

Savannah was an important center of Confederate naval activity and warship construction.[4] More naval construction took place in Savannah than any other southern port. Three ironclads were built in Savannah yards: *Georgia, Atlanta,* and *Savannah*, in addition to several gunboats and other smaller craft. The yard of Henry F. Willink turned out a number of these vessels. The most ambitious project was the conversion of the blockade-runner *Fingal* into the C.S.S. *Atlanta,* largest of the Confederate ironclads. This work was contracted to Nelson and Asa Tift and was completed in early 1863. The career of the *Atlanta* was short lived. On her first venture from port, *Atlanta* ran aground on a mudbank in Wassaw Sound and was captured after a short engagement.

Nevertheless, due to the blockade, Savannah's prosperity was rapidly diminished. Charles Olmstead returned to Savannah in 1862 after his capture and reported, "A strange, mysterious, weird quietude reigns perpetually [in Savannah] and stagnation and paralysis obstructs the channels where business briskly flowed. The whole town—everything—seems to have halted."

As a consequence of the blockade, Savannah became the profiteering center of Georgia, a development inspired by the rampant inflation precipitated by the closure of the port. For example, the price of flour rose from $40 to $125 a barrel. Food supplies became increasingly insufficient and scarce, due in part to the inflationary costs. A Union private wrote from Thunderbolt, near Savannah, in 1864, "It looks like to me the Confederate States is compelled to starve in a short time." Boiled shrimp became the breakfast staple of Savannah; were it not for the availability of seafood from the local tidal creeks and marshes, the large white and black population of wartime Savannah might have had an even more difficult time.[5]

GEORGIANS IN THE CIVIL WAR

Georgians saw action in every major campaign of the war. Although Georgia units were engaged in the battles of the western theater, particularly in the siege and attempted relief of Vicksburg, most men from the state served in the eastern theater in the Army of Northern Virginia. From Manassas to Appomattox, Georgians played a conspicuous role in Lee's army. Georgia contributed many of

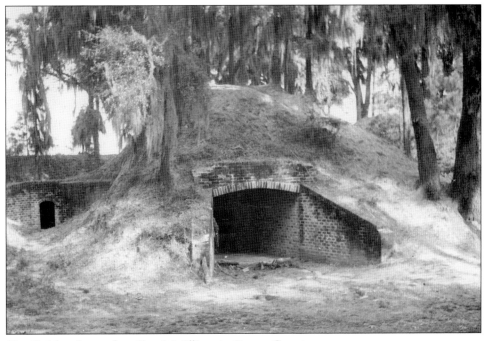

Fortified bomb-proofs at Fort McAllister in Bryan County.

the Confederacy's leading general officers, including Joseph Wheeler, William J. Hardee, John B. Gordon, and Lafayette McLaws.

Francis S. Bartow was one of the first Georgians to distinguish himself in battle. A lawyer by training, Bartow was elected to the secession convention, after which he served in the Confederate Congress in Montgomery. There he chaired the House Committee on Military Affairs and is generally credited with selecting gray as the color for the Confederate uniform. Although perceived by many as cold and aloof, Bartow was a gifted orator whose speaking style was once described as "logic on fire." When the war began, he resigned his seat in the congress and led the Oglethorpe Light Infantry to Virginia, declaring to Governor Brown, "I go to Virginia to illustrate Georgia." He was elected colonel of the 8th Georgia Infantry and was killed leading his Georgia brigade at the Battle of First Manassas, July 21, 1861. He was the first high-ranking Georgian to fall in the conflict and his death transformed him into an instant martyr. At least 11 military units were named after him and Cass County, Georgia changed its name to Bartow in his honor.

Another Georgian who rose to prominence during the war was John B. Gordon. A native of Upson County and, like Bartow, a lawyer by training, Gordon was operating a mine in northwestern Georgia when the war began. He raised a company of volunteers known as the "Raccoon Roughs" and took his men to Alabama, where they were incorporated into the Sixth Alabama Infantry and elected Gordon lieutenant colonel. Noted for his almost reckless boldness and audacity on the battlefield, Gordon emerged as one of the finest combat officers in the Army of Northern Virginia and arguably the best non-professional soldier of the war. Appointed brigadier general and given command of Lawton's Georgia Brigade in 1863, he performed brilliantly and quickly won promotion. Eventually rising to the rank of major general, he was in command of half the army at Appomattox, although he was only 33 years old.

Probably no Georgian shaped the destiny of Confederate military affairs more than James Longstreet. A native of South Carolina, Longstreet was raised in Georgia, graduated from West Point, and saw service in the Mexican War. Longstreet was a talented combat officer who rose quickly in the army. As commander of the First Corps, "Old Pete," as he was known to his friends, was second in command of the Army of Northern Virginia and emerged as Lee's most trusted lieutenant after the death of Stonewall Jackson. Indeed, Lee referred to Longstreet as "my old war horse." Longstreet's most famous and controversial moment came during the Battle of Gettysburg in July 1863. His disagreement with Lee's plan of battle and tactical arrangements led many after the war to blame him for losing the decisive engagement of the conflict.

THE HOME FRONT: GEORGIA INDUSTRY DURING THE WAR

Until the latter part of 1864, Georgia was the engine of industry and production for the Confederate war effort. Augusta, critical to the Confederacy's war effort, contained the Confederate States Powder Works, the largest gunpowder factory in the South. It utilized an average of about 100 white and black workers during

THE CONFEDERATE NAVAL EFFORT ON THE CHATTAHOOCHEE RIVER

One of the least recognized aspects of the Civil War in Georgia is the significant Confederate naval effort centered upon Columbus and the lower Chattahoochee River. The Confederacy realized early in the war the importance of maintaining communications between Columbus and Apalachicola, Florida, at the river's mouth on the Gulf of Mexico. In response, the Union Navy clamped a blockade on Apalachicola; the thrust of Confederate naval activities at Columbus became centered on a goal to break the Federal stranglehold on the lower section of the river.

Critical to southern military plans were operations in Columbus centered upon the Confederate Naval Iron Works and the Columbus Navy Yard. The ironworks manufactured naval engines and machinery, while the shipyard attracted some of the leading naval experts in the Confederacy. The Columbus naval facilities were responsible for the steam machinery for the ironclads C.S.S. *Savannah*, constructed at Savannah, and C.S.S. *Muscogee*, built in 1863 and 1864 at Columbus. The Naval Iron Works produced machinery for 11 vessels and supplied parts and equipment for several others.

Lieutenant Augustus McLaughlin arrived in the fall of 1861 to begin the activities of the naval shipyard. He was responsible for the construction of the Confederate gunboat *Chattahoochee* on the river at Saffold, 175 miles south of Columbus. After a brief career on the river, the *Chattahoochee* suffered a disastrous boiler explosion, causing extensive damage and the loss of 18 seamen. The vessel was towed to Columbus for repairs, but never returned to action. In the fall of 1862, Chief Engineer James H. Warner arrived at Columbus to supervise the Navy Yard, serving there until the end of the war. Warner proved to be one of the Confederacy's most capable administrators.

The Navy Yard at Columbus was responsible for the construction of two warships, the ironclad *Muscogee*, later renamed *Jackson*, and the ironclad torpedo boat *Viper*. The *Jackson* was launched in early 1864, but modifications on the vessel delayed her completion for another year. *Jackson*'s propulsion system was altered from a center paddlewheel to a twin propeller drive, a conversion still in progress when the war ended.

In April 1865, General James H. Wilson's Union cavalry made its sweep through Alabama and western Georgia. After a brisk skirmish with Columbus home guards centered on the Chattahoochee River bridges—the last land battle of the war in Georgia—the Federals occupied the city on April 16. General James Winslow, in command of local Confederate forces, ordered the burning of the almost-completed *Jackson* and the *Chattahoochee,* still undergoing repairs. These vessels were raised in 1961 and 1964, respectively, and the timbers of their hulls are now exhibited at the Port Columbus National Civil War Museum.[12]

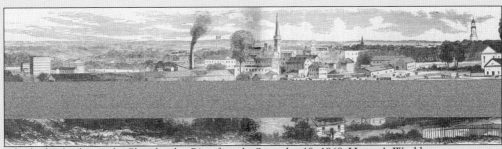

Sketch of Columbus on the Chattahoochee River from the September 19, 1868, Harper's Weekly.

1862 and 1863. The city was also home to the Augusta Cotton Factory, one of the largest textile mills in the South; the Confederate Clothing Bureau, with 1,500 women on its payroll to produce military wear; and the Confederate States Shoe Manufactory, which supplied the southern armies with footwear. Augusta, like other Georgia cities, also had an arsenal for the manufacture of weapons.

Macon had three important facilities: the Confederate States Arsenal in the Findlay Iron Works, which produced ordnance and gun carriages, as well as smaller weapons and other military equipment; the Arsenal, which produced rifles and pistols; and the Confederate States Central Laboratory for the experimentation and manufacture of shells and bullets.

The Atlanta Arsenal produced ordnance and supplies for Confederate armies in Tennessee, Georgia, and Alabama. Atlanta's Gate City Rolling Mills was the only concern other than Richmond's Tredegar Iron Works capable of producing iron rails. Atlanta also contained a major Confederate hospital center and military quartermaster depot, in addition to being the South's leading railroad center.[6]

Columbus, at the head of navigation on the Chattahoochee River, housed the Confederate Naval Iron Works, which manufactured armor and ordnance for warships.[7] By 1865, Columbus had become the Confederacy's leading manufacturer of naval engines and machinery, and its ironworks played a role

Union General William Tecumseh Sherman (1820–1891).

in the construction of two ironclad warships at the town (see sidebar). Three cotton and woolen mills, a foundry, a paper mill, and a cotton gin factory made Columbus an important Confederate industrial center. Its Eagle Mill could produce 12,000 yards of cloth and 8,000 yards of tent cloth per week. In the first year of the war, Columbus produced over 4,000 uniforms for the Confederate Quartermaster Department.

Financing the business and production of war by the state of Georgia—apart from the rapidly rising body count as a result of battle deaths—dampened the early enthusiasm for secession. Money ran short by early 1862, after Governor Brown implemented the issuance of treasury notes to serve as currency, rather than the sale of bonds as others advocated. In response to the growing shortage of capital, the state instituted profit taxes on virtually everything manufactured and sold. The manufacture of war materiel was superseded by the growing expense (largely due to the Union naval blockade and the difficulties of war finance) of supplying the armies in the field with food, clothing, and medical supplies. Not surprisingly, the tenuous economy and financial structure of Georgia and the South collapsed long before the actual end of fighting.

ATLANTA: THE DECISIVE CAMPAIGN OF 1864

Full-scale military operations in Georgia began in the summer of 1863. In September, a Union army under General William S. Rosecrans captured Chattanooga and swept into northwestern Georgia. Later that month, Confederate forces under General Braxton Bragg dealt the Union armies a severe defeat at the Battle of Chickamauga.[8] This outcome led to Rosecrans's replacement by Ulysses S. Grant as commander of all Union forces in the West, with General William Tecumseh Sherman becoming Grant's chief subordinate in this theater of the war. Grant pushed Bragg's forces back into Georgia after successful assaults at Lookout Mountain and Missionary Ridge. These battles were a precursor for the north Georgia spring campaign of 1864.

In May 1864, Sherman began the invasion of north Georgia with 113,000 men in three armies: the Army of the Cumberland, commanded by General George H. Thomas; the Army of the Tennessee under General James B. McPherson; and the Army of the Ohio under General John M. Schofield. Sherman's objective was Atlanta. In his path lay a considerably smaller Confederate force—the 70,000-man Army of Tennessee under the command of General Joseph E. Johnston, who had replaced Bragg. What evolved was one of the most important and complex military campaigns of the war. Using his superior numbers to good effect, Sherman executed a series of flanking maneuvers and feints to steadily drive Johnston's forces southward down the Western & Atlantic Railroad toward Atlanta. Johnston's strategy was to utilize delaying tactics and inflict losses on Sherman, while avoiding a large-scale, set-piece battle in which the Federals could bring their numerical superiority to bear.

Sherman outflanked Johnston twice early in the campaign following pitched battles with the Confederates near Dalton in the second week of May, then again

further south at Resaca between May 13 and May 15. The following week, after crossing the Oostanaula River, Johnston's army withdrew to Cassville, followed by another withdrawal across the Etowah River. Sherman flanked Johnston once again at Allatoona on May 23 through May 25. There ensued a series of three bloody clashes in the space of four days during the last week of May at New Hope Church, Pickett's Mill, and Dallas, which forced the Confederates to withdraw and entrench themselves in solid defensive positions around Kennesaw Mountain, just north of Marietta.

By now, heavy spring rains, which led to mud-soaked clay roads, and an increasingly overtaxed supply line from Tennessee began to create delay and difficulty for Sherman's army. On June 27, Sherman committed one of the few real blunders in his otherwise methodical advance on Atlanta when he unwisely hurled his forces in a direct and bloody frontal assault upon strongly emplaced Confederate entrenchments at Kennesaw Mountain. The Union forces were repulsed with 3,000 casualties, including 2 brigadier generals, while Confederate losses numbered only 800.

Continued on page 113

Brothers Joseph Clay Habersham and William Neyle Habersham of Savannah were both killed in the Battle of Atlanta on July 21, 1864.

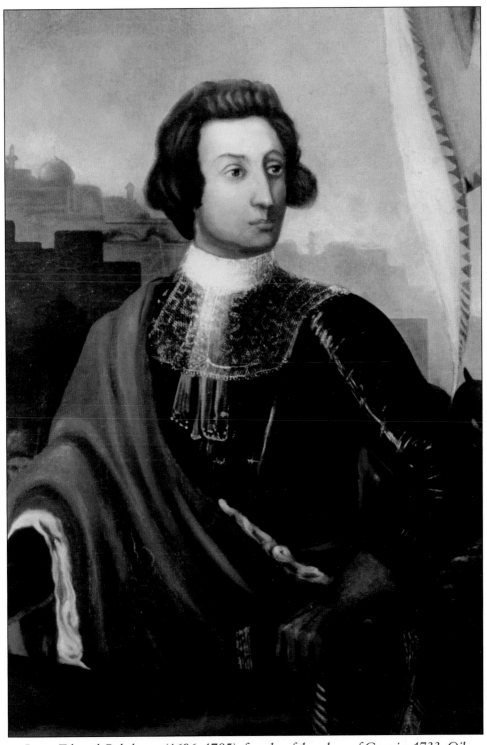

James Edward Oglethorpe (1696–1785), founder of the colony of Georgia, 1733. Oil painting by Richard West Habersham, pre-1885.

Compass used by James Edward Oglethorpe to lay out the city of Savannah.

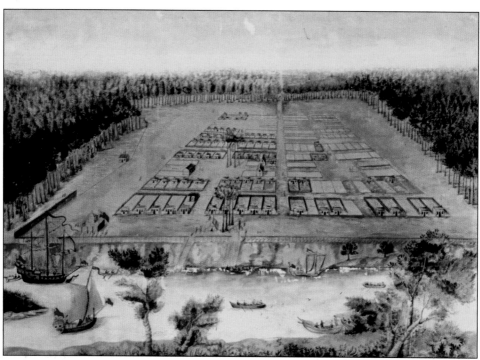

"A View of Savannah as it Stood the 29th of March 1734," attributed to early Georgia colonist Peter Gordon.

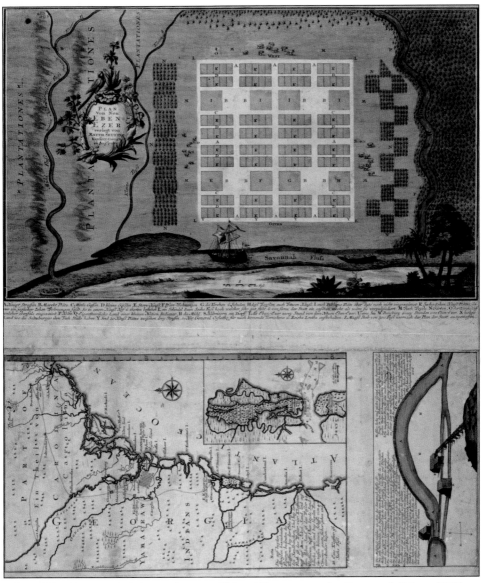

Plan of the German Salzburgers' town of New Ebenezer on the Savannah River, 1747.

"A Map of South Carolina and a Part of Georgia," compiled in 1757 by William Gerard DeBrahm.

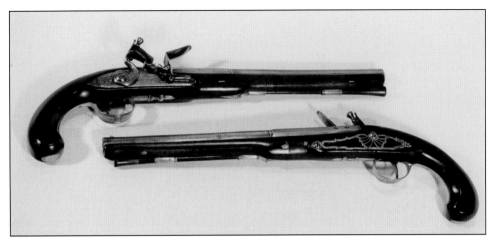

Silver-mounted officer's pistols, c. 1770s, owned by James Jackson (1757–1806), Revolutionary War hero, Georgia governor (1798–1801), U.S. congressman and senator, and bitter foe of the Yazoo land fraud. The pistols have the initials "JJ" engraved on the butt cap escutcheons, are stocked in English walnut, and are of the "transition" type.

Daily business ledger kept between 1774 and 1783 by Andrew McLean, merchant and Indian trader of Augusta.

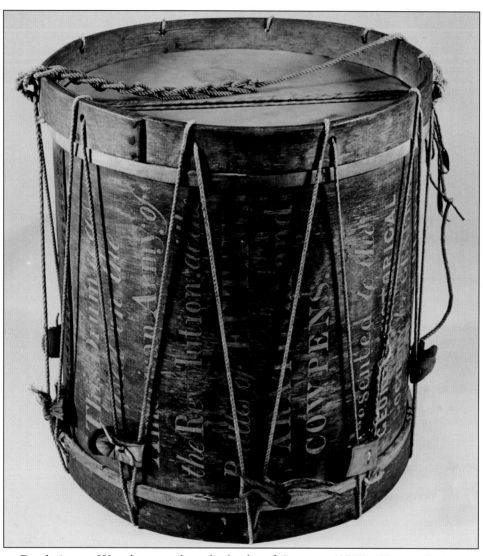

Revolutionary War drum used at the battles of Saratoga (1777), Eutaw Springs (1781), and Cowpens (1781), presented to the Georgia Historical Society by General Charles R. Floyd in 1841.

Powder horn used in the Revolutionary War by James Valloton of Savannah (1753–1805).

"Grapeshot which mortally wounded Count Casimir Pulaski, October 9, 1779, extracted from his body by Dr. James Lynah" at the Battle of Savannah during the Revolutionary War.

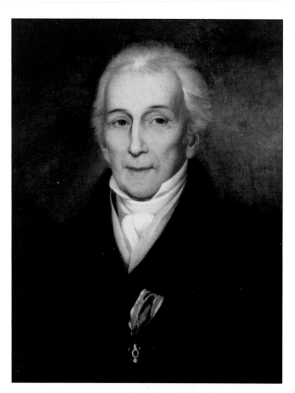

John Wereat (c. 1730–1799), governor of Georgia during the American Revolution, 1779 to 1780. Portrait by Rembrandt Peale.

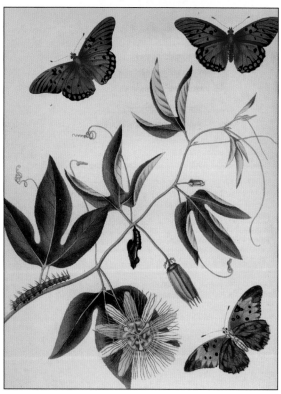

Folio from The Natural History of the Rarer Lepidopterous Insects of Georgia *by John Abbott and James Edward Smith, published in London in 1797.*

W E, the People of the United States, in order to form a more perfect union, to establish justice, insure domestic tranquility, provide for the common defence, promote the general welfare, and secure the blessings of liberty to ourselves and our posterity, do ordain and establish this Constitution for the United States of America.

ARTICLE I.

Sect. 1. ALL legislative powers herein granted shall be vested in a Congress of the United States, which shall consist of a Senate and House of Representatives.

Sect. 2. The House of Representatives shall be composed of members chosen every second year by the people of the several states, and the electors in each state shall have the qualifications requisite for electors of the most numerous branch of the state legislature.

No person shall be a representative who shall not have attained to the age of twenty-five years, and been seven years a citizen of the United States, and who shall not, when elected, be an inhabitant of that state in which he shall be chosen.

Representatives and direct taxes shall be apportioned among the several states which may be included within this Union, according to their respective numbers, which shall be determined by adding to the whole number of free persons, including those bound to servitude for a term of years, and excluding Indians not taxed, three-fifths of all other persons. The actual enumeration shall be made within three years after the first meeting of the Congress of the United States, and within every subsequent term of ten years, in such manner as they shall by law direct. The number of representatives shall not exceed one for every forty thousand, but each state shall have at least one representative: and until such enumeration shall be made, the state of New-Hampshire shall be entitled to chuse three, Massachusetts eight, Rhode-Island and Providence Plantations one, Connecticut five, New-York six, New-Jersey four, Pennsylvania eight, Delaware one, Maryland six, Virginia ten, North-Carolina five, South-Carolina five, and Georgia three.

When vacancies happen in the representation from any state, the Executive authority thereof shall issue writs of election to fill such vacancies.

The House of Representatives shall chuse their Speaker and other officers; and they shall have the sole power of impeachment.

Sect. 3. The Senate of the United States shall be composed of two senators from each state, chosen by the legislature thereof, for six years: and each senator shall have one vote.

Immediately after they shall be assembled in consequence of the first election, they shall be divided as equally as may be into three classes. The seats of the senators of the first class shall be vacated at the expiration of the second year, of the second class at the expiration of the fourth year, and of the third class at the expiration of the sixth year, so that one-third may be chosen every second year: and if vacancies happen by resignation, or otherwise, during the recess of the Legislature of any state, the Executive thereof may make temporary appointments until the next meeting of the Legislature.

No person shall be a senator who shall not have attained to the age of thirty years, and been nine years a citizen of the United States, and who shall not, when elected, be an inhabitant of that state for which he shall be chosen.

The Vice-President of the United States shall be, ex officio, President of the senate, but shall have no vote, unless they be equally divided.

The Senate shall chuse their other officers, and also a President pro tempore, in the absence of the Vice-President, or when he shall exercise the office of President of the United States.

The Senate shall have the sole power to try all impeachments. When sitting for that purpose, they shall be on oath. When the President of the United States is tried, the Chief Justice shall preside: And no person shall be convicted without the concurrence of two-thirds of the members present.

Judgment in cases of impeachment shall not extend further than to removal from office, and disqualification to hold and enjoy any office of honor, trust or profit under the United States: but the party convicted shall nevertheless be liable and subject to indictment, trial, judgment and punishment, according to law.

Sect. 4. The times, places and manner of holding elections for senators and representatives, shall be prescribed in each state by the legislature thereof: but the Congress may at any time by law make or alter such regulations, except as to the place of chusing senators.

The Congress shall assemble at least once in every year, and such meeting shall be on the first Monday in December, unless they shall by law appoint a different day.

Sect. 5. Each house shall be the judge of the elections, returns and qualifications of its own members, and a majority of each shall constitute a quorum to do business: but a smaller number may adjourn from day to day, and may be authorised to compel the attendance of absent members, in such manner, and under such penalties as each house may provide.

Each house may determine the rules of its proceedings; punish its members for disorderly behaviour, and, with the concurrence of two-thirds, expel a member.

Each house shall keep a journal of its proceedings, and from time to time publish the same, excepting such parts as may in their judgment require secrecy; and the yeas and nays of the members of either house on any question shall, at the desire of one-fifth of those present, be entered on the journal.

Neither house, during the session of Congress, shall, without the consent of the other, adjourn for more than three days, nor to any other place than that in which the two houses shall be sitting.

Sect. 6. The senators and representatives shall receive a compensation for their services, to be ascertained by law, and paid out of the treasury of the United States. They shall in all cases, except treason, felony and breach of the peace, be privileged from arrest during their attendance at the session of their respective houses, and in going to and returning from the same; and for any speech or debate in either house, they shall not be questioned in any other place.

No senator or representative shall, during the time for which he was elected, be appointed to any civil office under the authority of the United States, which shall have been created, or the emoluments

Abraham Baldwin's copy of the Committee on Style version of the United States Constitution, with Baldwin's handwritten notes.

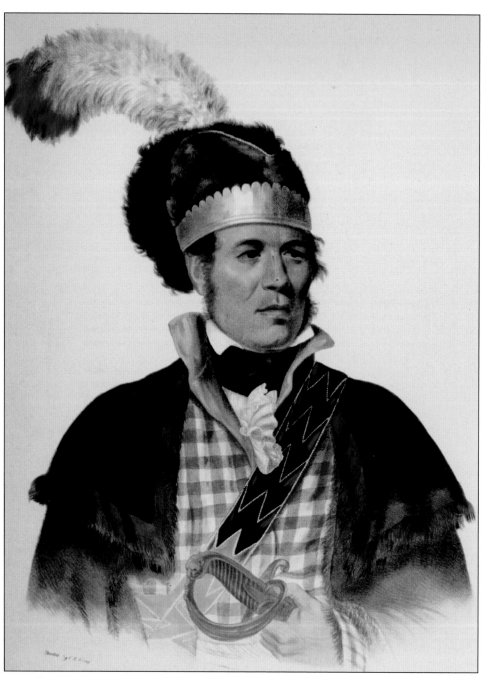

William McIntosh (1775–1825) chief of the lower Creek Indians.

In this letter, dated February 15, 1825, from Thomas Jefferson to William Harris Crawford, the former President expresses disappointment over Crawford's loss of the presidential election. Crawford (1772–1834) was a Georgia state legislator and judge, U.S. senator, Minister to France, Secretary of War and Treasury, and an 1824 presidential candidate.

Dear Sir Monticello Feb. 15. 25.

Your two letters of Jan. 31. and Feb. 4. were received in due time. with the former came safely the seeds from mr Appleton which I commit to the agricultural society of our county of which mr Madison is president. of the talents and qualifications of Dr Jackson, as a Professor in the branches of science specified in your last letter, your recommendation would have had great weight in our estimation. but our Professors are all designated, so that we have no vacancy in which we can avail ourselves of his services.

I had kept back my acknolegement of these letters in the hope I might have added in it congratulations which would have been very cordially offered. I learnt yesterday however that events had not been what we had wished. the disappointment will be deeply felt by our state generally, and by no one in it more seriously than by myself. I confess that what we have seen in the course of this election has very much damped the confidence I had hitherto reposed in the discretion of my fellow citizens. the ignorance of character, the personal partialities, and the inattention to the qualifications which ought to have guided their choice augur ill of the wisdom of our future course. looking too to Congress, my hopes are not strengthened. a decided majority there seems to measure their powers only by what they may think, or pretend to think, for the general welfare of the States. all limitations therefore are prostrated, and the general welfare in name, but consolidation in effect, is now the principle of every department of the government. I have not long to witness this. but it adds another to the motives by which the decays of nature so kindly prepare us for welcoming the hour of exit from this state of being. be assured that in your retirement you will carry with you my entire confidence, and sincere prayers for your health, happiness and prosperity.

Th. Jefferson

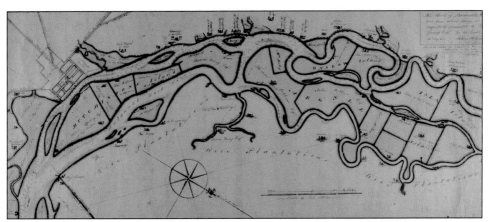

Contemporary map of Savannah River rice plantations, 1825, by John McKinnon.

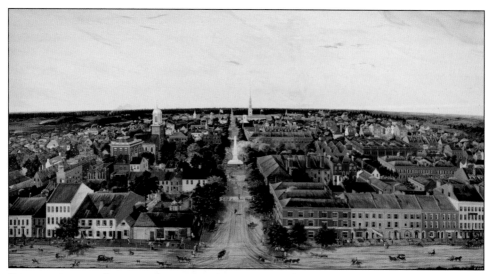

Panoramic view of Savannah in 1837, by Joseph Louis Firmin Cerveau.

Thomas Spalding (1774–1851), Sapelo Island planter. Oil painting by John Maier, c. 1845.

Robert Toombs (1810–1885), Georgia statesman, member of the U.S. Congress and Senate, Confederate Secretary of State, and general in the Confederate army. Portrait by John Maier, c. 1860.

Battle flag of the Jeff Davis Legion, a cavalry unit consisting of men from Georgia, Mississippi, and Alabama, which served with the Army of Northern Virginia and saw action at Brandy Station, Gettysburg, and in the Bentonville campaign.

Major General Lafayette McLaws (1821–1897), West Point graduate, veteran of the Mexican War, and Confederate officer. As the senior major general from Georgia in the Army of Northern Virginia, McLaws led his division at Harper's Ferry, Sharpsburg, Fredericksburg, Chancellorsville, Gettysburg, and the defense of Savannah. Oil painting by Willis Pepoon, pre-1902.

Artifacts belonging to Confederate General Lafayette McLaws: coconut dipper, tortoise shell pocket knife, ivory letter opener, china mustache cup, leather officer's belt with "C.S." buckle, spurs, percussion pistol, brass and gold epaulettes, 1840 dragoon saber, leather holsters, stirrup, and saddle bag.

Small plantation medicine chest, dated c. 1840–1900.

The reading room in Hodgson Hall (dedicated in 1876), the statewide headquarters of the Georgia Historical Society (founded in 1839).

Spanish-American War uniform worn by Trooper Elmer Bolsen, Company A, 7th U.S. Cavalry. Bosen was stationed in Savannah with the 7th Cavalry before departing for Cuba.

Confederate General Joseph E. Johnston (1807–1891).

Continued from page 96

In his memoirs, Sherman noted the following:

> I am moving heaven and earth to accomplish [flanking Johnston again], in which event I shall leave the railroad and move to the Chattahoochee. . . . I think we can whip [Johnston's] army in fair battle, but behind the hills and trunks our loss of life and limb on the first assault could reduce us too much. . . . I have no idea of besieging Atlanta but may cross the Chattahoochee and circle around Atlanta, breaking up its roads.

Thus, two days after the defeat at Kennesaw, Sherman was once again on the move, neatly flanking Johnston again in a race to the Chattahoochee, beyond which lay Atlanta. On July 8, the first Union forces crossed the river, and Johnston's army fell back within the perimeter defenses of Atlanta itself.

Johnston had fought a skillful delaying campaign in the face of great odds and, to that point, had actually inflicted greater casualties on Sherman's army than he had sustained himself. Nevertheless, Johnston had allowed himself to be pushed back to the gates of Atlanta without an all-out attempt to halt his adversary. President Davis, therefore, chose at this juncture (July 17) to replace Johnston with John Bell Hood, whom he judged to be a more aggressive general. With

Confederate General John Bell Hood (1831–1879) succeeded Joseph Johnston.

Atlanta now directly threatened by the massed Union forces, which crossed the Chattahoochee in strength on July 16, Governor Brown called out the Georgia militia to bolster Hood's army and impressed slaves to throw up more defensive works around the city.

Hood did not disappoint Davis in his assessment. He immediately went on the offensive by executing a series of three major assaults against elements of Sherman's army in late July, all of which were repulsed. In the Battle of Peachtree Creek on the afternoon of July 20, Hood mounted a vigorous attack on several fronts against Union defensive positions, but faulty planning and difficult terrain contributed to both General William J. Hardee's and General Alexander P. Stewart's Confederate corps being thrown back with heavy losses. This fight cost Thomas's Army of the Cumberland nearly 2,000 casualties, but Hood's losses were greater—2,500 dead and wounded, and worse, he had failed to dent the resilience of his Union foe. Two days later, in the Battle of Atlanta (July 22), Hood attacked again, this time in an attempt to outflank McPherson's Army of the Tennessee between Decatur and Atlanta. After a six-hour battle, Hood's gamble had failed and the Union held the field despite fierce fighting that resulted in 5,000 Confederate and 4,000 Federal casualties, including the death of McPherson himself.

A brief lull ensued, then Sherman sent the Army of the Tennessee under McPherson's successor, General Oliver O. Howard, on a counterclockwise march around the northern end of Atlanta, then south as part of a plan to cut Confederate supply lines west of the city. Hood reacted quickly as he sought to check the Union encircling movement. What followed in the Battle of Ezra Church on July 28 was yet another failed Confederate assault. At this point, Hood retired into defensive entrenchments around Atlanta. A 40-day siege began with Union artillery shells regularly falling inside the city, terrorizing citizens and creating great hardship and loss of life.[9]

Meanwhile, Union cavalry under General George Stoneman led a wide, sweeping raid through west Georgia and east Alabama in July and August. Stoneman's momentum was effectively neutralized, however, in two separate defeats inflicted by Confederates on July 30. The first occurred at Brown's Mill near Newnan, southwest of Atlanta, where a Confederate cavalry force commanded by the highly efficient General Joseph Wheeler thoroughly defeated Union cavalry under General Edward M. McCook. The other Federal defeat occurred at Macon, where Stoneman himself was hurled back at the Ocmulgee River by Confederate defenders led by General Alfred H. Iverson. Setbacks in the Macon area ended Stoneman's plan to liberate thousands of Federal prisoners at the Andersonville prison camp near Americus. Some 13,000 Union prisoners

Abandoned Confederate defenses of Atlanta, after the city's fall in 1864.

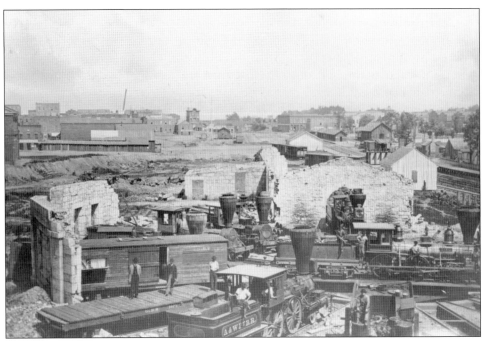

Atlanta railroad yards following the city's capture in September 1864.

perished at this overcrowded camp with scarce food and shelter and appalling sanitary conditions.

In Atlanta, Hood made a final attempt to break out and force Sherman to loosen his vise around the city. When Sherman moved south to close the remaining rail link into Atlanta, Hood came out in force to break the Federal stranglehold. Hood's slim hopes were dashed by his defeat with heavy losses in the Battle of Jonesboro, south of Atlanta, between August 31 and September 1. With a sizeable portion of his army under Hardee having retired southward to Lovejoy's Station, Hood's remaining forces were compelled to evacuate Atlanta on the night of September 1 and Sherman occupied the city the next day. Atlanta, and with it the heart of the Confederacy, had fallen at last.

THE MARCH TO THE SEA AND THE END OF THE WAR

During September, Sherman expelled those Atlanta residents who had weathered the siege, about 1,600 civilians. Hood, meanwhile, marched north toward Tennessee with 40,000 troops, hoping to disrupt Sherman's tenuous supply lines and compel his withdrawal from Atlanta. Thomas pursued and neutralized Hood in Tennessee. After burning all the major structures in Atlanta, including the city's railroad shops and other infrastructure vital to the Confederacy, Sherman began his march to the coast in mid-November. The loss of Atlanta was a serious blow to the Confederacy, one from which it clearly could not recover. Sherman's campaign against Johnston and Hood

ensured the reelection of Lincoln in the 1864 fall election and reenergized Union hopes for final victory.

Splitting his army into two wings outside Atlanta, Sherman advanced in a 40- to 60-mile sweep southeastward toward the coast, destroying everything in his path that could be of use to the Confederates—railroads, bridges, mills, factories, and warehouses. Contrary to Sherman's orders, many civilian homes were raided, destroyed, or looted. Thousands of slaves were liberated during the march and many followed the Union Army eastward, creating a scene of chaos and confusion. Federals occupied the undefended Georgia capital at Milledgeville on November 22, after which Sherman pushed toward his objective of Savannah. Civilian property losses mounted as the march to the sea progressed. However, the Federals generally adhered to Sherman's instructions to refrain from harming unresisting civilians.

On the evening of December 9, after spirited resistance during the day from Hardee's infantry and artillery, Sherman's forces occupied Pooler's Station, a Central of Georgia Railroad depot 8 miles west of Savannah. Federal cavalry under General Judson Kilpatrick then crossed the Ogeechee River and made raids to the south in Bryan and Liberty Counties, disrupting Confederate communications on the Atlantic & Gulf Railroad. Savannah's fate was sealed on December 13 as elements of Sherman's XV Corps, commanded by General William B. Hazen, overwhelmed the outnumbered contingent of Confederates defending Fort McAllister, thus opening the critical line of communication and supply for Sherman with Union naval forces offshore.[10] The ragged remnants of Hardee's army crossed the Savannah River into

Romanticized view of Georgians fleeing before Sherman's March.

South Carolina and the ironclad *Savannah* was blown up and sunk near Fort Jackson to prevent her capture.

On December 21, 1864, Sherman occupied Savannah, at which time he telegraphed his famous message to President Lincoln: "I beg to present you as a Christmas Gift, the City of Savannah with 150 heavy guns and plenty of ammunition; and also about 25,000 bales of Cotton." Since local officials agreed to end resistance, Sherman spared the city from destruction, a fate not shared by Columbia after Sherman's army moved into South Carolina.[11]

With the fall of Savannah, the state was thoroughly beaten. Union cavalry under General James H. Wilson administered the final blow. This force swept through Alabama before moving into Georgia, capturing Columbus on April 16, 1865 (a week after Lee's surrender at Appomattox Courthouse in Virginia), then accepted General Howell Cobb's surrender of Macon on April 20. Governor Brown surrendered the remaining Georgia forces in the field soon after. The final meeting of the Confederate States government, held as its members fled south from Richmond, was conducted at Washington, Georgia, just before President Jefferson Davis's arrest near Irwinville on May 10, 1865.

GEORGIA AND RECONSTRUCTION

With the end of hostilities, Federal authority, already established at Savannah, was extended to the rest of the state. James Johnson, a Columbus attorney, was appointed provisional governor. Under Federal supervision, a new state convention

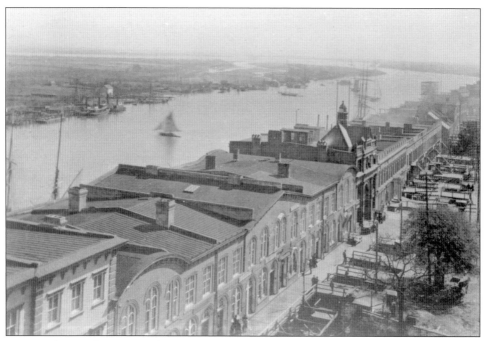

Savannah waterfront, December 1864.

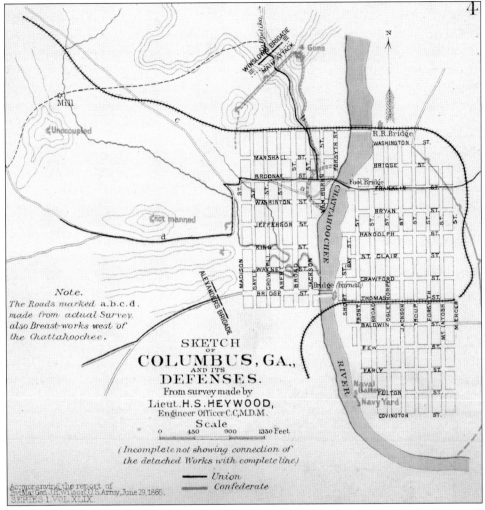

"Sketch of Columbus, Ga., and its Defenses. From survey made by Lieut. H.S. Heywood, Engineer Officer," April 1865.

repealed the ordinance of secession and officially abolished slavery in the fall of 1866. The Freedmen's Bureau became a major part of Federal occupying forces as Reconstruction began. This agency, with mixed success, coordinated and directed the difficult transition to freed status for the huge numbers of former slaves in Georgia and the defeated South.

In November 1866, a new state legislature ratified the 13th Amendment, freeing the slaves, and enacted other laws legitimizing the equality of the freed African Americans. Charles J. Jenkins of Augusta, a Unionist judge, became governor as Georgia and the other former Confederate states fell under the mandates of the federal Military Reconstruction Act. Georgia came under military rule, while a large number of African Americans were included in the management of a

reorganized state legislature for the first time. This development was partly the result of a concerted registration drive of black voters coordinated in April 1867 by Freedmen's Bureau officials for the purpose of electing delegates to a new state constitutional convention held in Atlanta in December 1867. A Republican majority convention comprised of numerous so-called "scalawags" (white Georgians willing to cooperate with the emerging Republican political power base in the state) adopted a new constitution that provided the foundation of state government until 1877. Radicals and conservatives alike were in agreement on a provision to absolve the staggering war-related debts of Georgians incurred prior to 1865. In addition, the new constitution provided for a free public education program, inclusive of the children of both whites and freedmen. In 1868, the new Republican government moved the state capital from Milledgeville to Atlanta, an increasingly powerful political center.

Rufus B. Bullock, a Radical Republican, became governor in April 1868, winning a bitterly contested election over highly regarded former Confederate general John B. Gordon. With the election of 32 African Americans to the state House and Senate, the Republicans had a majority that ensured Georgia's ratification of the 14th Amendment, securing black civil rights, in July 1868.

The massive and violent resistance of conservative Democrats and white vigilante groups such as the Ku Klux Klan, however, prevented much progress being made in the assimilation of blacks into the mainstream of Georgia society. In contradiction of the Reconstruction Act and the 14th Amendment, African-American legislative members elected in 1868 were expelled from their seats in September of that year and were replaced briefly by white conservatives. Tensions ran high between whites and blacks in many parts of the state during this period, as glaringly demonstrated by the Camilla Riots of 1868 in southwest Georgia's Mitchell County. Because of ongoing difficulties between Bullock and the conservative Democrats in the legislature, the expulsion of black members, and a disturbing pattern of anti-black violence by the Ku Klux Klan, Bullock requested the reinstatement of federal military rule in Georgia. This resulted in a third reorganization of state government in December 1869. The new legislature, meeting in January 1870, oversaw the restoration of numerous seats to those African Americans expelled earlier, as well as many Republicans, and it ratified the 15th Amendment guaranteeing African-American suffrage.

These unsettled times, aside from the war years themselves, certainly qualify as among the most difficult for people of both races in Georgia's history. Their essence is captured in the evocative prose of Ella Gertrude Thomas, wife of a bankrupted plantation owner near Augusta, who wrote the following in November 1868:

> I have not alluded to the present unsettled state of affairs among the Negroes and white people, but it has for some time been a subject of much interest. Things are rapidly approaching a crisis. Tuesday will be the day for the Presidential election, and the South feels instinctively that

Rufus B. Bullock (1834–1907) was Georgia's Reconstruction governor from 1868 to 1871, and the state's first elected Republican governor.

she is standing upon the mouth of a volcano, expecting every moment an eruption, and if it takes place—what then? Tonight it is reported that all of the houses of the neighborhood are to be burnt up.

Georgia was finally readmitted to the Union in July 1870. Democrats regained legislative control by the end of 1870 and, less than a year later, the hapless Bullock resigned as governor and fled Georgia, leaving behind a cloud of controversy and a legacy of inefficiency. Bullock, a Radical Republican and a former Confederate military officer, was regarded by his political opponents as the consummate "scalawag." His gubernatorial administration, aided and abetted by many in the legislature, was charged with being the most corrupt and incompetent in the history of Georgia, before or since. There were many scandals, some involving the fraudulent sale of over $5 million in railroad bonds and the systematic financial looting of the state-owned Western & Atlantic Railroad. Nevertheless, Bullock returned to face trial on charges of corruption in 1877 and was acquitted of all charges by an all-white Democratic jury.

By early 1872, conservative white Democrats were again in control of both houses of the state legislature. By the late 1870s, the Georgia Democrats came to be dominated by a faction known as the "Bourbons," largely old-line Whig Democrats who espoused white supremacy and the preservation of Confederate ideals. Conversely, as the Reconstruction era evolved into the postbellum years of the last two decades of the nineteenth century, the Bourbon faction promoted a "New South," built upon less reliance on traditional agriculture and greater focus on adopting the strengths of the North: industry and commerce.[13]

John Brown Gordon (1832–1904) was a Confederate general, Georgia governor from 1886 to 1890, and a U.S. Senator. He fought from Manassas to Appomattox and, after the war, became one of Georgia's "Bourbon Triumvirate," which dominated state politics in the 1880s. Gordon, seen here in this rare postwar photograph, was the reputed head of the Ku Klux Klan in Georgia during Reconstruction. He served as commander of the United Confederate Veterans until his death.

9. THE NEW SOUTH

A s GEORGIA STRUGGLED TO OVERCOME the devastation of the Civil War, sectional reconciliation and reform were the rallying points for many progressive voices in the impoverished South in the 1880s. Their most vocal advocate was young Georgia journalist Henry Woodfin Grady. Born into a prosperous Athens business family and a graduate of the University of Georgia, Grady became the leading spokesman for the New South. He fervently embraced the concept that in order for Southerners to rebuild economically and join the mainstream of American life, they must cease dwelling on the frustrations of defeat in the Civil War and adopt a more progressive focus toward the future and the potential for renewed prosperity.

As Henry Grady preached his gospel of the New South creed, Georgians also celebrated and gave meaning to their past. The post–Civil War period witnessed a flurry of memorial services, monument dedications, and veterans' reunions as white Georgians remembered the sacrifice of the dead and honored the courage and service of the living. They sought to ennoble their fight for independence and transmit to their children the experience of the war. The overpowering influence of this cult of the Lost Cause ensured that succeeding generations of Georgians would grow up in the shadow of the war, and the way in which it was remembered would shape Georgia politics and society for generations to come. In looking back, white Georgians would increasingly argue that the conflict had been, not a failed attempt to preserve the institution of slavery, but rather a heroic struggle for states' rights and against the tyranny of the North.

One of the foremost proponents of both the New South creed and the cult of the Lost Cause was former Confederate general and Grady ally John B. Gordon. Having shed his soldier's uniform for a business suit, Gordon espoused a vision that called for a new economic future free of the shackles of slavery, but which also paid homage to the Confederate past. His unification of these themes made him nearly impossible to defeat politically, and he won election for multiple terms as governor and United States senator. It was only natural that, upon the formation of the United Confederate Veterans Association, he was selected as the new organization's first commander. By the time of his death in 1904, Gordon had become, for many Georgians and Southerners in general, the living embodiment of the Confederacy.

Map of Atlanta, 1877.

One of the most visible symbols of change in Georgia and much of the South following Reconstruction was the gradual replacement of the old prewar planters by a greatly expanded middle business and commercial class. This movement precipitated a pronounced shift in those holding the preponderance of the state's wealth. The planters had lost most of their capital as a result of the devastated agricultural economy created by the war, losses from which few were able to sufficiently recover. By the mid-1870s, crop production, as well as the value of farms and farm machinery, was dramatically depressed, particularly when compared to prewar standards. Meanwhile, in the cities and towns of Georgia, a growing industrial and business class came to the forefront in the 1870s.

This emerging commercial class was especially evident in Atlanta, a city that made a rapid recovery in a remarkably short amount of time following its destruction by Sherman's forces in late 1864. A group of entrepreneurial businessmen in Atlanta embarked upon a building boom almost before the war ended. Atlanta, as during the war, once again became the transportation hub of the South. Dominated by the resurrection of its railroad machine shops

Hannibal Kimball (1832–1895) was an Atlanta business entrepreneur in the 1870s.

and other facilities, Atlanta's city center rebuilt quickly on a wave of energy unparalleled elsewhere in the South. Robert Somers, a visitor to Georgia, reported in 1870:

> The town is gathering in thick and hot haste about the railways. . . . Passengers are put down in the mud to be screamed at by steam engines, barricaded on every side by trains of cars, bales of cotton, boxes of merchandise and building materials. Atlanta is expected to grow into a great city.

"The God of Atlanta is money," another observer noted. "Atlanta is a new place, modern, democratic, a fresh production, wholly practical, without antiquities or prejudices."

Symbolic of the city's rebirth was Hannibal Kimball, a transplanted Chicagoan who became Atlanta's leading businessman. The president of three railroads and a close ally of Governor Rufus Bullock, Kimball built the new state capitol and the Kimball House, Atlanta's finest hotel. By the mid-1870s, Atlanta had become

125

the economic, political, and industrial center of Georgia. Its population increased from 37,000 in 1880 to 90,000 in 1900.

Henry W. Grady had strong political allies in famed Confederate general John B. Gordon, former governor Joseph E. Brown, and business leader Alfred H. Colquitt. This Bourbon Triumvirate dominated Georgia politics from 1872 to 1890. These three men served in various capacities, from governor to senator. Colquitt served as Georgia governor from 1877 to 1882, Gordon from 1886 to 1890. "Business is the biggest thing in the country," editorialized Grady in the *Atlanta Constitution*. "When the princes of commerce and industry say to the politicians that they must let dangerous experiments alone they will be heard and obeyed. Politicians may talk, but businessmen will act, control and dominate the destinies of this common sense country."

The growing power of Atlanta as the political center of Georgia and the symbol of business and industrial growth in the New South drew the attention of the rest of the nation, but was not without its critics at home. Noted one outside observer, "Atlanta is now the political power of the state concentrated in the hands of a few men. . . . Is Atlanta the state? And are the people willing to submit to the concentration of power in Atlanta?" Demonstrating just how little things

Henry W. Grady (1850–1889) was editor of the Atlanta Constitution *and champion of the New South.*

International Cotton Exhibition in Atlanta, 1881.

sometimes change, the same sentiments were being expressed about Atlanta more than 100 years later.[1]

As its young, aggressive editor, Grady built the *Constitution* into the leading newspaper of the New South. He was one of the planners of the International Cotton Exposition, held in Atlanta in 1881, which demonstrated the economic potential of the South through improved technology for agriculture and industry. While Grady did not "invent" the New South, he certainly became its greatest and most vocal advocate. Grady gushed in a typical oration:

> I see a South, the home of fifty millions of people, blessed cities, hives of industry, her countryside the treasures from which her resources are drawn, her streams vocal with whirring spindles, her rulers honest, her wealth diffused—Almighty God shall not look down on a happier land!

His energy and enthusiasm for reconciliation between North and South won numerous followers. Grady's sudden death from pneumonia in December 1889, however, followed by a resurgence of Populism and regional sectionalism in the 1890s, blunted much of the momentum of the New South movement of the 1880s.

BOURBON DEMOCRATS AND THE POPULIST MOVEMENT

Heavily Democratic majorities controlled Georgia politics in the 1880s. The Republican Party in the state, burdened by a legacy of excesses during Reconstruction, failed to mount any challenge to the Bourbon Democrats,

Thomas E. Watson (1856–1922), the "Sage of Hickory Hill," Populist leader, editor, U.S. congressman, and senator. His inflammatory views of blacks, immigrants, and Catholics made him one of the most controversial Georgians of any era.

who maintained their posture of white supremacy in Georgia. Angry blacks felt alienated from the Republicans and left that party in large numbers during the 1880s. African Americans, as a rule, withdrew from the political process in an arena more and more dominated by Democrats, who supported the New South movement and white economic interests.

In the 1890s, a new coalition of old Republicans and the new national Populist Party made an effort to dislodge the Bourbon hold on state politics. The Populists sought economic redress and less government intrusion in the management of local affairs. They encouraged poor whites and blacks, primarily from within the large sharecropping agricultural class, to join its growing movement. Many members of the increasingly influential Farmer's Alliance movement, begun in the late 1880s, embraced the Populists. In the long run, the national Populist effort was overcome by the Bourbon Democrats, but not before its proponents had made some significant inroads, including the achievement of the direct election of United States senators. In Georgia, the Populist movement achieved effective

128

railroad legislation, tariff reform, abolishment of convict leasing programs, and needed educational reforms.

Georgia's agrarian Populist movement was led by a young Democratic congressman from Thomson, Thomas E. Watson. Watson's fervent advocacy of Populism was most clearly demonstrated in Congress when, in 1891, he strongly opposed a fellow Georgian, Charles F. Crisp, as House speaker. Watson sought the position himself as a representative of the Populist Party, thus turning his back on the Democrats whom he felt were obstructing real reform in Georgia and the nation. In the 1890s, Watson became a powerful and charismatic advocate for the poor rural farming class of both races. During his congressional term, he successfully introduced legislation to establish a new program for the rural free delivery of mail. Watson actively sought African-American support in his 1892 congressional race in the Tenth Congressional district of Georgia, an effort that brought animosity from many whites. He narrowly lost the next two elections, but gained so much national attention that he ran for Vice President, unsuccessfully, on the Populist ticket with William Jennings Bryan in the 1896 presidential election.

Thomas Watson was arguably the most influential and controversial political figure in Georgia politics in the first two decades of the twentieth century. He became an increasingly outspoken opponent of many of his former political allies, advocating disfranchisement of black voters and, after 1900, he conducted numerous anti-black and anti-Catholic campaigns in the state.[2]

Meanwhile, throughout much of the 1890s, the Farmer's Alliance made inroads in the Democratic Party. Supporters of the Alliance gained control of the state legislature and elected William J. Northen, president of the State Agricultural Society, as Georgia governor from 1890 to 1894. Georgia Democrats strongly courted African-American voters in the elections of 1892 and 1894 in an effort to counter the Populist movement. Numerous instances of election fraud, corruption, and "strong-arm" tactics used against black voters by the Democrats cast a poor reflection upon state politics in the 1890s. Nevertheless, most blacks supported the Democrats, despite the efforts of Watson and other Populist leaders. In 1894, the Populists still carried more than 44 percent of the state vote and made solid inroads in the state legislature. During the succeeding four years, however, Democrats managed to undermine most of the Populist gains and had swayed much of the farm vote. In 1896, Democrats advocated the free and unlimited coinage of silver, further eroding support for the national Populist movement. By 1898, the Populists had lost most of their support and many of their advocates rejoined the Democratic Party.

POSTBELLUM INDUSTRY AND AGRICULTURE

Expanding textile mills led Georgia's industrial revival in the 1870s. Though cotton agriculture was still the dominant economic force in Georgia, industrial expansion was quickly coming to the fore. Encouraged by adherents such as Grady and Colquitt, industrial development was pronounced far and wide as the economic salvation of the state in the 1880s.

Cotton mills, as an obvious industrial extension of the state's agricultural economy, were seen as the quickest route to success. Textile mills expanded, particularly in the Fall Line towns of Columbus, Macon, and Augusta, from 34 facilities in 1870 to 53 by 1890. In the latter year, the state's cotton mills, valued at $17.6 million, produced goods valued at $12.6 million, including both the cheaper types of cotton cloth and burlap and the higher quality bleached yarns. The two large cotton expositions held in Atlanta in 1881 and 1895 did much to encourage the growth of the textile industry in Georgia. By 1900, Georgia was third in the South and sixth nationally in the number of spindles in operation.

Industrial growth in the region went far beyond simply numbers. Southern textile production attracted northern capitalists, who invested money in the industry because of the wide availability of cheap labor. Ten- and 12-hour days and 60- to 70-hour weeks were common in the mills, as was child labor. In the 1880s, some state legislators pushed for laws eliminating these labor conditions, to no avail. Striking workers in Augusta's cotton mills created disruption to the point that, in 1890, a law was enacted prohibiting picketing by mill workers.

In addition to textiles, lumber and turpentine production in south Georgia made rapid inroads as important economic movements. The Altamaha River became a natural conveyor belt for yellow pine timber cut and floated in rafts to the waiting sawmills of Darien and St. Simons Island. Darien, for a time, became the leading pine timber exporter on the East Coast in the 1880s and 1890s.[3] By the 1890s, Savannah and Brunswick led the world in the shipment of naval stores—turpentine, rosin, shingles, and railroad ties.[4] Elsewhere in the state, the 1880s saw a marked growth in the development of cotton seed

African-American sharecropper and an oxcart. In many ways, sharecropping was only a step beyond slavery itself.

oil production in Georgia, as well as a significant increase in the number of fertilizer-producing (guano) factories. Coal and iron ore were mined in north Georgia in ever-increasing amounts. There were also growing numbers of other industrial enterprises, such as sawmills, flour and gristmills, turpentine distilleries, and tanneries.

Another promising industrial development arose from the mineral resources of north Georgia. This section of the state had almost unlimited potential in respect to mining. Dade County, by 1880, led the state in coal production with more than 150,000 tons mined that year. Dade, Polk, and Bartow Counties were the source of extensive iron ore mining in the 1880s and 1890s. Two other mining industries in Georgia, marble and granite, developed in the postbellum era, but not until well into the twentieth century did these activities approach anything near their real potential.

Georgia's industrialization during the period 1870 to 1890 was by far the most pronounced in the state's history to that point, but still paled in comparison to the ambitious progress in the North. Even in those industries in which the South clearly specialized, such as textiles, much of the manufactured cloth was still shipped north for the production of quality consumer goods.

Conversely, the industrial growth of Georgia in the 1880s was the precursor to the urbanization of the state's larger cities, specifically Atlanta, Macon, Augusta, Columbus, and Savannah, all of which grew tremendously in the last decades of the nineteenth century. These population changes had a far-reaching impact in Georgia upon social and labor conditions, race relations, and civil rights. The responses and results were usually far from encouraging, particularly in regard to racial issues.

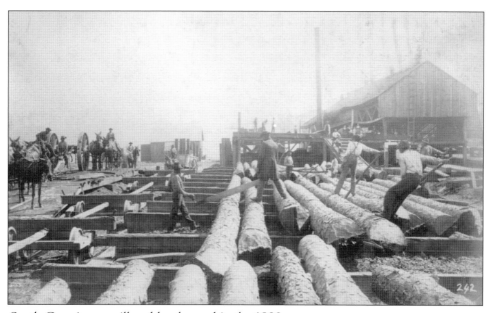

South Georgia sawmill and lumberyard in the 1890s.

131

Despite the growth of its cities and the movement toward industrialization, Georgia remained largely a rural state during the postbellum period. Even as late as the 1900 census, about 85 percent of Georgia's population still lived on farms or in small rural communities. As much as 60 percent of the state's workforce in 1900 continued to till the soil. The number of persons farming in Georgia actually increased significantly during the 30 years from 1870 to 1900, from 336,000 to just over 500,000. Much of this activity can be attributed to the rapid increase in sharecropping and tenant farming after the Civil War (see sidebar). Farms during the postbellum period were also far less self-sustaining than those prior to the Civil War. After 1870, the majority of family subsistence and feedstock were acquired either off the farm or, in some cases, outside the state.

Cotton remained Georgia's primary agricultural staple during these years. Indeed, cotton was the lifeblood of debt-ridden sharecroppers attempting to forge a living in Georgia's red-clay Piedmont and Fall Line regions. So much dependence was placed on cotton as the leading cash commodity that the crop was over-cultivated in many areas, leading to gradually worsening conditions of soil erosion by the turn of the century. The 1870 agricultural census reported an all-time record cotton crop for Georgia, 726,406 bales, testimony to the emphasis placed on revitalizing production of the commodity during Reconstruction. In 1874, Georgia became the first state to establish a department of agriculture. This agency provided information to farmers relating to soil analysis, geological conditions, and effective use of fertilizers.

The federal Homestead Act catalyzed, for the westward population, movement from 1870 to 1900. New cotton lands developed in Texas and other parts of the southwestern United States. This competition hurt production in Georgia and the South and cotton prices slid ever downward—from $1 per pound at the end of the Civil War, to 12¢ in the mid-1870s, to 9¢ in the 1890s. Small landholders incurred heavy debt that became increasingly difficult to repay. In 1892, a worldwide surplus of 13 million bales left much unsold cotton stacked on the docks at Savannah, which remained Georgia's leading cotton-exporting center in the 1880s and 1890s.[5]

POSTBELLUM DEVELOPMENT IN WIREGRASS GEORGIA

South Georgia counties east of the Flint River had a lesser dependence on the cotton economy in the years before the Civil War and thus recovered more quickly in the 1870s. People in these sparsely populated areas relied chiefly on raising large herds of livestock and harvesting yellow pine timber along the Ocmulgee and Altamaha Rivers. The area around Lumber City at the Altamaha River forks became a gathering point for timber rafts bound for the sawmills downstream at Darien. Meanwhile, large numbers of turpentine men migrated into south and southeast Georgia from the Carolinas. Sawmills and turpentine stills began to develop extensively in the region, particularly near the railroads.

Waycross, which became the seat of Ware County, developed around a sawmill and railroad depot after 1870. The town developed rapidly at the convergence of

SHARECROPPING AND FARM TENANCY IN POSTBELLUM GEORGIA

In the postbellum years, the abolition of slavery forced white Georgians to find new methods of labor if the traditional reliance upon agriculture was to survive. Innovation and experimentation after the Civil War resulted in contractual arrangements between landowners and labor, with the workers being provided a portion of the crop as financial compensation. This fusion of landowners (primarily whites) and labor (mostly by blacks) became known as sharecropping. Sharecroppers worked the cotton crop, provided all the labor, and depended on the landowner for all farm supplies. In return, they usually received half the profits from the crop. Tenants who rented both land and farmhouse from a landowner typically paid their rent with one-quarter to one-third of the cotton crop. The tenant system largely died out in the 1880s and most farmers became "straight sharecroppers," dependent on the owner for supplies in return for 50 percent of the crop.

Georgia's devastated agricultural economy slowly recovered in the postbellum era through sharecropping. Poor whites and blacks became the majority workforce on lands that constituted, in most cases, the sole source of capital for the old, prewar planter elite. Sharecropping—in many ways only a step advanced above slavery itself—nevertheless provided the farm laborers with a fair degree of independence. Writing about sharecropping in 1881, landowner David C. Barrow Jr., of Oglethorpe County, noted the following about tenants:

> plant whatever they please, and their landlord interferes only far enough to see that sufficient cotton is made to pay the rent, which is 750 pounds of lint cotton to each one-horse farm. The usual quantity of land planted is between 25 and 30 acres, about half of which is in cotton and the rest in corn and patches. An industrious man will raise three times the amount of his rent cotton.

Farm tenancy and sharecropping by blacks and poor whites resulted in thousands of small farms scattered throughout the state. The old plantations were broken up into family-sized units, while cotton remained the number one cash crop in Georgia throughout the 1880s and 1890s. As a consequence of the new labor order, the culture of sharecropping transcended racial lines and provided common bonds between blacks and whites engaged in this process.

Sharecropping and farm tenancy were the linchpins of control—often exploitation—by many white landowners over the poor blacks and whites, best exemplified by the crop-lien system of credit. Local white merchants extended credit for cottonseed, fertilizer, and equipment in return for first claim on the sharecropper's harvest. Food, clothing, and household goods for the tenant and his family were often extended on credit by the landlord, always against the next harvest. In the years after the Civil War, few banks existed in Georgia, especially in the more rural areas. Thus, town merchants often extended farm credit for landowners and tenants alike. Clearly, good crops benefitted all parties. But a poor harvest or significant fluctuations in the cotton market often occasioned heavy debt for the sharecropper, usually resulting in a mortgage on the following year's crop. Successive bad crop years resulted in double and triple mortgaging of crops, which usually resulted in intolerable financial consequences for the sharecropper.

The economic depression of the mid-1890s precipitated problems for all classes and was especially burdensome for sharecroppers. Cotton, however, continued to be the sharecroppers' primary cash staple. Cotton cultivation expanded in Georgia from about 3.5 million acres in 1895 to more than 5 million acres by 1915. Clearly, it would be a long, hard struggle before the state truly overcame the devastation of the war.

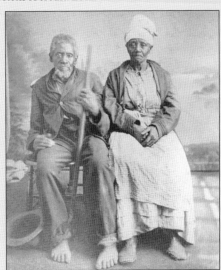

Black sharecropping family in postbellum Georgia.

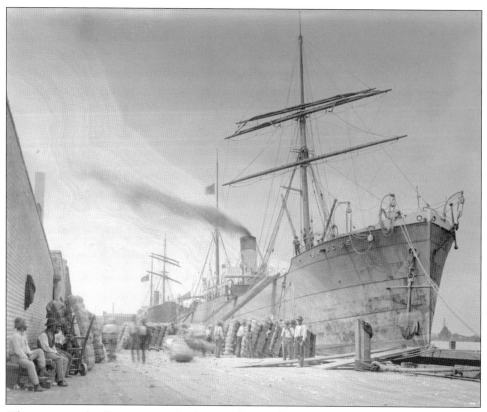

These men are loading cotton at the Savannah waterfront, c. 1900.

the Atlantic & Gulf and the Brunswick & Albany Railroads as a rail and naval stores processing center, sprouting up almost overnight amid a thinly settled section of the southeast Georgia Wiregrass. Its expanding commercial enterprises, centered around railroad yards, machine shops, foundries, planing mills, and barrel plants, spearheaded a growth that, by 1890, saw the town's population surpass that of the entire county just a decade earlier.

In the late 1860s, New York City businessmen William E. Dodge and William P. Eastman bought thousands of acres of pine timberland. They created the Georgia Land and Lumber Company, which became the dominant sawmill concern in the state for the next 15 years, leading to the development of such new towns and counties as Eastman (seat of Dodge County), McRae, Lumber City, and Jacksonville (Georgia) during the 1870s. The timber economy of this section of the Wiregrass reached its peak in the late 1890s, then gradually gave way to a revival in the production of cotton. The new town of Jesup, on the Atlantic & Gulf Railroad between Savannah and Waycross, became a timber and turpentine center after 1872.

Through the business acumen of Nelson Tift and others, Albany, at the head of navigation on the Flint River, gradually became southwest Georgia's leading

commercial center. Albany had been a cotton shipping point before the war and continued in that role during the Reconstruction period and beyond. The town also saw rapid commercial and industrial expansion during the period. In 1870, Tift obtained the rights to link Albany with Thomasville by rail. Another rail link was built between Thomasville and Bainbridge to the west through the extension of the Atlantic & Gulf from Savannah, giving south Georgia improved commercial connections to the Florida panhandle and Gulf coast. In between Bainbridge and Thomasville, the village of Cairo (in Thomas County, pronounced "kay-ro") grew and developed as a market town.

Railroads, sawmills, and turpentine production energized the economies and spurred development in a number of south Georgia towns, including Valdosta, Quitman, Thomasville, and Cairo. In southwest Georgia, Camilla and Pelham developed as business centers in the 1880s, both built around the railroads, cotton processing, and naval stores. In 1872, Henry H. Tift, nephew of Nelson Tift, acquired large tracts of timberland in upper Berrien County and developed a growing sawmill enterprise. By the mid-1880s, the sawmill and naval stores village of Tifton had become an important link on the Brunswick & Albany Railroad in the middle of south Georgia.[6]

Henry Harding Tift, founder of Tifton.

The boom period of railroad development in the 1880s provided the catalyst for town development in the south Georgia Wiregrass. The expanding rural population came to depend upon the new towns as market centers for their cotton crops, turpentine, and lumber, and as retail outlets for the acquisition of goods and services. Plus, they provided improved accessibility to churches and county schools. By the mid-1890s, however, commercial growth slowed. Declines in the cotton market and its attendant cash trade and credit structure in south Georgia hurt farmers and naval stores operators alike. A number of local banks and railroad companies went into bankruptcy and merchants saw a pronounced reduction in business. However, this decline reversed itself by 1898 and the sluggish economy of the mid-1890s recovered, gathering momentum as the new century began.

POSTBELLUM EDUCATION AND CULTURE IN GEORGIA

Georgia's dynamic population growth and economic development dramatically increased the need for improvements in public education. Prior to the Civil War, private schools largely provided the state's educational needs, usually local academies supported primarily from tuition. For children whose families could not afford private education, there were "poor school" funds set up in most counties. The Georgia legislature finally created a statewide public school system

Clark University in Atlanta, the "Colored College of the South."

African-American schoolchildren, Liberty County.

in October 1870. Governor Rufus B. Bullock was largely unsuccessful, however, in advancing public education during his tenure and large amounts of funds intended for schools were diverted elsewhere. In early 1872, new Democratic governor James M. Smith appointed Gustavus J. Orr as the state school commissioner. Under Orr's guidance, public education in Georgia made great advancements over the next 15 years, until his death in 1887. Orr became the true "father" of elementary education in Georgia, and his efforts drew national attention and commendation.

The new 1877 state constitution provided for public schools for the children of both races, legislation that created much controversy. White residents' fears were alleviated somewhat by the provision for the creation of separate institutions for black students, who were not allowed to attend white schools, but still received the educational basics in a system of four-month common schools in local communities. As a general rule, the Bourbon Democrats, who controlled the state legislature in the 1880s, largely supported Orr in his efforts to improve and expand public education. School attendance for both races increased from about 50,000 in 1870 to 210,000 in 1890. By 1900, free education was available at least six months a year to children in most parts of the state.

Higher education in Georgia benefitted after the Civil War from the passage of the federal Morrill Act in which states received proceeds from the sale of public lands for the establishment of agricultural and industrial education in colleges and universities. The University of Georgia in Athens (closed during the Civil War and reopened in 1866) particularly benefitted from this legislation through the establishment of its College of Agriculture and Mechanic Arts in 1872. Up to that

point, the curriculum of the state university had been almost exclusively devoted to liberal arts and classical studies. Meanwhile, in 1885, the Georgia School of Technology (Georgia Tech) in Atlanta received its charter to provide technical educational skills in response to the growing New South emphasis on industry.

Georgia's leading private colleges—Emory, Wesleyan, Oglethorpe, and Mercer—also had difficult times in the postwar years before regaining more solid financial and academic footing. A number of new colleges opened in north Georgia during the Reconstruction years, including Shorter at Rome in 1873, Brenau at Gainesville in 1878, Reinhardt at Waleska in 1883, and Young Harris in Towns County in 1886. State-sponsored colleges were also established during the period, led by the North Georgia Agricultural College in Dahlonega in 1871, Southwest Georgia College of Agriculture at Cuthbert in 1879, and Middle Georgia Military and Agricultural College in Milledgeville in 1880.

Educational opportunities for African Americans at the college level developed more slowly than those in public elementary education in the years following the Civil War. African Americans in Georgia finally received an opportunity for state-sponsored higher education in 1890 with the founding in Savannah of the Georgia State Industrial College for Colored Youths, later Savannah State College. Beginning in 1891, Savannah State received a large portion of public Morrill Act funds.

Private colleges for African Americans were established soon after emancipation. The American Missionary Association, an organization that did

An image of Georgia poet Sydney Lanier's "Marshes of Glynn."

much to improve educational opportunities for blacks during the turbulent times of Reconstruction, founded Atlanta University in 1867. In 1870, Clark College was founded in Atlanta. The private Augusta Institute began in 1867. It moved to Atlanta in 1879 and became Morehouse College. Another Augusta institution for blacks, Paine College, was founded in 1881 under church sponsorship. The African Methodist Episcopal Church undertook sponsorship of Morris Brown College in Atlanta in 1881. The same year, the Atlanta Baptist Female Seminary, later Spelman College, was established by Sophia B. Packard and Harriet E. Giles.

The years following the Civil War witnessed a resurgence in intellectualism in Georgia. Numerous memoirs of their Civil War experiences by Georgia's Confederate Army veterans found their way into print. Georgia's most prolific historian during this period was Charles Colcock Jones Jr. of Savannah and Liberty County. Jones wrote extensively of Georgia's history from colonial times through the Civil War and was also a leader in the Georgia Historical Society until his death in 1893.[7]

Sidney Lanier, Macon native and Confederate veteran, became one of America's greatest poets in the years during and just after Reconstruction. Lanier's immortal poems, "The Marshes of Glynn" and "The Song of the Chattahoochee," captured the diverse beauty of his native Georgia and demonstrated clearly through his words and verse the remarkable resilience of the human spirit. Another Georgia writer, Joel Chandler Harris, promoted the spirit of the New South in his editorials in the *Atlanta Constitution*. Harris also penned his popular Uncle Remus stories of the Old South during the postbellum period, featuring "Br'er Rabbit" and "Br'er Fox."

10. The Turn of the Twentieth Century and Beyond

As Georgia moved uneasily into the early years of the twentieth century, the problems of the nineteenth century—including the devastation of the Civil War—lingered on. Georgians continued to grapple with economic dislocation, political instability, and the ever-present problems of race. The new century brought loud cries for "reform," but for some Georgians, particularly African Americans, reform came at a very high price indeed.

In the political arena, the state continued to create counties until 1924, when Peach County brought the total to 161. Georgia reached its present total of 159 when two laws passed in 1929 and 1932 merged Campbell and Milton with Fulton County. Only Texas, with 254, has more counties than Georgia. The most far-reaching consequence of the creation of so many rural counties in Georgia between 1870 and 1920 was the development of the county-unit system of government, which concentrated legislative power in the hands of Democrats. In 1908, the state adopted this system, which enabled the rural, less populated areas to maintain a dominant role for the next half-century in the election of the governor and state senators. Counties had a specified number of votes, with nominations determined by unit—rather than popular—votes. A particular county's unit votes would thus be awarded to the candidate with a popular plurality in that county. The system was established upon an inverse pyramid that awarded six unit votes to the eight most populous counties in Georgia, four each to the next thirty populous counties, with the remaining counties each receiving two unit votes. By this formula, the 121 smallest counties in Georgia could amass 242 unit votes to easily outdistance the 168 votes accumulated by the 38 most populous counties, which, by 1960, contained more than two-thirds of the state's population. At the turn of the century, a single unit vote could theoretically represent 938 people in a rural county, while in urban areas, a unit vote could represent almost 93,000 people. This remarkable imbalance in state politics remained in place until 1962 when the county-unit system was declared unconstitutional.

The county-unit system developed because, during the 1890s, farmers, businessmen, and politicians from Georgia's small towns and counties increasingly expressed concern over the ongoing efforts of New South supporters in the state's urban centers to attract northern capital. Northern finance more often than not served as the catalyst for the creation of banks, railroads, textile mills, and quarries in late nineteenth-century Georgia. Increasingly resentful farmers complained bitterly over what they perceived as the erosion of legislative equality and support.

As the Populist movement died out by 1898, reform-minded Democrats established a solid, lasting foothold in the Georgia political arena, supplanting the old Democratic coalition of Bourbons and ex-Confederates. Democrat Allen D. Candler, a former U.S. congressman, served as Georgia governor from 1898 to 1902. Candler was succeeded by two-term governor Joseph M. Terrell (1902–1907). Terrell's administration, coming amidst a period of general prosperity in Georgia, was characterized by a lack of strong leadership and direction, despite

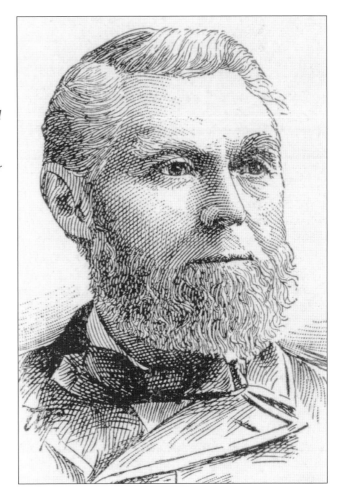

Allen D. Candler (1834–1910), the "one-eyed plowboy of Pigeon Roost," was governor of Georgia from 1898 to 1902. Candler lost an eye in the fighting around Jonesboro in 1864 and went on to a long and successful career, serving without defeat in the U.S. House and in Georgia as representative, senator, secretary of state, governor, and compiler of Georgia's records. He oversaw the publication of many of the volumes of The Colonial Records of Georgia, The Revolutionary Records of the State of Georgia, *and* The Confederate Records of the State of Georgia.

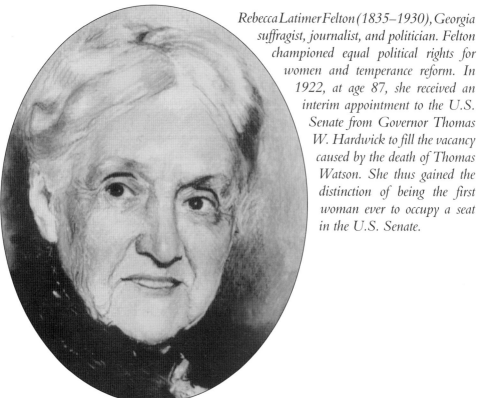

Rebecca Latimer Felton (1835–1930), Georgia suffragist, journalist, and politician. Felton championed equal political rights for women and temperance reform. In 1922, at age 87, she received an interim appointment to the U.S. Senate from Governor Thomas W. Hardwick to fill the vacancy caused by the death of Thomas Watson. She thus gained the distinction of being the first woman ever to occupy a seat in the U.S. Senate.

repeated calls for child labor reforms, more efficient railroad regulation, and improved public education.[1]

In 1906, Hoke Smith, running on a platform sympathetic to the concerns of rural Georgians, was elected governor. Smith's political surge on the shoulders of the rural electorate marked the beginning of a long period of dominance of Georgia politics by the state's small towns and counties. The reform movement gathered momentum after Smith's election and continued during the first two decades of the twentieth century, a period historians have labeled the Progressive Era.

Reform efforts in Georgia involved many people on numerous fronts. Smith made significant efforts in railroad reform, Rebecca Latimer Felton and Frances Whiteside lobbied for women's suffrage, and Bishop Warren A. Candler championed educational reform. Much of the Progressive Era's reforms originated in Georgia's larger cities, in contrast to the Populist movements of the 1890s that had embraced the state's farmers and poor people. Progressive movements were, in many cases, promulgated by middle- and upper-class whites. Blacks and poorer whites who lived in the cities rarely benefitted from Progressive programs. These groups comprised the vast majority of the urban labor forces in the textile mills of Augusta, Columbus, and Macon, and the factories and railroad yards of Atlanta and Savannah.

Hoke Smith, representative of the Democrats' growing reform movement, was challenged in the 1906 gubernatorial election by New South standard-bearer Clark Howell, editor of the *Atlanta Constitution*. Smith, in addition to his advocacy of railroad reform, ran on a platform that endorsed the disfranchisement of black voters and thus garnered the support of two powerful politicians with similar political sentiments, Thomas E. Watson and Thomas Hardwick. Smith won the election easily and led an administration that, during his term, saw the prohibition of alcohol become a leading cause in the reform movement. Another important reform concerned the convict lease system, by which the state could utilize convicts on public road projects, though politically connected individuals and entities could no longer engage convicts for private purposes.

Succeeding governors—Joseph M. Brown, son of the former governor (1909–1911, 1912–1913), John M. Slaton (1911–1912, 1913–1915), Nathaniel E. Harris (1915–1917), and Hugh M. Dorsey (1917–1921)—demonstrated less commitment to reform. Child labor continued to be one of the worst abuses, particularly in Georgia's cotton mills. The mills employed children—some less than ten years of age—for up to twelve hours a day for pay that amounted to pennies an hour. In 1920, Georgia led the nation in numbers of employed

Hoke Smith (1855–1931), Progressive governor of Georgia, 1907–1909 and 1911. He also served as Secretary of the Interior under Grover Cleveland and in the U.S. Senate.

children under 15 years of age, due primarily to a loosely enforced 1914 state child labor law.

Women's suffrage gained momentum slowly. Georgia's legislative indifference to the cause of advancing women's rights became even more notable when the state became the first in the Union to reject the 19th Amendment to the U.S. Constitution, which gave women the right to vote. The amendment nevertheless achieved national ratification and women began voting in Georgia in the 1920 election.

Other reforms were significant. In 1916, the state general assembly approved legislation requiring school attendance for children between the ages of 8 and 14 for a minimum of 12 weeks a year. In response to increased automobile use, Georgia created its first state highway commission in 1916 to build and maintain roads. By 1920, the state had embarked on a new program to develop a more efficient system of highways. Federal funds augmented state revenues, as a nationwide paved highway system began.

COTTON, INDUSTRY, AND THE "COMMON MAN" IN BLACK AND WHITE

At the turn of the twentieth century a substantial majority of Georgians—60 percent—continued to be employed in agriculture. Fully 85 percent of the state's population lived in rural areas on farms or in small towns. Over 500,000 people in Georgia worked on farms on 224,000 farm units in 1900, compared to about 336,000 persons 30 years before. Cotton remained the crop of choice for most farmers in Georgia and throughout the South, and sharecropping was the means by which much of the state's cotton was cultivated, harvested, and marketed. According to the 1880 agricultural census, sharecroppers operated about 36 percent of the farms in the Georgia cotton belt.

Declining cotton prices in the 1890s and the first two decades of the twentieth century have been attributed to a variety of factors. The U.S. Department of Agriculture in an 1899 report officially blamed the decline on overproduction. With their land rented out to tenants, landowners usually felt little inclination to personally supervise farm operations, which often resulted in inefficient agricultural practices. Consequently, many tenant farmers were unable to pay off the local merchants and bankers to which they were indebted. It was a hard and vicious cycle, especially for black tenants and sharecroppers, who were still attempting to develop a sense of self-sufficiency only one generation removed from emancipation.

The rising outcry of Georgia's farmers in the 1890s led to a backlash and the establishment of their own political lobby, the Farmer's Alliance. This development paralleled the national Panic of 1893, which precipitated a drop in cotton prices to less than 5¢ a pound. By the mid-1890s, many members of the farming class became affiliated with the national Populist movement, with Thomas Watson of Georgia as their leading spokesman. The state's Democratic machine, by 1900, had effectively countered this movement by turning white farmers against African

Cotton Street in LaGrange, c. 1900. LaGrange became almost solely reliant upon textile manufacturing in the late nineteenth and early twentieth centuries.

Americans, chiefly by manipulation and "invented threats," such as the eventual black takeover of white farmland.

After the turn of the century, rural poverty and need were the rule rather than the exception. The first decade of the 1900s brought a brief burst of optimism. In 1911, the state's farmers produced 2,769,000 bales of cotton, an all-time high. Prices for cotton and other farm staples edged even higher during World War I. Then came the advent of the boll weevil and the rush to abandon many of the state's cotton lands after 1920.

The 1920 agricultural census documented about 55 percent of farms still being managed by tenants. Soil erosion and the impending threat of the boll weevil had seriously damaged the cotton-based agriculture of Georgia. The fact that the majority of farmers did not own their own land only aggravated already miserable conditions. Poorer land and even poorer profits from over-cultivation were the energizing forces in the growing exodus of poor blacks from Georgia and the rest of the South to pursue new livelihoods in the urban centers of the North.

Textile manufacturing laid the foundation of Georgia's industrial development in the first decades of the twentieth century, as it had since Reconstruction. A good deal of the financial resources for the development and growth of the Georgia textile industry came from outside the state. True to the ideals embodied in Henry Grady's vision of the New South, the flow of northern industrial capital into the South energized cotton manufacturing in Georgia's urban centers.

145

In the half-century from 1890 to 1940, textile manufacturing almost completely dominated Georgia industry. The Fall Line towns of Augusta, Columbus, and Macon had been textile centers since antebellum times. In the postbellum industrial boom and well past the turn of the century, these cities built entire economies around their cotton mills. Smaller towns, such as LaGrange, Thomaston, Forsyth, and Barnesville, also became almost solely reliant upon textile manufacturing. A new class of industrial worker emerged, mill workers, which included heavy percentages of women and children, all laboring for up to 70 hours a week for cheap wages earned amid often horrific working conditions.

The paradox of the cotton culture in Georgia in the early 1900s was two-fold. The staple was cultivated and harvested by blacks and poor whites in a tenancy system not far removed from the slavery of antebellum times, while the manufacture of cotton was expedited in the dust-laden and lint-filled mills of the lower Piedmont exclusively by the poor class of whites.

In Georgia's textile towns, mill villages comprised of thousands of workers from the local cotton mills sprang up with homes, schools, and churches all revolving around the central cotton manufacturing culture. These villages were usually comprised of small frame houses of similar pattern or design, often owned by the textile mill companies.

The conditions in the mill villages were frequently appalling. Georgia educator Clare de Graffenried, writing in 1891, noted the following:

Lindale was a typical Georgia mill town.

rows of loosely-built, weather-stained frame houses, all of the same ugly pattern and buttressed by clumsy chimneys, are set close to the highway. . . . The homes are but shells of human presence. . . . A straggling brick mill gives forth the sound of flying spindles and the measured jar of many looms. . . . The race that tends the spindles is altogether unique . . . "crackers" they are in dialect, feature, coloring, dress, manner, doings and characteristics, hundreds of thousands of non-slaveholding whites in antebellum days and their present descendants. . . . The housing is . . . often inadequate. [They] are forced to lodge in rotting, neglected habitations, even though they be rent-free. . . . They herd, dirty and disorderly, in filth and semi-idleness, in leaky hovels without furniture other than the barest necessities.

Many villages had company stores where workers acquired groceries and supplies for their families against future wages in the mill.[2]

Occasionally, mill workers attempted to organize themselves in pursuit of improved wages and working conditions. Although unionization of the textile industry was unsuccessful in Georgia, textile workers still managed to organize labor strikes in the early 1900s, some resulting in violence. Unions caught on slowly in the South, due in part to the economic stranglehold textile mill owners usually had over one-industry towns.[3]

Beyond the growth of textile mills, evidence of mounting northern financial influence in Georgia could be found in the seasonal migration of a number of the nation's industrial leaders to Georgia and other southern states during the so-called Gilded Age, 1890 to 1915. John D. Rockefeller, J.P. Morgan, William Vanderbilt, and Joseph Pulitzer, among others, formed an exclusive winter retreat at Jekyll Island near Brunswick in 1886. Thomas Carnegie of Pittsburgh bought much of Cumberland Island about the same time. Thomasville, in south Georgia, became a favorite winter resort for affluent Northerners. Later, in the 1920s, two leading Detroit automotive industrialists, Henry Ford (at Richmond Hill near Savannah) and Howard E. Coffin (at Sapelo Island in McIntosh County) established residences and business activities on the Georgia coast. Both made important contributions to social, educational, and vocational improvements to the region for poor blacks and whites.

RACE RELATIONS AND JIM CROW, 1890–1920

After the Civil War, many newly freed African Americans capitalized on improved educational opportunities, and black illiteracy rates in Georgia dropped substantially, from 92 percent to 52 percent between 1870 and 1900. Blacks also became landowners of some consequence in the state. In 1906, Georgia documented black ownership of 1.4 million acres of land. Certainly then, African Americans made significant progress in education and property ownership in the space of one generation. Edward R. Carter, a black minister from Atlanta, wrote the following in 1894:

THE KU KLUX KLAN AND LYNCHING IN GEORGIA

The masked nightriders of the Ku Klux Klan began their forays of intimidation as a challenge to African-American freedom during Reconstruction. Blacks in many areas of the South were often murdered, beaten, flogged, tortured, and otherwise threatened if they proved uncooperative toward the attainment of white objectives. Racial violence by the Klan and others led to the reinstitution of military rule in Georgia and other southern states by the United States Congress.

Later, the Klan and, by extension, the lynching of blacks became the instruments of terror for whites during the racial turmoil of the unsettled period during the first three decades of the twentieth century. The Ku Klux Klan had its national reorganization in Atlanta in 1915, largely in response to Georgia governor John M. Slaton's commutation of the death penalty against accused murderer Leo Frank, a white Jew from Brooklyn, New York. He had been convicted in the rape and murder of a 14-year-old Marietta girl, Mary Phagan. Despite reasonable doubt and the questionable evidence associated with the case, public opinion against Frank was so inflamed that a guilty verdict and death by execution proved a foregone conclusion. When Governor Slaton commuted Frank's sentence to life imprisonment, an enraged mob took Frank out of jail and lynched him in Marietta in August 1915.148[5]

CONSTITUTION AND LAWS
of the
Knights of the Ku Klux Klan
(Incorporated)

Imperial Palace, Invisible Empire
Knights of the Ku Klux Klan
Atlanta, Ga.

Bylaws of the Knights of the Ku Klux Klan in 1921.

Several months later, the hooded order of the Klan was reorganized to serve as an outlet for white frustrations and hate against Jews, Catholics, Blacks, the Progressive movement in general, and national cultural changes evolving as a result of heavy immigration to the United States from eastern Europe in the late nineteenth and early twentieth centuries. Membership in the organization was limited to native white Protestants. The Klan, though adopting a campaign of intimidation against blacks and other minorities, also embarked on a nationwide effort to make its virulent racism more appealing by cloaking it in an endorsement of traditional values and morals.

By the mid-1920s, the Klan had grown to a national membership of some 5 million. Its political influence across the nation during this period was considerable. Membership in the Klan crossed a wide spectrum of professions, including lawyers, judges, doctors, storekeepers, and civic officials. Even more significantly, the Klan had the tacit support of state elected officials (including some governors over the years) and members of the state supreme court. On the national level, the Klan succeeded in electing the governor of Indiana in the 1920s.

An even more sinister development in the South and in Georgia was the widespread occurrence of lynching from the 1890s to the 1930s. Lynching was concurrent with the collapse of cotton prices across the South, attended by white frustrations. These were, in turn, fueled by perceived threats upon land ownership and crop production by blacks. Lynching was more prevalent in Georgia than in any other state—there were almost 400 documented lynchings in Georgia between 1890 and 1920; 360 of these were against blacks. Lynching and persecution of African Americans in some Georgia counties reached such proportions by 1921 that Governor Hugh M. Dorsey ordered a study that resulted in a published report documenting at least 135 instances of lynching and other cruelties in the preceding two years.

Lynching occurred in all areas of Georgia. In 1899, there were 27 reported instances of lynching, the highest number of any year. Perhaps the worst single episode took place at Watkinsville, near Athens, in 1905. A mob of whites stormed the local jail and removed and lynched seven blacks and one white. Following a lynching in Statesboro in 1904, Chicago reporter Ray Stannard Baker effectively summarized the feelings of both races: "All the stored-up racial animosity came seething to the surface, all the personal grudges and spite. . . . The [lynching] widened the breach between the races, led to deeper suspicion and hatred, fertilized the soil for future outbreaks."

In 1918, the south Georgia counties of Lowndes and Brooks experienced a wave of racial violence in which mobs lynched 11 blacks and drove another 500 from the area. The decline of timbering led to the increasing dependence on cotton cultivation as south Georgia's chief economic mainstay from 1900 to 1920. An attendant rise in blacks involved in cotton culture during that time made the region more susceptible to racial violence and a higher incidence of lynching. Brooks County led south Georgia—and the state—with 22 lynchings. Every county in south Georgia had one or more lynchings from 1890 to 1930. In 1894, the *Savannah Tribune,* an African-American newspaper, described south Georgia as "the last gate to hell . . . a Hell Hole on Earth."[6]

> Notwithstanding the unfriendly relations existing between most of the whites and blacks . . . the Black Side of this beautiful, enterprising city of Atlanta has surmounted obstacles, leaped over impediments, gone ahead, purchased the soil, erected houses of business and reared dwellings.

Meanwhile, poor whites continued to struggle economically during this period, particularly in light of the decline in cotton prices at the turn of the century. By 1900, for the first time, white tenant farmers outnumbered blacks. During the period 1900 to 1920, more whites than blacks became farm tenants and sharecroppers, almost always with a consequent accumulation of debt and increased impoverishment.

Black advances in education and property acquisition, with a concurrent decline in the fortunes of many poorer whites, proved to be a major factor in the increased attention to segregation, which amounted in many instances to the near-subjugation of blacks. White perceptions about their loss of position in society, coupled with fears of black voter "corruption" in politics, created the growing impetus for segregation in the 1890s, with the subsequent Jim Crow legislative movement. Segregation and black disfranchisement thus ironically became part of the larger Progressive "reform" movement of the early twentieth century.

In 1891, the Georgia legislature passed the first of the so-called Jim Crow laws, requiring railroads to provide separate coaches for whites and blacks. Laws adopted in 1891, 1897, and 1908 segregated the races on chain gangs and in convict lease camps; other Jim Crow laws prohibited blacks from being buried in white cemeteries.

Some cities required blacks to sit in the rear of streetcars. In 1906, the city of Savannah went so far as to enact a law that entirely prohibited blacks from riding with whites on the city's streetcars. Blacks successfully mounted a yearlong boycott that resulted in the streetcar company losing more than $50,000 in revenues. By 1908, however, the boycott had lost its impetus and the segregation of streetcars in Savannah became firmly established. (The Jim Crow laws were frequently more applicable to Georgia's urbanized areas. Beyond the major cities of the state, local governments passed few Jim Crow laws.)

"Separate but equal" facilities, from churches, to schools, to public transportation and accommodations, became the prevailing doctrine across the United States during this time. Even the liberal attitudes exhibited toward blacks by many Northerners began to decline, and federal courts began more and more frequently to establish the legal precedents for segregation across the nation, eventually culminating in the "separate but equal" ruling affirmed by the United States Supreme Court in 1896 in *Plessy v. Ferguson*.

The Georgia General Assembly continued to pass Jim Crow legislation throughout the first half of the twentieth century. White supremacy and the denial of access for blacks to many white institutions had the support of both lawmakers

149

and local law enforcement officials. Black disfranchisement and exclusion from political office gained widespread support, and the Democratic Party came to embody the white power structure across the South. In essence, southern politics became strictly a one-party system after 1900. Blacks voters, who had traditionally been primarily Republicans, were eliminated from the process. The white primary effectively prevented blacks from voting in anything but general elections and these always featured all-white slates of candidates.

In the first two decades of the twentieth century, Thomas Watson and Thomas Hardwick were at the forefront of the movement toward black disfranchisement in Georgia. As a Populist in the 1890s, Watson had criticized Democrats for inflaming racial tensions in order to divert attention away from more important economic issues: "The fear of the Negro has hypnotized Democratic voters into abject submission . . . Negro Domination is their mainstay, their chief asset . . . their never-ending means of striking terror into the souls of whites." After the dissolution of the Populist movement, however, Watson came to embody the white backlash against blacks after 1900.

Inflamed racial tensions led to a number of violent confrontations in communities across Georgia. The worst incident was a race riot in Atlanta in September 1906 that continued for four days. Mob violence resulted in the

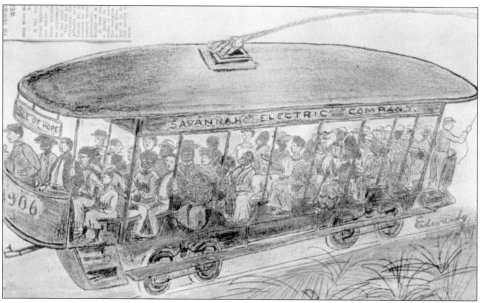

This postcard was sent to the Savannah Electric Company (which operated the cars) from "A Sufferer" demanding that "the law be enforced that will Inhibit Negroes from sitting in the laps and all over white people . . . who have to submit to this indignity the year round." In 1906, the city of Savannah prohibited blacks from riding with whites on the city's streetcars. Blacks successfully mounted a year-long boycott that resulted in the streetcar company losing more than $50,000 in revenue.

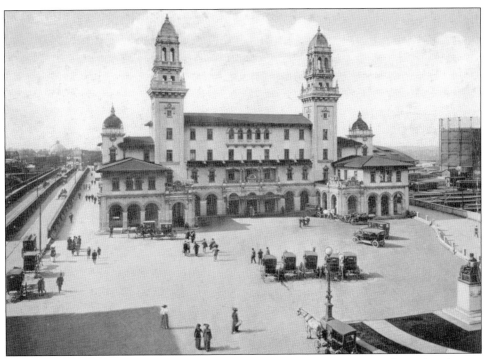

Terminal Station, Atlanta, c. 1920. "Separate but equal" facilities—from churches, to schools to public transportation and accommodations—became one of the ironic reforms of the Progressive era.

deaths of 25 blacks and 1 white, plus over 250 injuries to persons of both races. The trouble began over inflammatory Atlanta newspaper reports about the city's African-American community. The riot occurred against the backdrop of the heated 1906 gubernatorial campaign of Hoke Smith who, with the encouragement of Tom Watson, ran on a promise to work toward black disfranchisement if elected.[4] Coupled with several other notable racial disturbances during this period, such as the Varn Mill Riot in Ware County in 1891 and the Darien Insurrection in McIntosh County in 1899, in addition to a renewal of activities of the Ku Klux Klan (see sidebar) and the wave of black lynchings across the South, it is no surprise that racial tensions, always tense, ran extremely high during these year. The period from 1890 to 1930 was the most violent in Georgia's history in terms of race relations.

Hoke Smith proved true to his word following his victory in the governor's race. A 1908 amendment to the state constitution required a voter in Georgia to be a Confederate veteran, or descended from one; able to read or write any part of the United States or Georgia Constitutions; and the owner of at least 40 acres of land worth a minimum of $500, with all poll taxes paid from the preceding 30 years. These stringencies effectively eliminated the great majority of blacks as qualified voters. The radical legislation required a public referendum before it could become law, but with

151

black turnout limited by fraud, white intimidation, and the white primary system, the amendment's passage was never in doubt. An interesting footnote to this sordid chapter in Georgia legislative history is the fact that some 40,000 Georgia voters, including many whites, cast their ballots against the amendment.

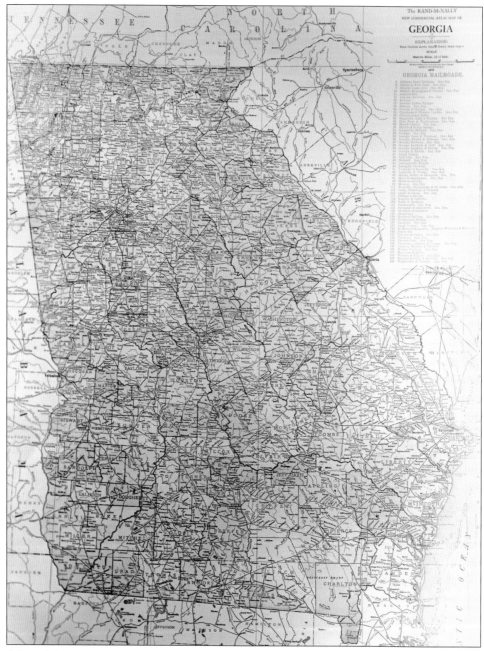

Map of Georgia in 1912.

11. THE 1920S, 1930S, AND THE GREAT DEPRESSION

T HE YEARS FOLLOWING WORLD WAR I were a watershed in Georgia history. Like the rest of the South, Georgia found itself—to paraphrase historian George Tindall—in two worlds, one dying and one struggling to be born. Even as they created their own unique institutions that looked backward to another era—segregation, disfranchisement, sharecropping, and the cult of the Lost Cause—Georgians were thrust into a period of change and instability that would undo everything that seemed familiar. Increasingly, they would not be able to resist the forces of conformity that would break down their peculiar institutions and bring them inexorably into the national mainstream.

EDUCATIONAL ADVANCES

In the first two decades of the twentieth century, Georgia made significant advances in public and higher education. By 1911, the state board of education had been awarded increased responsibilities over Georgia's schools, including required certification for public school teachers. County governments in Georgia, following a statewide mandate, had begun levying taxes on residents for the support of local public education by 1919. Educational improvements continued into the Depression era; the state legislature mandated a minimum of a seven-month school term and made provision for free textbooks for students in public schools beginning in 1937.

Educational reforms proceeded along different paths for whites and blacks. The separation of the races continued in public education and, almost without exception, black schools were inferior to white ones. With state and local school boards controlled exclusively by whites, funding appropriations for black education were held to a minimum, particularly in the first four decades of the twentieth century. The same standard applied to teachers—black educators were usually less well trained than their white counterparts.

At the college level, the University of Georgia realized numerous improvements under President David C. Barrow's leadership from 1906 to 1925. The university's curriculum made strong inroads in its schools of

agriculture, education, and journalism, as well as in its graduate programs. The increased emphasis on higher education in the liberal arts made the University of Georgia attractive to a broader range of students. Women were admitted full-time starting in 1919.

The Georgia Institute of Technology had been opened to students in 1888 in Atlanta. Georgia Tech quickly became the preferred destination of higher learning for students pursuing studies in science and engineering. The rapid progress made in the 1920s and 1930s in the expansion of its educational curricula, particularly in engineering studies, placed the Atlanta university among the forefront of technical institutions in the United States.

AGRICULTURAL DECLINE

Georgia's cotton kingdom, having already been in a slow decline for the previous 20 years, came apart at the seams in the first half of the 1920s. The boll weevil administered the cruelest blow. It arrived in south Georgia in 1915, having migrated eastward from Mexico by way of Texas, and had begun to devastate cotton crops throughout Georgia by the early 1920s. In the heart of the state's cotton belt—Greene, Hancock, Washington, and Jefferson Counties—tenant families abandoned their farms and left the region in ever-increasing numbers. In the half decade from 1920 to 1925, about 3.5 million acres of cotton land were abandoned in Georgia due to the boll weevil. The number of farm units declined during this same period from 310,000 to 249,000. The 1920 federal agricultural census reported a Georgia cotton crop of 1.7 million bales the year before. In 1923, that figure dropped to 588,000. Many Southerners also proved reluctant to adopt mechanization and other new technology in cotton agriculture. The only mitigating factor during these difficult years was that cotton prices remained fairly high because of the prosperity generated by the national mobilization for World War I.[1]

THE GREAT DEPRESSION AND URBAN GROWTH

The Great Depression and the boll weevil created even greater hardships. A great number of Georgians, white and black, lived under physical conditions little better than those of antebellum slaves. Most tenant farmers lived in unpainted three- or four-room frame houses little better than shacks. Sanitary facilities were almost nonexistent, and most homes retrieved water from outdoor wells. Many families subsisted on home-produced foods. Less than 3 percent of Georgia farms had electric lights in 1930 and only 3.1 percent had indoor plumbing. Ground meal and molasses, with occasional meat produced on the farm, was the staple diet for many Georgians, and already poor medical conditions were aggravated by malnutrition and other miseries.

The Great Depression began with the stock market crash of October 1929. Farm prices plummeted, especially cotton, which dropped to its lowest levels since the 1890s. By the early 1930s, more farms were abandoned due to the rising

unavailability of credit for the purchase of seeds, fertilizers, and other necessary supplies. Georgia and the other southern states lost not only farms, but also an even more valuable commodity—people. The exodus of southern blacks to the northern cities began in earnest during World War I, but it gathered new momentum during the Depression.

Poor social and economic conditions in the first three decades of the twentieth century were the catalyst for this migration. In 1890, blacks comprised 47 percent of Georgia's population; by 1930, this figure had dropped to 37 percent; and by 1960, to 29 percent. During the 1920s and 1930s, many struggling white Georgians, also attracted by industrial growth to more urban areas, abandoned their farms and moved to the state's cities.

Georgia's larger cities made up a mere 14 percent of the state's population in 1890. By 1940, that figure had grown to almost 35 percent. The most rapidly growing Georgia city was Atlanta. This dynamic New South city grew from a population of 65,500 in 1890 to 90,000 ten years later. By 1940, Atlanta's population had increased to over 300,000. Atlanta emerged as the railroad, marketing, and

African Americans at Lebanon plantation in Chatham County, 1938.

155

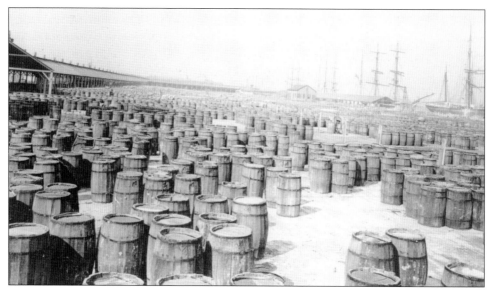

Savannah was the world's largest exporter of naval stores.

commercial hub of the South. It became the region's center for banking and insurance, and a leading producer of cotton textiles, cottonseed oil, fertilizer, farm equipment, and paper.

Other cities in the state also experienced significant growth in the 1920s and 1930s. Savannah, with a population exceeding 90,000 by the 1930s, continued in its role as one of the leading southeastern seaports and naval stores exporters. It also became prominent in the pulpwood industry and the production of paper products and sugar. In west Georgia, the population of Columbus increased to 54,000 by 1940 and the city on the Chattahoochee continued to be a regional industrial leader with its textile mills and iron foundries. Textile production also figured prominently in the growth of other towns such as Macon, Augusta, Gainesville, Dalton, LaGrange, Rome, Griffin, and West Point.[2]

The development of the automotive industry brought a consequent decline in the reliance on railroads for public transportation and shipping. In the 1920s, the peak era of Georgia's railroads, the state had 7,600 miles of track. But with the increased use of trucks and cars as means of transportation, railroad mileage in the state declined to 6,334 by 1940.

Since Reconstruction, the South had been heavily reliant on the North for industrial capital and materials, financial investment, and essential supplies and commodities, including many foodstuffs. While Georgia produced large amounts of raw materials, it depended on the North for the majority of its manufactured goods.

Georgia, from the 1880s to the 1920s, shipped huge amounts of cotton, lumber, and turpentine from the ports of Savannah, Brunswick, and Darien, principally to the northeastern United States and Europe. Meanwhile, the state's textile mills produced an endless supply of cheap cotton goods and other raw materials. In the

early twentieth century, the majority of finance, public utilities, railroads, banking, insurance, and iron and steel industries in Georgia and the South were controlled by northern investors and stockholders. Southern industrial workers earned a pittance compared to their counterparts in the North, while southern consumers paid high prices for northern manufactured goods. Conversely, southern industry could do little to compete with the more established manufacturing centers of the North. The Great Depression magnified all of these issues, and Georgia and the rest of the South suffered greatly as a consequence.

The economic salvation for many Georgians proved to be the New Deal programs of the Franklin D. Roosevelt administration, which began guiding the nation out of the Depression in 1933. The overproduction of crops had been identified years earlier as a significant contributor to the burdensome debt and attendant economic hardship of farmers. The Roosevelt administration hoped to counteract overproduction in 1933 in part by encouraging reduced cultivation by farmers in exchange for federal subsidies. This New Deal farm program was aimed chiefly at the consistent overproduction of cotton, but also included corn, wheat, peanuts, and tobacco. Soil erosion in Georgia over the previous three decades, due to the effects of tenancy and increased number of small farming operations, had also become a serious problem. The New Deal farm programs played a major role in reversing the problem of erosion through the widespread implementation of soil conservation and soil restoration efforts.[3]

The New Deal encouraged agricultural diversification as a means of easing Georgia farmers off their over-reliance on cotton as the primary, often only,

A typical Civilian Conservation Corps work camp in the 1930s.

West-central Georgia was one of America's leading peach producers.

staple crop. Despite the debilitating effects of the boll weevil at that time, cotton still accounted for about 65 percent of the agricultural output in the state in the mid-1920s. The New Deal's programs emphasized planting tobacco and peanuts and a gradual reduction in the cultivation of cotton. By the end of the 1930s, Georgia led the nation in peanut production and had become a major tobacco-producing state as well. Georgia's peach production also saw a revival following a severe drop during the Depression. In the first three decades of the twentieth century, Georgia led the nation in peach harvesting, but had fallen to fourth nationally by 1945.

Georgia also increased its livestock and poultry production. The number of dairy farms in the state rose to just over 2,000 by 1940. Hog production, a major factor in Georgia agriculture since the 1880s, took on increased importance during the 1930s. And by 1940, chicken production in Georgia had become one of the state's most lucrative economic ventures. North Georgia's growing broiler industry made that section one of the most rapid to recover during the Depression. By the early 1950s, the poultry industry, centered at Gainesville, had become the

national leader, a position it has held into the twenty-first century. Meanwhile, the development of the Farmers Market program around the state provided for the sale of agricultural goods at regional outlets.

The federal government also dispensed long-term loans at low interest rates to promote farm recovery and improved farm management efforts. The Federal Land Bank program provided improved agricultural credit assistance for farmers, an effort that gradually reduced the exorbitant mortgage rates on farms in the state.

New Deal programs in Georgia also included the development of several model farm communities. One of the most impressive of these was at Pine Mountain Valley in west-central Georgia between LaGrange and Manchester. It included cooperative agricultural programs, as well as recreational, park, and cultural facilities. The model communities program never achieved the success originally envisioned for them. The one at Pine Mountain benefitted, however, because of its immediate proximity to Warm Springs, where President Franklin D. Roosevelt frequently sojourned at his home, the Little White House, and small farm.[4]

In the early decades of the twentieth century, Georgia was the world's leading producer of naval stores, chiefly rosin, turpentine, railroad crossties, and other

Charles Holmes Herty (1867–1938) was a prominent Georgia chemist who was instrumental in establishing a paper industry in Georgia. He was also the first director of athletics at the University of Georgia and the father of intercollegiate athletics there.

commodities related to the burgeoning pine timber forests in the southern sections of the state. In the 1920s and 1930s, naval stores production was greatly enhanced by the research and development of native Georgian Dr. Charles H. Herty, a chemist whose techniques and scientific applications had far-reaching and lasting impacts on the pine byproducts industry. At the same time, the paper-pulp industry, as an important extension of the forestry industry, came to the forefront in the 1930s on the Georgia coast. Pulp mills established at Savannah (1934) and Brunswick (1936) were among the most productive facilities of their kind in the world and remained so for decades.

The Rural Electrification Administration (REA) of 1935 also brought great change to Georgia. Up to that time, over 90 percent of Georgia farms and rural homes did not have electrical service. The REA provided low-interest loans for the development of rural electrical cooperatives throughout the state. By 1950, this program had resulted in over 40 cooperatives in Georgia and had provided electricity to almost all of the state's farms and rural areas.

Planning for several ambitious projects to develop hydroelectric power in the upper Savannah River basin between Georgia and South Carolina also began during the New Deal. Clark Hill power dam and reservoir just above Augusta was authorized in 1944; construction began two years later. The Hartwell Dam and Reservoir, the second component in the Savannah River basin project, was authorized in 1950 and completed in 1961. The Richard B. Russell Dam and Lake Project near Elberton was not completed until 1983.

STATE POLITICS AND THE NEW DEAL (1922–1940)

Beginning in the mid-1920s, politics in Georgia began a new era, largely dominated by the personalities and political power of four figures: Walter F. George, Eugene Talmadge, Eurith D. Rivers, and Richard B. Russell. Up to that time, the state political scene had been controlled by the imposing presence of Thomas E. Watson and Thomas W. Hardwick, a combination that had advocated the disfranchisement of blacks in earlier years. In 1921, Hardwick began a two-year term as Georgia governor. The year before, Watson had won a U.S. Senate seat in the Democratic primary.

Watson's death in 1922 resulted in the historic appointment by Hardwick of Rebecca Latimer Felton to fill Watson's seat for one day. Felton thus became the first woman to serve in the Senate. Hardwick's bid in a 1922 special election against Walter F. George to fill the remainder of Watson's term in the Senate failed largely because of his vigorous denouncement of mob violence in the state and the consequent efforts of the Ku Klux Klan to keep him from winning office. Hardwick lost to Clifford M. Walker in the governor's race later the same year. Walker served two terms as governor (1923–1927), followed by Lamartine G. Hardman (1927–1930).

In 1930, another young star on the state political scene, Richard B. Russell Jr., won election as governor, defeating the politically powerful John N. Holder, chairman of the Georgia Highway Commission, and Eurith D. Rivers, a state

Richard Brevard Russell (1897–1971) was Georgia governor from 1931 to 1933, and U.S. senator for 38 years. Russell was Georgia's youngest popularly-elected governor and, in 1932, became the U.S. Senate's youngest member. He became one of the most respected and powerful members to serve in that body in the twentieth century.

legislator. Russell, the son of the chief justice of the Georgia Supreme Court, served five consecutive terms in the Georgia legislature beginning in 1920. The chief accomplishment during Russell's two years as governor was the reorganization and streamlining of the state bureaucracy and the incorporation of more efficient administrative procedures.

In 1932, Russell successfully ran for one of Georgia's two seats in the Senate, defeating Representative Charles R. Crisp, a veteran congressman and chairman of the House Ways and Means Committee. Walter George continued to hold Georgia's other Senate seat. Russell thus began a career that saw him rise to become one of America's most powerful and effective senators until his death in 1971.

The heir to Tom Watson's close bond with the white "common man" of the state was an energetic attorney from McRae, Eugene Talmadge, "the Wild Man from Sugar Creek." With his trademark red suspenders and flamboyant personality, Talmadge became the symbol of hope for many rural and small-town Georgians. He won four Georgia gubernatorial campaigns, actually serving for three terms from 1933 to 1937 and 1941 to 1943, the most since Civil War–era governor Joseph E. Brown. Talmadge capitalized on Georgia's rural-dominated

GEORGIANS AND THE
WORKS PROGRESS ADMINISTRATION

Katie Brown of Sapelo Island in 1939, photographed by Muriel Barrow Bell and Malcolm Bell Jr. for the Savannah unit of the Georgia Writers' Project.

In 1933, in the midst of the Depression and the first year of Franklin D. Roosevelt's presidency, the federal government launched a series of aggressive initiatives to alleviate the nation's fiscal difficulties. Two of these early programs, the Civilian Conservation Corps (CCC) and the Works Progress Administration (WPA), had important ramifications for Georgians, particularly in the latter half of the 1930s into the early 1940s.

The CCC began with a twofold mission: to provide useful work for unemployed young men and to conserve the nation's natural resources. In Georgia, CCC camps were set up at various locations throughout the state. Georgians in the CCC constructed and improved federal and state parks for public recreational purposes, planted hundreds of thousands of acres of new forests, and built dams to retard soil erosion.

In June 1933, the National Industrial Recovery Act was enacted, out of which emerged, in 1935, the WPA, a program administered by Harry Hopkins. Billions of WPA federal dollars were spent on programs of rural electrification, flood control, public waterworks and sewage treatment plants, school construction, slum clearance in urban areas, and a variety of educational and cultural initiatives. In Georgia, the WPA could claim a number of achievements.

One of the more interesting WPA programs employed artists, writers, and musicians in the state. They painted murals in public buildings and inventoried and catalogued newspaper and manuscript holdings in libraries and archives throughout Georgia, an effort that proved to be of enormous benefit to researchers.

The Federal Writers Project was another cultural initiative of the WPA and its impact on Georgia was far reaching. The Writers Project produced the American Guide Series, a nationwide effort to

compile comprehensive guidebooks for all 48 states. The Georgia volume, coordinated by Samuel Yoer Tupper Jr. of Atlanta, was published by the University of Georgia Press in 1940. *Georgia: A Guide to Its Towns and Countryside* took readers on a journey through the state's politics, culture, education, and history, along with a series of highway tours.

The first paragraph of the guide demonstrates just how greatly Georgia has changed in the 60-plus years since its publication:

> The average Georgian votes the Democratic ticket, attends the Baptist or Methodist church, goes home to midday dinner, [and] relies greatly on high cotton prices. . . . Georgia's young people, more widely traveled than their parents, have lost much of their sectional individuality. . . . They have learned to accept many conditions formerly rejected in their state. Their attitude toward the educated Negro, for instance, may be different from that of their elders who still prefer the old-fashioned unlettered kind. The college-bred Negro is likely to be lonely, except in Atlanta. . . . But however cool he may be toward the cause of Negro education, the Georgian is usually kind to his own servants and not a little apprehensive of hurting their feelings.

Two other important works, both definitive coastal studies, emerged as a result of the Writers Project program—*Drums and Shadows: Survival Studies Among the Georgia Coastal Negroes* and *Savannah River Plantations.*

Drums and Shadows, published in 1940, contained near-verbatim oral history interviews in Gullah-Geechee dialect with coastal Georgia African Americans, chiefly in Chatham and McIntosh Counties. The Savannah Unit of the Georgia Writers Project produced this compelling work, with text accompanied by a series of now-priceless black and white photographs taken by Muriel Barrow Bell and Malcolm Bell Jr. of Savannah. This volume, 60 years later, remains a definitive source on the nearly lost culture of Georgia's coastal African Americans.

Savannah River Plantations was an exhaustive study and documentation of the ownership and use of rice cultivation lands along the Savannah River. The Savannah Unit also compiled this volume, edited by local historian Mary Granger. The study first appeared as a series of articles beginning in 1938 in the *Georgia Historical Quarterly*, before its publication in book form by the Georgia Historical Society in 1947.

Several important Georgia historians also emerged during this era and made significant contributions to an understanding of the history of the state, including the University of Georgia's E. Merton Coulter. A prolific author, Coulter edited the *Georgia Historical Quarterly*, the scholarly journal of the Georgia Historical Society, for nearly 50 years.

Though not directly a result of WPA programs, a number of other significant books by Georgia authors appeared to national acclaim in the 1930s. The best known is *Gone With The Wind*, Margaret Mitchell's epic of Civil War and Reconstruction Atlanta, published in 1936 and awarded the Pulitzer Prize that year. Based on sales and reprints alone, this book has become one of the most popular in the history of American literature. Another Pulitzer Prize winner from Georgia was Caroline Miller for her *Lamb in His Bosom* in 1933. Other important works included Erskine Caldwell's *Tobacco Road* (1932) and *God's Little Acre* (1933), both of which elucidate the deplorable conditions endured by tenant farmers and textile mill workers in Georgia.

Eugene Talmadge (1884–1946) was Georgia governor from 1933 to 1937 and 1941 to 1943. Elected to four terms, Talmadge thrived on controversy. He stridently opposed the New Deal, but still became one of the most popular politicians in Georgia history. He boasted that "poor dirt farmers in Georgia ain't got but three friends on this earth: God Almighty, Sears Roebuck, and Gene Talmadge." (Courtesy of Hargrett Rare Book and Manuscript Library, University of Georgia Libraries.)

county-unit system. In the 1932 governor's race, he polled 118 more county-unit votes than his seven Democratic primary opponents, despite receiving 43,000 fewer popular votes. Ernest Vandiver Sr. of Franklin County promoted Talmadge in the *Lavonia Times* in 1933:

> We have a real dirt farmer for our Governor. Eugene Talmadge is the greatest Governor Georgia has ever had. Talking with the Governor the other day, he said to me: "Vandiver, I will make some mistakes, but I am doing the best I can." Boys, Gene Talmadge has a heart in him as big as a mule and he is 100 per cent for the wool hat and overall fellow.

Talmadge's suspicion of and antipathy toward Roosevelt's New Deal—due to an aversion to "big government" and social programs—prevented Georgia from reaping the full benefit of the various federal relief efforts of the 1930s. As a result, many Georgia farmers, especially the large number of those still working

tenant farms, continued to suffer economically. Talmadge's reluctance to embrace the New Deal created unnecessary and avoidable burdens for many Georgians, particularly those he claimed to want to help most. His reduction of taxes and utility rates benefitted transportation, industry, and corporate interests in the state far more than the poorer classes of Georgians. As the Depression deepened, thousands of Georgians remained unemployed and largely insolvent, a situation aggravated by Talmadge's relentless attacks on the Roosevelt administration's recovery policies. Only the imposition of federal relief programs between 1933 and 1941 prevented even more disastrous economic consequences for the state. Federal funds during this period, for example, enabled Georgia to embark on active programs of highway construction and improvement of public education.[5]

Talmadge, by state law, could not serve more than two consecutive terms as governor, thus he opted to oppose the incumbent Russell in the 1936 election for the United States Senate. Georgia's elections that year were among the most intense in the twentieth century, evolving as a basic conflict between those factions that either supported or opposed Roosevelt's New Deal programs. Eurith D. Rivers, a pro-New Dealer, won the first of two successive terms as governor (1937–1941), defeating Charles D. Redwine, the anti-New Dealer backed by Talmadge. In the Senate campaign, Russell ran against Talmadge on a platform supportive of the New Deal and lauded its benefits to the common people of Georgia all across the state. Russell won handily, retaining his Senate seat with 60 percent of the vote over Talmadge after one of the most bitter campaigns in years.

Beginning in early 1937, Georgia began a series of recovery programs, advocated by Governor Rivers, that embraced the New Deal to a much greater degree than the previous four years under Eugene Talmadge. Federal programs were adopted to create a state housing authority to improve urban conditions with the construction of public housing projects. Land conservation districts were created to promote soil improvement programs, and the reorganization of the State Highway Department resulted in a greater infusion of federal funds for highway and transportation improvements.

Talmadge ran for the Senate again in 1938, this time opposing incumbent Walter F. George. Another bitter campaign followed in which New Deal policies were again the major issue. George ran against Talmadge, but was hampered by a crucial disadvantage—he lacked even the tacit support of Roosevelt himself, who felt George had been less than enthusiastic in supporting his New Deal efforts. Nevertheless, George retained his seat, leaving Talmadge to ponder two consecutive losses in his quest for the Senate seat.[6]

Meanwhile, Rivers's second term as governor was considerably less auspicious than the first. In 1939 and 1940, his strong advocacy of New Deal policies worked against him. State debts rose to unacceptable levels and a number of welfare and educational programs were scaled back or eliminated altogether in an attempt to reduce state expenditures. Rivers was eventually forced to use state highway funds to keep Georgia's public schools open, causing a further erosion in his political and popular support.

By the 1940 election, many Georgians longed for the return of Eugene Talmadge. He again campaigned against the New Deal and this time easily won election for his third term as governor. But by that time, Georgians, like other Americans, could no longer isolate themselves from the events of the larger world. They soon found themselves engulfed in the conflict already consuming Europe and Asia. A year later, Georgians were at war.

WPA nutritional lunch program in Savannah in the 1930s.

12. Turbulent Times: Mid-Century

WORLD WAR II HAD A PROFOUND AND LASTING IMPACT on the state of Georgia. From the moment Japanese bombs fell at Pearl Harbor, Georgians responded to the call for arms. Men and women, black and white, all over the state contributed to the surging United States military-industrial juggernaut that was gearing for a war on two fronts. Some 320,000 men and women from Georgia served in the United States armed forces during World War II.

The war itself came home to Georgia very early; in April 1942 the German submarine *U-123* torpedoed and sank two American oil tankers in shallow water a few miles off St. Simons Island within sight of land. Brunswick and Glynn County residents rescued a large number of survivors. German submarines remained a constant threat along the east coast during the first two years of the war.

Part of the military buildup in the two years before America's entry into the war, as well as throughout the four years of the conflict, had a great impact on Georgia. The U.S. Army established some of the nation's largest training bases at Fort Gordon in Augusta, Fort Benning near Columbus, and Camp Stewart near Savannah. Fort Benning had actually been established during World War I, and the army's infantry and airborne training facilities there played a critical role in the United States' effort during World War II. Near Macon, the Robins Air Service Command was a major army air corps facility and employed 15,000 civilians. This base spawned Warner Robins, a new Georgia city south of Macon in Houston County. Other air training facilities were located at Hunter Field in Savannah and at Harris Neck in McIntosh County. The navy also had an important coastal air facility, the Glynco Naval Air Station, near Brunswick.[1]

Perhaps the greatest civilian contribution to the war effort in Georgia came from the massive shipbuilding efforts in Brunswick and Savannah, where Liberty ships were constructed by the dozens (see sidebar) to transport men and war materiel to the European and Pacific theaters.[2] Other civilian war efforts involved the Bell Aircraft works in Marietta, which employed over 20,000 Georgians to build the large B-29 bombers, and ordinance factories at Macon and Milledgeville.

Augusta Air Base construction activity, April 1941.

Construction of training facilities at Fort Benning, 1942.

RACE RELATIONS

World War II also crystallized the moral dilemma faced by Georgians and the rest of the nation concerning racial attitudes. Americans fought the war to preserve the ideals of freedom and liberty against the global ambitions of Germany and Japan, yet the subjugation of African Americans at home continued unabated. Blacks made significant contributions to the military effort in the war, but the armed services remained largely segregated.

By the mid-1940s, all of Atlanta's parks, museums, theaters, and other public venues were officially segregated. Teams of different races could not compete against each other in scholastic and collegiate athletic events. African Americans literally existed in a separate world; they were required to sit in the back of buses, to view movies in the balconies of white theaters, were forbidden to eat at white lunch counters, and had separate waiting rooms at medical practices, railroad depots, and other public gathering places. In the 1940s and 1950s, separate drinking fountains were provided, one marked "white" and the other "colored," with the dispenser for whites invariably always providing machine-cooled water. Those for blacks did not.

Georgia civil rights activist Lillian Smith painted a typical picture of the segregated South at mid-century:

> I can almost touch that little town, a little white town rimmed with Negroes. There it lies, broken in two by a strange idea, segregation. There are signs everywhere: White, colored, white, colored, over doors of railroad and bus stations, over doors of public toilets, over doors of theaters, over drinking fountains. There are signs without words: big white church, little unpainted colored church, big white school, little ramshackle colored school, big white house, little unpainted cabins; white graveyard with marble shafts, colored graveyards with mounds of dirt. There are the invisible lines: places you go, places you don't go; white town, colored town; white streets, colored streets; front door, back door; places you sit, places you cannot sit. Little Southern children learn their ritual.

Nowhere was the disfranchisement of African Americans more evident than in the realm of public education. Until 1961, no black person ever attended a white public school or college in Georgia. This unfortunate circumstance covered the full spectrum of education—quality of curriculum, teacher training, school facilities, and equipment. A black educator in Albany in 1936 wrote the following:

> the population [of Albany] is equally divided between white and colored. Seventeen hundred colored pupils were enrolled during the school year 1935–36, but this number could not be accommodated on account of inadequate buildings. The school buildings for colored children are three frame buildings, aged, in need of repair, one condemned by the building

inspector, another a temporary structure used for housing tools during the construction of a $250,000 white high school. The white buildings are four elementary and two high schools, all brick or stucco. Funds have been used in improving playgrounds for white children, constructing a large football stadium. Nothing has been done to relieve the inadequate facilities for colored schools. Progress in education will be impeded as long as such conditions exist.

African Americans had taken widely differing views in their approach to their place in Georgia society in the first half of the twentieth century. One response was toward acceptance and accommodation as espoused by Booker T. Washington of Alabama's Tuskegee Institute. Speaking at the Atlanta Cotton States Exposition in 1895, Washington urged blacks to refrain from political participation, and to work instead toward acquiring property rights and their own homes and businesses. Other African-American leaders espoused a more extreme separatism. During Reconstruction Bishop Henry McNeal Turner of the African Methodist Episcopal Church advocated black emigration to Africa, arguing that they would never be accepted as equals by whites in America.

A prominent black sociologist at Atlanta University, W.E.B. DuBois, believed that the key to black advancement in a white society was through the education of black leaders. Unsympathetic to Washington's accomodationism, DuBois instead advocated black political involvement and continued protest for equal political and social rights. With a large number of African-American fraternal and social organizations, Atlanta became the center of organized black resistance to Jim Crow in Georgia. As violence toward blacks increased in the first two decades of the twentieth century, they benefitted from the attempts of a sympathetic white governor, Hugh M. Dorsey, to effect some change. Dorsey's outspokenness against the injustices perpetuated upon blacks was rare in that era. His efforts during and after his governorship played an important role in gradually changing the attitudes of many whites toward violence against blacks in the state.

One important step toward reform in race relations occurred in 1919 with the biracial formation in Atlanta of the Commission on Interracial Cooperation (CIC). This effort spread throughout the South, although the Georgia chapter remained the strongest. The CIC evolved into the Southern Regional Council, established in 1944 to counter racial injustice and segregation.

With the close of World War II, change began to come—slowly at first, but with gradually increasing momentum. Liberal Georgia Governor Ellis Arnall pushed for and received from the legislature the end of the stringent voting requirements imposed during the Jim Crow era, including the onerous poll tax. In 1946, blacks were legally allowed to vote in white primary elections in Georgia, the first state in the South to remove this voting obstacle. With over 100,000 African Americans voting in 1946, black voter registration numbers began a steady rise: 23 percent in 1952, 29 percent by 1960, and 64 percent by 1970. Arnall, the most progressive

GEORGIA SHIPBUILDING IN WORLD WAR II:
THE LIBERTY SHIPS

The urgent need for cargo and troop transports to move men and materiel to the war fronts in Europe and the Pacific produced the largest naval expansion program in history. In September 1941, the United States Maritime Commission began a $350-million shipbuilding program. In three and a half years, the United States would construct the equivalent of more than half of the world's prewar merchant shipping.

The result of this massive shipbuilding effort produced 4,400-ton (net tonnage) "emergency ships," vessels which could be built rapidly and cheaply. When the first such ship, the U.S.S. *Patrick Henry*, was launched, President Roosevelt gave a speech in which he quoted Henry's famous oration of 1775 that ended with the phrase, "Give me liberty, or give me death." Roosevelt told America that the ships would bring liberty to Europe. From then on, these became known as "Liberty ships." In 1942, 727 ships of 55.5 million tons were built, numbers which increased to 140 ships and a million tons built *per month* by April 1943.

In Georgia, two of the nation's largest shipbuilding efforts for Liberty ships were in Savannah and Brunswick. In Savannah, Southeastern Shipbuilding Corporation began in early 1942 and won a contract for the construction of 36 Liberty ships. The site of this shipyard was on the Savannah River at the old Deptford plantation tract just east of the city. The first vessel launched was the U.S.S. *James Oglethorpe* in November 1942. A German submarine sunk this Liberty ship in 1943.

Overall, 88 Liberty ships were constructed at Savannah with more than 15,000 persons employed at the Southeastern yard. Many of these were women, which was common at shipyards around the nation during the war, leading to the famous term "Rosie the Riveter" for women engaged in the national buildup during World War II.

Brunswick's shipbuilding effort surpassed even Savannah's. The J.A. Jones Shipyard employed over 16,000 men and women (more than the prewar population of Brunswick) during the peak production years of 1943 and 1944. Brunswick's was a "six-way yard," with keels laid and ships built simultaneously on six slips on the Brunswick River. The company produced 441-foot, 4,400-ton Liberty ships at the rate of about one per month during peak effort. The Brunswick yard set a national record by delivering seven ships from six ways in just one month in December 1944.

"It was something that would never be duplicated," said Ralph Blackwell, a foreman on Way 3, which delivered one of the seven ships on December 4 and the seventh on December 30. "Our boys battling for their lives over there in

Launch of the Liberty ship James Oglethorpe *in Savannah in 1942.*

Europe won't have a merry Christmas," he told a gathering of workers one day. "Why don't we show them our appreciation by working on Christmas Day for nothing?" The Brunswick workers greeted this suggestion with great enthusiasm. All the yard bosses shed authority and took up tools that day and the yard cafeteria prepared free turkey dinners. Since the workers could not work without pay under federal law, the J.A. Jones Company gave them separate checks for their labors on Christmas. The yard workers then unanimously signed over their checks to the federal government to go toward the war effort. "The people who worked at the Brunswick yard were just the finest," Blackwell said. "They never failed once to give everything they had every hour of every day. They were proud of what they did and justifiably so."

Brunswick produced 99 Liberty ships in 1943 and 1944, ahead of Savannah's 88. In 1944, the peak year of construction, Brunswick built 53 vessels, ahead of Jacksonville and Panama City with 51 each, and Savannah's 44. Brunswick's first ship launched was the *James M. Wayne*, in March 1943. The last ship, the 99th, was the U.S.S. *Coastal Ranger* in August 1945. Outside of the men and women she gave to the armed services, these ships proved to be one of Georgia's most important contributions to World War II.[5]

southern governor of his generation, was the only leading Georgia politician to criticize publicly the political, educational, and social injustices perpetuated against blacks in the 1940s.

The United States Supreme Court, in the 1940s and early 1950s, made a series of important rulings that precipitated the legal breakdown of segregation across the nation. One case, in 1944, struck down the requirements by some states that public conveyances crossing state lines be segregated. In 1948, President Harry Truman proposed the creation of a civil rights commission, and legislation was enacted banning lynching, unfair employment practices, and poll taxes. In May 1954, the Supreme Court, in *Brown v. the Board of Education of Topeka, Kansas*, issued one of the most significant rulings in American judicial history when it proclaimed that separate schools for whites and blacks were unequal and affirmed that educational segregation as practiced in 17 states must end. A year later, another court ruling made segregation illegal in public parks and playgrounds.

Not surprisingly, desegregation arrived slowly in the South despite the Supreme Court's ruling. President Dwight D. Eisenhower sent federal troops to Little Rock, Arkansas in 1957 to enforce the integration of the white public high school. By late 1958, suits had been filed in Atlanta to end the segregation of public schools and transportation. Georgia Governor Marvin Griffin defiantly proclaimed after the Supreme Court's ruling of 1954, "Come hell or high water, races will not be mixed in Georgia schools!"

Segregated waiting room for blacks at Union Station in Savannah.

Ellis Arnall (1907–1992) was governor from 1943 to 1947. He oversaw an era of sweeping change and reform in Georgia. (Courtesy of the Georgia Department of Archives and History.)

THE 1940S AND 1950S: TURBULENT TIMES IN STATE POLITICS

During the period 1940 to 1970, three Georgians played prominent roles in the formulation of national policy in the United States Congress, particularly in foreign affairs and military appropriations. Senator Walter F. George chaired the Senate Foreign Relations Committee in the early 1940s and vigorously supported the Roosevelt administration's defense buildup before and during World War II. Georgians Richard B. Russell and Carl Vinson chaired the armed services committees in the United States Senate and House of Representatives, respectively.

Baldwin County's Carl Vinson served over 50 years in the House, a record for longevity of service. He chaired the House Naval Affairs Committee from 1931 to 1947 and the House Armed Services Committee twice (1949–1953, 1955–1965). Vinson, more than any other congressman, was responsible for the American naval buildup that ultimately won the Pacific war against Japan. He was also the architect of the U.S. Navy in the Cold War, always advocating a strong national defense as the most effective deterrent to foreign aggression against United States interests.

Carl Vinson (1883–1981) served in the U.S. House from 1914 to 1965 for a record 50 years. Vinson also chaired the House Naval Affairs Committee and its successor, the House Armed Services Committee, for 30 years. When reporters asked him in 1952 about serving as Eisenhower's Secretary of Defense, he replied, "No, I'd rather run the Pentagon from here." (Courtesy of the Carl Vinson Institute of Government, University of Georgia.)

Richard B. Russell played a similar role on behalf of national defense in the Senate. He also strongly opposed integration and, in the 1950s and 1960s, led the southern congressional delegation in its opposition to desegregation of schools and the civil rights movement.

On the state scene, Georgia's gubernatorial politics were at their most volatile in the mid-1940s, in large part because of the continuing influence of the county-unit electoral system in which the 121 smallest counties, with 242 unit votes, held political sway over the 38 largest counties and their 168 unit votes. The county-unit system, however, did not favor Eugene Talmadge in the 1942 governor's race—he lost his bid for reelection to state attorney general Ellis G. Arnall, supported by former governor Eurith D. Rivers.[3]

Arnall was the first Georgia governor elected for a four-year term after the ratification of a state constitutional amendment to that effect in 1941. Arnall's term as Georgia's chief executive from 1943 to 1947 was characterized by efficiency, honesty, and a proactive approach to state government that earned him a highly favorable national reputation. He worked to achieve significant administrative

reforms, the repeal of the poll tax, and improvements in Georgia's abominable prison system and penal code, all accomplished without the implementation of tax increases.

The 1946 governor's race was one of the most controversial in state history. Eugene Talmadge, ably supported by his son Herman Talmadge and former state house speaker Roy Harris, ran for a fourth term. The senior Talmadge, who conducted this campaign in declining health, employed a more analytical scrutiny of the breakdown of county-unit votes in 1946 than he had in his 1942 loss to Arnall. Talmadge, running on a campaign promise to solidify white supremacy in state politics, proved as feisty as ever. "Poor dirt farmers in Georgia ain't got but three friends on this earth: God Almighty, Sears Roebuck, and Gene Talmadge," he once boasted. Still touting the wisdom of limited government and low taxes, Talmadge won the Democratic primary in a close race against James V. Carmichael of Marietta. Carmichael actually had a slight edge in the popular vote, but Talmadge easily carried the county-unit tally, 242 votes to 146 for Carmichael and 22 for Rivers.

Talmadge's death in December before he could take office led to a bizarre and unprecedented constitutional and legislative battle for the governorship. Talmadge supporters urged the state legislature to immediately select a governor based on the two candidates with the largest number of write-in votes, one of whom, not surprisingly, happened to be the late governor-elect's son Herman.

Incumbent governor Arnall noted, however, that the constitution required him to remain in office until his successor "shall be chosen and qualified." He announced his intention to vacate his seat only to the incoming lieutenant governor, Melvin E. Thompson. Herman Talmadge actually had only the third highest number of write-in votes, but a subsequent recount in his home county, Telfair, conveniently provided him with an additional 56 votes to give him the write-in lead, and the state legislature promptly elected him governor. Arnall, always anti-Talmadge in his politics, defiantly refused to give up the governor's office; the Talmadge faction, undeterred, forcibly took possession of both the governor's office and mansion. Arnall countered by submitting the governorship to Thompson, who set up his own governor's office in downtown Atlanta. This political tug-of-war ended only when the state supreme court ruled two months later that Thompson was acting governor and set a date for a special election in 1948 to resolve the issue.

Herman Talmadge, echoing the rhetoric of his father, ran a campaign based on race, white supremacy, and states' rights in 1948, issues that led to the formation of the Dixiecrat Party on the national scene that same year. The conservative Talmadge won the Democratic primary over Thompson and secured the general election to finally assume the governorship he claimed had been his all along. Talmadge actually served almost seven years as governor (1948–1955), after winning a four-year term in the regular election of 1950. He became a popular governor and improved administrative efficiency in state government and made

significant advances in education. However, the *Brown v. the Board* Supreme Court decision of 1954 solidified the anti-desegregation forces in Talmadge's administration and Talmadge, in partial response, supported a private school constitutional amendment.

In the 1954 election, Marvin Griffin, a plain-spoken, popular newspaper editor from Bainbridge and the state's lieutenant governor, won the governor's race. Griffin was a prominent member of the state's Talmadge faction and had the support of the outgoing governor in the election. Despite winning only 36 percent of the primary popular vote, Griffin carried 115 counties with 302 county-unit votes to secure the office. Griffin's administration, from 1955 to 1959, was clouded by corruption in the state highway and state purchasing departments. Echoing the sentiments of his predecessor, Griffin strongly advocated the continued segregation of Georgia's schools. He also encouraged the continuation of the county-unit system, which was increasingly coming under fire from the more progressive elements in state politics. On the positive side, Griffin's term was marked by economic progress and the development of state docking facilities

Herman Talmadge (1913–2002), pictured here (holding hat) at Commercial High School in Savannah in April 1953, was Georgia governor from 1948 to 1955 and also served for 24 years in the U.S. Senate—the only Georgia politician to win six consecutive statewide campaigns.

at the ports of Brunswick on the Atlantic Ocean, Columbus on the Chattahoochee River, and Bainbridge on the Flint River.

In 1956, Herman Talmadge joined Richard B. Russell in the Senate. An aging Walter George opted for retirement rather than run in what likely would have been a losing campaign against the popular former governor. Talmadge easily defeated old political foe Melvin E. Thompson in the election. Talmadge's victory in the Senate race and his subsequent move to the national political scene proved to be the catalyst for the gradual demise of "Talmadge faction" politics in Georgia. Ultimately, the old county-unit system was finally declared unconstitutional in 1962.

In the 1958 governor's race, S. Ernest Vandiver easily won the Democratic primary. His wife Betty was the niece of Senator Russell, but Vandiver himself was a longtime member of the Talmadge political faction. Although Vandiver campaigned on a platform of resistance to segregation in 1958, his four-year term was marked by a clear mandate not to oppose school desegregation, the more radical path taken by Orville Faubus in Arkansas and George Wallace in Alabama. Despite vocal opposition from Georgia's segregationists, Vandiver kept the schools open and protected public education by complying with federal court mandates. Vandiver's integrity, vision, and wisdom in a difficult four-year term (1959–1963) ranks him as one of Georgia's most far-sighted modern governors.

THE POSTWAR ECONOMY

National mobilization in World War II produced an economic surge unparalleled in Georgia to that time. The burst of industry and manufacturing in the state carried over into a postwar economic boom that gave Georgia some of the most prosperous times in its history. It is significant that more Georgians were engaged in manufacturing jobs than in agriculture as the state entered the 1950s. Although agriculture continued to play an important role in the state's economy, the manufacturing and processing of textiles, lumber products, clothing, and foodstuffs began to place Georgia in the forefront of southern states in commerce, transportation, and business.

The rapid growth of metropolitan Atlanta exemplified this change. Three counties in metro Atlanta—Fulton, DeKalb, and Cobb—accounted for over one-fourth of the state's industrial and manufacturing output by 1960. Automotive assembly plants, including the Ford Motor Company, came to Atlanta, and Lockheed Aircraft Corporation of Cobb County became the state's largest employer in the 1950s.

By the early 1960s, Atlanta had emerged as one of the nation's premier cities, in large part due to the energy and business acumen of Ivan Allen Jr., who developed the hugely successful "Forward Atlanta" effort. This program, begun when Allen became Atlanta mayor in 1961, resulted in a downtown building boom that produced an ever-rising skyline, the development of business, transportation, and retail outlets on the city's perimeter and suburbs, and Atlanta's emerging status as the transportation center of the South. Its airport became one of the

nation's busiest and the new interstate highway system merged in the city's center from all points of the compass. By the 1960s, 440 of the *Fortune* magazine top 500 companies had offices in Atlanta and eight were headquartered there. Other Georgia cities also experienced economic growth in the 1950s and early 1960s, particularly Columbus, Augusta, Macon, Albany, and Savannah.[4]

In agriculture, the decline of cotton as the state's primary farm staple became more pronounced by the 1960s. Cotton cultivation occupied substantially less acreage in the 1960s and 1970s than it had in earlier decades. By 1970, the production of peanuts and associated by-products, and the continued growth and development of poultry and livestock production, came to dominate Georgia agricultural output. "King Cotton" was finally dead, and the remnants of the racial system that had so long supported it would soon follow.

Delta Air Lines aircraft, Savannah, c. 1945.

13. To the New Millennium: Civil Rights and the Emergence of Modern Georgia

The period from the mid-1950s to the early 1970s was one of far-reaching social change in Georgia and across the South. For many Georgians, this era of civil rights defined more sharply than ever the deep-seated racial divides that had long gripped the region. A climate of social unrest revolved around persistent civil agitation by blacks for social equality and an attendant resistance by many whites toward change. What finally emerged was the gradual elimination of Jim Crow and the "old order," particularly as it pertained to education and state politics.

Resistance and intolerance by elements of the white population brought renewed activity by the Ku Klux Klan. In 1956, in response to federal school mandates and other court decisions, several thousand Klan members participated in cross-burning ceremonies at Stone Mountain, where the modern version of the Klan had been established 40 years before. Another demonstration of white backlash and excess occurred about the same time at the Koinonia Farm in Sumter County. Here a small interracial Christian agricultural community founded in 1942 came under virtual siege from local whites, punctuated by several violent episodes.

The reactionary response by some southern whites was further fueled by the persistent efforts of the NAACP to implement social change. As the South resisted the mandates of the 1954 Supreme Court decision to desegregate public schools, the NAACP filed a series of lawsuits to force more rapid integration of schools, parks, golf courses, public transportation, and other facilities. The organization filed many of these suits in Atlanta.

In the spring of 1960, African-American college students in Atlanta conducted organized sit-in demonstrations at white lunch counters at several downtown sites, including the state capitol. Other sit-ins were organized in Savannah, Augusta, and Albany and included department store lunch counters, restaurants,

and bus stations. The sit-in efforts continued for several years and spread to other Georgia cities and some of the smaller towns, typically with the assistance of civil rights organizations, such as the Southern Christian Leadership Conference and the NAACP. Not surprisingly, many whites resisted these efforts to achieve desegregation. Some of the more moderate elements in several of Georgia's municipalities—including Mayors William B. Hartsfield and Ivan Allen Jr. of Atlanta, Mayor Millard Beckum of Augusta, and Mayor Malcolm MacLean of Savannah—sought to curb the more reactionary responses by whites and successfully maintained the order in their towns that was often missing in other parts of the South.

One of the more high-profile black demonstrations aimed at ending segregation occurred in 1962 in the south Georgia city of Albany. A series of confrontations between blacks and the town's white civic leaders and law enforcement marked the beginning of the end of white resistance and the start of concerted efforts toward accommodation between the races. While organized demonstrations and sit-ins achieved some results, two landmark pieces of federal legislation, the Civil Rights Act of 1964 and the Voting Rights Act of 1965, sounded the death knell for segregation in the South.

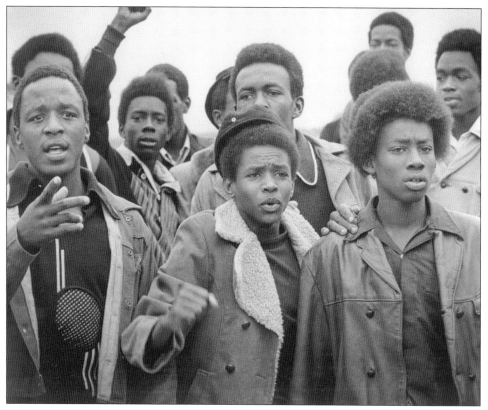

Civil rights protesters, early 1960s.

Atlanta led the way toward integrated schools in the early 1960s. Under Mayors Hartsfield and Allen, the Atlanta school board complied with federal mandates despite pressures from many in the state legislature to resist integration. In 1960, the general assembly gave some ground and appointed John A. Sibley, a prominent Atlanta businessman and civic leader, to chair a state committee to develop guidelines and more understanding on integration issues in Georgia. The Sibley Committee held numerous meetings during the course of a statewide canvass, and subsequently issued recommendations that Georgia allow local school boards to set their own policies and agenda for federal integration compliance.

The effort to achieve integration was a gradual one, beginning with the admission of two African-American students to the University of Georgia in 1961 and the incremental integration of four Atlanta city high schools in 1961 and 1962. In 1963, local high schools in Savannah, Athens, and Brunswick followed suit and began integration. Although the move toward compliance took almost a decade, by the early 1970s, public schools in Georgia achieved almost full integration.

School integration and the gradual end of segregation in public facilities and accommodations brought a growing "white-flight" movement in the 1960s and 1970s. Huge numbers of urban whites in cities in Georgia and across the South moved out of the city centers and into growing suburbs. Atlanta was typical during this period. As metro Atlanta's population passed 2, then 3, million in the late 1970s and 1980s, its central city population decreased (see sidebar). White migration to the suburbs created an unintended and unanticipated paradox in the march toward full school integration. Inner-city schools in Atlanta and other large southern cities came to have disproportionately high numbers of African-American students, while suburban schools were primarily white.

The response to this emerging trend was the federally mandated school busing effort of the early 1970s. Students of both races were bused out of their local neighborhoods to schools in other sections as a means of achieving racial balances in school attendance. Forced busing was the most controversial aspect of public education during the period in Georgia and across the United States. Mandated busing to attain balanced public school integration began to subside by 1980, largely due to the overwhelmingly negative response by parents of schoolchildren of both races.

CIVIL RIGHTS AND DR. MARTIN LUTHER KING JR.

The Southern Christian Leadership Conference (SCLC) was one of the most effective organizations promoting speedier implementation of social change and racial equality. The growing role of the SCLC was as an important benchmark in the civil rights movement in Georgia. Formed in 1957 under the leadership of Martin Luther King Jr., a dynamic, young black minister from Atlanta, the SCLC ultimately came to overshadow the NAACP in furthering the civil rights agenda of African Americans in the 1960s and 1970s.

Dynamic Atlanta:
A City for the New Millennium

For most of the latter half of the twentieth century, Atlanta has been known as the home of Coca-Cola, Delta Airlines, Peachtree Street, and CNN. But it is, and has been, much more. Atlanta is the unchallenged capital of the modern South and was an international city long before the summer Olympic Games were held there in 1996.

In the early twentieth century, Atlanta's cultural and commercial psyche was briefly threatened by its regional competition with neighboring Birmingham, Alabama, 150 miles to the west. In 1920, Birmingham had only slightly less population than Atlanta and had visions of becoming the South's leading urban center behind its thriving steel industry. Atlanta, however, was already the South's rail center and the site of a Federal Reserve Bank. When Atlanta's business community, led by Ivan Allen Sr. and Biltmore Hotel owner William Candler, initiated a nationwide "Forward Atlanta" campaign in 1926, the city's business prospects took off. By 1930, some 679 new businesses had located in the city with an annual payroll of $30 million. During the turbulent decades of the 1950s and 1960s, Atlanta took a more moderate stance on desegregation and other racial issues than did Birmingham. Georgia's capital has never looked back.

Ivan Allen Jr. led the second "Forward Atlanta" campaign from 1961 to 1964. By then, Atlanta had become the transportation hub of the South and its new Hartsfield Airport was the nation's fourth busiest. As Atlanta's business and financial status continued to expand—including the rapid growth of locally based Delta Airlines—Hartsfield had emerged as the world's busiest air center by the

Atlanta hosted the 1996 Summer Olympic Games. (Courtesy of the Atlanta History Center and the U.S. Olympic Committee.)

end of the century. Attendant to its growth as a transportation hub, the city carefully cultivated a glossy, high-profile public relations image to become one of the nation's leading corporate convention destinations, a factor that further served to enhance the posture of Atlanta as a national business and financial mecca. In 1966, another catalyst in the quest for "big city" arrived when Atlanta became a major-league sports town, complete with a new stadium and professional baseball and football teams.

Atlanta's economic development has been spurred by the energies and vision of several key individuals over a relatively short time: Hannibal Kimball after the Civil War; Henry Grady in the New South of the 1880s; Asa Candler of Coca-Cola in the early 1900s; Ivan Allen Sr. and Ivan Allen Jr. in the 1950s and 1960s; Ted Turner; and Bernie Marcus and Arthur Blank of Home Depot in the last quarter of the century. In more modern times, Atlanta's growth was amplified by the contributions of architect John C. Portman, who made an indelible mark on Atlanta's downtown development and an ever-rising skyline. A graduate of Georgia Tech, Portman infused Atlanta's city center with a new architectural dynamism from the 1960s to the 1990s. His contributions include the massive and hugely successful Hyatt-Regency Hotel and adjoining merchandise complex (1967) and the impressive 73-story, 1,100-room Peachtree Plaza, a steel and glass cylindrical structure that was the world's tallest hotel when it opened in 1976. Another important element to the vitality of Atlanta's downtown was the opening of the World Congress Center in 1976, established upon a unique partnership of public and private interests in support of the city's expansion as a convention and tourism center.

Ted Turner built a cable television empire and used it to project his Atlanta Braves baseball team to nationwide markets. In 1980, Turner embarked on a new concept of 24-hour televised news with his Cable News Network, a gamble that paid off enormously and established Atlanta as a national media outlet, barely trailing behind New York and Los Angeles.

The last four decades of the twentieth century saw steady expansion of Atlanta's metropolitan area. The 1970 census reported a population of 497,000 for the city of Atlanta, a 2 percent increase from the preceding decade, but the five-county metro area grew by 36.7 percent to 1.4 million residents. Atlanta's metro area expanded to 15 counties in 1973, then to 18 by 1983. The 1980 census reflected this trend toward outward growth. The metro population was over 2 million, while the city of Atlanta itself saw a decrease to 425,000, a drop of 14.5 percent from 1970. Suburban growth continued unabated through the end of the century; by 1990, metro Atlanta had nearly 3 million residents. Meanwhile, the central city's population continued to fall to 394,000.

Suburban communities, particularly sections of Gwinnett, Cobb, and Clayton Counties, became core commercial centers unto themselves, luring increasing amounts of convention business from downtown and midtown Atlanta. Some of the nation's largest shopping malls developed in these areas, including the Mall of Georgia and Gwinnett Place in Gwinnett, Cumberland Mall and Galleria Mall on the northside, Perimeter Mall in Dekalb County, and Southlake Mall in Clayton.

When Atlanta was awarded the 1996 Centennial Olympic Games over 13 other U.S. applicants, the city's standing as an international center became firmly and permanently established. The Atlanta Organizing Committee, led by the efforts of Atlanta attorney Billy Payne, a former star football player at the University of Georgia, and Mayor Andrew Young, engineered the remarkable achievement. The *Atlanta Journal* flashed the news to a startled world: "It's Atlanta."

The massive volunteer effort and the hospitality exhibited by Atlantans in all aspects of the event drew widespread—and worldwide—praise. Clearly, the Olympics represented the defining moment in Atlanta's modern history and established Georgia's capital as one of the world's true rising stars of the New Millennium.

A good argument could be made that King was the most influential Georgian in history. Certainly, few sons of Georgia have had a greater impact upon the national stage at such a historic crossroads of social change.

King was born in Atlanta in 1929, the son and grandson of Baptist ministers, and graduated from Atlanta's Morehouse College. He completed theological studies at seminary and earned his Ph.D. at Boston University, where he met his future wife, Coretta Scott. King was ordained a minister in 1947 at his father's Ebenezer Baptist Church in Atlanta. In 1953, he became pastor of a church in Montgomery, Alabama. It was there that King led a boycott of that city's municipal bus system after Rosa Parks refused to give up her seat to a white passenger on a bus in 1955. King became president of the SCLC in 1957 and expanded his role in the civil rights movement, while advocating a nonviolent approach to achieving rights for African Americans.

In 1959, King returned to Atlanta, where he became co-pastor of his father's church. He organized and coordinated numerous protest demonstrations, marches, and sit-ins in Atlanta, Birmingham and Selma, Alabama, and other cities across the South in the early to mid-1960s. On several occasions, whites physically assaulted and verbally abused King and his followers, and they were placed under almost constant surveillance by the FBI, largely due to the prejudices of director J. Edgar Hoover.

Few would argue that King's greatest moment as a prominent national civil rights leader occurred on August 23, 1963, when he led a great march on Washington, D.C., an event culminated by the delivery of his famous "I Have a Dream" speech at the Lincoln Memorial. King demonstrated the passion and strength of his oratory. The speech galvanized national and worldwide attention to the civil rights struggle and was an important factor in King's winning the Nobel Peace Prize in 1964. As King's political reach expanded, he turned more of his focus on the civil rights struggle in the large cities of the North. His attacks on discrimination there coincided with the rising United States involvement in Vietnam, an increasingly unpopular conflict. The result was a wave of racial and anti-war violence that exploded across several northern and West Coast cities in 1965. King criticized the increased commitment of the United States government to the war in southeast Asia and saw it as a drain on national resources and energy. Federal programs to alleviate inner city poverty, as well as to establish improved educational standards and voting rights for blacks, represented important attempts at reform that proceeded in tandem with the civil rights movement.

In April 1968, King was assassinated by James Earl Ray as he stood on the balcony of the Lorraine Motel in Memphis, Tennessee. King was in Memphis to lead sanitation workers in a protest against low wages and poor working conditions. His martyrdom for the civil rights cause unalterably cemented King's primacy in the movement during the 15 most critical years of the national struggle.

The 1960s and 1970s in Georgia were also notable as a time of emerging African-American leaders. In a formula recognized early on by King, they saw politics—as opposed to violence—as the most effective leverage to achieve equal rights.

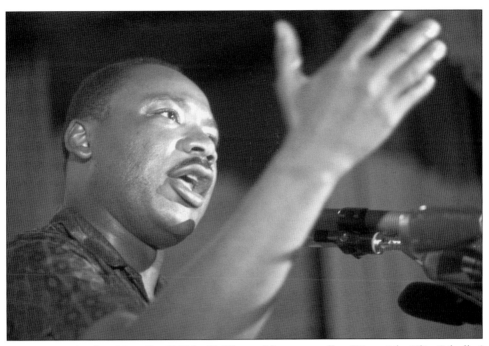

Dr. Martin Luther King Jr. (1929–1968) speaking at a rally. (Copyright Flip Schulke/ CORBIS. Courtesy of the King Center.)

In a historic election, Maynard Jackson, a young attorney, took office as Atlanta's first black mayor in early 1974. He succeeded Sam Massell, Atlanta's first Jewish mayor. Andrew J. Young, one of King's closest friends and advisors in the 1960s civil rights movement, became a congressman in 1972, representing Atlanta's fifth district, and became the first black Georgian in the House of Representatives in modern times. Young went on to serve as United States Ambassador to the United Nations in the Carter administration and won election as mayor of Atlanta in 1981. In 1984, Judge Robert Benham became the first African American to win a statewide election when he gained a seat on the state Court of Appeals.

GEORGIA POLITICS, 1962 TO 2000

A federal district court ruling in 1962 radically altered the landscape of Georgia politics when it declared the county-unit electoral system unconstitutional, followed by mandated state reapportionment of electoral districts based on population. This far-reaching decision, and its electoral consequences, was immediately felt in the state's 1962 gubernatorial election. With the county-unit system no longer a factor, Augusta state senator Carl E. Sanders directed his campaign toward the state's urban and suburban voters. The strategy paid off for Sanders, whose heavy majorities in metro Atlanta surpassed the rural edge built up by former governor Marvin Griffin.

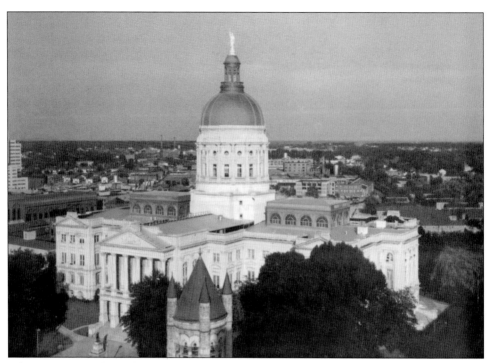

The State Capitol at Atlanta.

During his 1963 to 1967 term, Sanders proved to be Georgia's most liberal governor since Ellis Arnall, a factor that effected a smoother transition for Georgia in implementing the federal civil and voting rights legislation of the mid-1960s. Sanders was one of the state's most effective modern governors in a term highlighted by important achievements in public education.

With the end of the county-unit system and the implementation of school desegregation, the face of Georgia politics underwent another change, beginning with the national election of 1964. The Republican Party, for the first time since Reconstruction, began making inroads in state politics. In 1964, Republican candidate Barry Goldwater, running against incumbent Lyndon B. Johnson, became the first of his party to capture Georgia's electoral votes in a presidential election. Heretofore, Georgia had always been solidly Democratic in presidential politics. The tensions and emotions precipitated by civil rights and desegregation in the 1950s and 1960s made it easy for huge numbers of white voters in the conservative South to embrace the politics of the Republican Party. Meanwhile, African-American voters, whose numbers increased in succeeding elections, became overwhelmingly Democratic across the nation.

Republican inroads were so pronounced in 1964 that Howard H. "Bo" Callaway of the state's Third District (west Georgia) became the first candidate of that party in Georgia to be elected to Congress since Reconstruction. Callaway's election to federal office was the precursor of a complicated state gubernatorial campaign two

years later. Callaway ran as a Republican in the general election against Lester G. Maddox, who emerged as an upset winner over former governor Ellis Arnall in the Democratic primary. For the first time in memory, a Democratic sweep in the general election was not the foregone conclusion that it had been for generations. A true two-party contest also developed for the various congressional and state General Assembly seats.

Although both candidates ran ultra-conservative campaigns, the governor's race was a study in contrasts between the polished and articulate Callaway—wealthy heir to the Callaway textile fortune and educated at the United States Military Academy—and the plain-spoken Maddox, who came from a poor background. Maddox had established his reputation in the early 1960s as a staunch segregationist, threatening violence against African Americans who attempted to patronize his popular Atlanta restaurant.

The 1966 gubernatorial election had striking parallels to the controversy of 20 years earlier, when Herman Talmadge's forces took over the state capitol. Maddox dominated the voting in Georgia's small towns and rural areas, not surprising in light of his religious fundamentalism and his views on racial issues. Conversely, Callaway ran up sizeable electoral leads in the cities, particularly in the vote-rich precincts of Atlanta's affluent and conservative suburbs. Although Callaway held a slight lead overall, he was unable to achieve a majority over Maddox, due largely to a vigorous write-in campaign on behalf of Arnall, coordinated by the more moderate wing of the state's Democratic Party. Thus it was left to the General Assembly to choose the new governor. With a strong Democratic legislative majority, Maddox won the governorship. He served from 1967 to 1971, and had a largely successful and effective term.

Clearly, the controversies of the civil rights years had expanded the white conservative base of the Republican Party in Georgia. Nevertheless, Jimmy Carter of Americus, a liberal Democrat, emerged victorious in the 1970 governor's race over Atlanta television newscaster Hal Suit. James Earl Carter (b. 1924) was a graduate of the United States Naval Academy and served under Admiral Hyman Rickover on the naval nuclear reactor project. Carter later left the navy to manage his family's Sumter County peanut business and served two terms in the state legislature (1963–1967) before successfully running for governor. Carter's four-year term as governor (1971–1975) was characterized by administrative reform and centralization of state government services and procedures. He encouraged Georgia's continued evolvement from a state economy based on agriculture to one focused on energetic business and industrial development. His views on racial equality and school desegregation were diametrically opposed to those of his predecessor, Lester Maddox. Carter frequently articulated his belief that "the time for racial discrimination is over."

When his term as governor ended in January 1975, Carter, labeled early on as the "unheralded peanut farmer from Georgia," began his amazing campaign for the United States presidency. Carter defied the conventional odds against better-known candidates. Through a remarkable grass-roots effort, spearheaded by a

highly efficient campaign organization, the peanut farmer from Georgia scored an upset victory in the nation's first primary in New Hampshire, the springboard for his series of primary victories that culminated in the 1976 Democratic nomination. In the national election in November, Carter narrowly defeated Republican incumbent Gerald R. Ford by winning his native South and the key northern industrial states. He became the first Georgian to capture the presidency.

During his one term as president (1977–1981), Carter attempted to implement an open, more efficient, approach to federal government, in contrast to previous administrations. Among the notable accomplishments of his term were passage of the Panama Canal Treaty and the historic Camp David Peace Agreement (1979) between Israel and Egypt. Carter's administration was paved with good intentions, but a balky Democratic congress, a troublesome national economy, and the Iranian hostage crisis conspired to cost him reelection. He lost decisively to Ronald Reagan in the 1980 election and returned to private life in Georgia, where he became one of the most respected and active ex-presidents in United States history.

Houston County's Sam Nunn continued a long line of influential, efficient, and outstanding Georgians who have sat in the United States Senate. Nunn served in the Senate from 1972 until 1997, having been elected in November 1972 to fill the vacancy created by the death of Richard B. Russell. Nunn, during

President James Earl Carter (born 1924) of Georgia served as governor from 1971 to 1975 and became the first Georgian elected to the presidency. (Courtesy of the Jimmy Carter Library.)

Zell Miller (born 1932) was Georgia governor from 1991 to 1999. Miller served as lieutenant governor for 16 years before being elected governor in 1990. He was appointed by Governor Roy Barnes to fill the U.S. Senate seat vacated by the death of Paul Coverdell and won the seat outright in 2000. (Courtesy Zell Miller Papers, Richard B. Russell Library for Political Research and Studies, University of Georgia Libraries, Athens.)

his long tenure, became the nation's leading congressional authority on foreign policy and defense and, like Russell before him, chaired the influential Senate Armed Services Committee. Typical of the evolving face of Georgia politics, St. Simons Island Republican Mack Mattingly scored a significant electoral surprise in 1980 when he won a United States Senate seat by defeating 24-year Democratic incumbent Herman Talmadge. Mattingly served one six-year term, losing his bid for reelection in 1986 to Atlanta Democratic congressman Wyche Fowler. Meanwhile, other Georgians played key congressional roles as the twentieth century neared its end, perhaps most notably Cobb County Republican Newt Gingrich, who served four years as speaker of the House of Representatives, 1995 to 1999.

George Busbee, an effective administrator and longtime state legislator, won Georgia's 1974 gubernatorial race by defeating Lester Maddox in a spirited Democratic primary that summer. Busbee became Georgia's first governor to serve consecutive four-year terms (1975–1983). In 1982, Joe Frank Harris was elected

governor, also serving two terms (1983–1991), as did his successor Zell Miller (1991–1999), who won election in 1990. Miller served as lieutenant governor for 16 years prior to taking office as governor.

The centerpiece of Miller's two gubernatorial terms was the implementation of the state lottery-funded HOPE college scholarship program for Georgia students attending state colleges and universities. When Miller completed his second term in January 1999, he left office with a stunning 85 percent approval rating, which made him the most popular governor in the United States. In July 2000, Miller was appointed by new governor Roy E. Barnes to fill the unexpired senatorial term of Paul Coverdell, who died unexpectedly. Miller easily won election for a full term in the November 2000 election for United States Senate.

★ ★ ★

As Georgia stood on the brink of a new millennium, the state had overcome many of the challenges of its past. Rather than arising in the morning and putting their hands to a plow in a cotton field or marching into a textile mill, many Georgians dressed in business suits, drove into morning rush-hour traffic, and spent their days toiling in an office or retail shop. Thankfully, the days of Jim Crow and institutionalized segregation, of a sub-par educational system, of one-crop agriculture, and of one-party politics were gone. A major demographic shift brought thousands of residents from both northern states and other countries. The poverty of the Civil War, a legacy that cursed at least three generations of Georgians, had at last come to an end.

But no sooner had these challenges been met than new ones arose to take their place. Georgians now worry about a new array of sometimes bewildering issues, many of which are the product of the state's success and its new place in the larger world: suburban sprawl, pollution, crime, traffic congestion, and international terrorism. But although the particulars change, the challenges for Georgians in the next century and millennium remain the same as in years past: creating a prosperous, liveable state that somehow retains the best of the old while seizing the good of the new. Like their predecessors, twenty-first-century Georgians are called upon to find new meaning in Oglethorpe's original dream and, like he, create a community free of the ills of modern society. If the story of their past is any indication, they will succeed.

NOTES

CHAPTER 1

1. The best analysis of the Ayllon colony, based upon original Spanish documentation, comes from Paul E. Hoffman's *A New Andalucia and a Way to the Orient: The American Southeast During the Sixteenth Century*. Baton Rouge, LA: Louisiana State University Press, 1990. Hoffman makes a convincing argument that the "lost colony" of San Miguel was located in the Sapelo Sound region.
2. David Hurst Thomas. *St. Catherines, An Island in Time*. Atlanta: Georgia Endowment for the Humanities, 1988. p. 12–19.

CHAPTER 2

1. Georgia Trustees Papers, Collection 278, Georgia Historical Society, hereinafter cited as GHS.
2. William Bacon Stephens Papers, Collection 759, GHS, containing extracts from Allen D. Candler, et al., eds. *The Colonial Records of Georgia*. 32 volumes to date. (Atlanta and Athens, 1904–).
3. Charles Ellis Waring Map Collection, GHS, containing early colonial maps of Savannah and fortifications in the region as collected by Charles Waring (1900–1973) of Savannah; also Peter Gordon, "A View of Savannah," 1734, GHS.
4. James Edward Oglethorpe Papers, Collection 595, GHS. This collection contains many letters of Oglethorpe pertaining to the early years of the colony and was published by the Georgia Historical Society in 1873 as Volume 3 in its Collections series, p. 1–156.
5. Minis Family Colonial Papers, Collection 568, GHS.
6. Benjamin Martyn Papers, Collection 545, GHS. Martyn was secretary to the Georgia Trustees, 1732–1752. This collection contains a pamphlet, "An Impartial Enquiry into the State and Utility of the Province of Georgia," published by the GHS in 1840 in Volume 1, p. 153–201, of its Collections series.
7. Oglethorpe Papers. Georgia Trustees Papers, Collection 278, GHS.

8. Bessie Mary Lewis Papers, Collection 2138, GHS. This collection contains considerable documentation relating to the Darien Scottish Highlanders.

9. Manuel de Montiano Papers, Collection 572, GHS. This series of letters and observations, which pertain to the Spanish viewpoint of the Georgia colony and the English siege of St. Augustine, was published by the GHS in 1909 as Volume 7 in its Collections series.

10. Joseph Vallance Bevan Papers, Collection 71, GHS. Bevan (1798–1830), a Savannah lawyer, was appointed state historian of Georgian in 1824. A number of the documents in this extensive collection are contained in *The Colonial Records of Georgia*.

CHAPTER 3

1. Joseph Vallance Bevan Papers, Collection 71, GHS, including documents later included in Allen D. Candler, et al., eds. *The Colonial Records of Georgia*. 32 volumes to date. (Atlanta and Athens, 1904–).

2. Robert Bolton Papers, Collection 73, GHS. This collection documents many of the early land transactions of the colony.

3. Read-Mossman Ledger Book, Collection 1635, GHS.

4. James Habersham Papers, Collection 337, GHS. James Habersham (1715–1775) was a merchant, close friend of Governor James Wright and acting governor of the colony in 1771. This collection also contains Habersham's correspondence with George Whitefield, founder of the Bethesda Orphanage near Savannah.

5. Thomas Raspberry Letter Book, Collection 647, GHS. This collection contains business records for the period 1758–1761 and was published by the Georgia Historical Society in 1959 as volume 13 in its Collections series. Also useful for this period are documents contained in Tattnall-Jackson Papers, Collection 787, GHS.

6. Andrew McLean Ledger, Collection 1561, GHS, containing the journal and business records of Andrew McLean, merchant and Indian trader, for the period 1774 until his death in Augusta in 1784.

7. James Wright Papers, Collection 884, GHS. These papers were published by the Georgia Historical Society in 1873 as volume 3 in its Collections series, p. 157–378.

8. Telfair Family Papers, Collection 793, GHS. This extensive collection contains business and personal records of the prominent Telfair and Gibbons families of Savannah during the Colonial and Revolutionary eras. It also contains the correspondence of William B. Hodgson (1801–1871), who was instrumental in the early years of the development of the Georgia Historical Society (founded in 1839) and to whose memory the Society's Hodgson Hall library was dedicated in 1876.

9. Georgia Committee of Correspondence Letter Book, Collection 276, GHS.

CHAPTER 4

1. Jones Family Papers, Collection 440, GHS.
2. John Joachim Zubly Papers, Collection 892, GHS. Zubly (1724–1781) was a Swiss clergyman whose illuminating journal of local events during the Revolution was published by the GHS in 1989 as volume 21 in its Collections series.
3. Joseph Habersham Papers, Collection 339, GHS. Joseph Habersham (1751–1815) was the brother of James Habersham Jr. (1745–1799), both of whom were greatly involved in Georgia's Revolutionary movement in contrast to their loyalist father, James Habersham.
4. Georgia Council of Safety Papers, Collection 282, GHS. These papers were published by the GHS in 1901 as volume 5 in its Collections series.
5. James Wright Papers, Collection 884, GHS. Sir James Wright died in 1785. The papers in this collection include Wright's correspondence for the period 1772–1784 and were published by the GHS in 1873 as volume 3, p. 157–378, in its Collections series. See also Georgia Governor and Council Papers, Collection 277, containing proceedings and minutes of the council, 1774–1781.
6. Loyalists Papers, Collection 506, GHS. These papers relate to disposition of British lands confiscated by the state of Georgia from 1781–1783.
7. Lachlan McIntosh Papers, Collection 526, GHS. This collection contains letters and documents related to the activities of McIntosh (1727–1806) before and during the Revolution. Many of the letters were published by the GHS in 1957 as volume 12 in its Collections series.
8. Alexander Atkinson Lawrence Papers, Collection 2019, GHS. Lawrence wrote the definitive account of this campaign, *Storm Over Savannah*. Athens: University of Georgia Press, 1951. See also *Documents Relatifs a la Bataille de Savannah*, Collection 1284, containing official French officers' reports and accounts of the battle.
9. Joseph Clay Papers, Collection 152, GHS. Clay (1741–1804) was a prominent Savannah businessman, rice planter, and leader of the Revolutionary movement. Clay's letter books, which cover the period 1776–1793, were published by the GHS in 1913 as volume 8 in its Collections series.

CHAPTER 5

1. James Jackson Papers, Collection 422, GHS. Jackson (1757–1806) was a Revolutionary War soldier, state legislator, United States congressman and senator, and governor of Georgia. These records were published by the GHS in 1955 as volume 11 in its Collections series. For the Yazoo land frauds, see also the Robert Middleton Papers (Collection 987), Isaac Randolph Papers (Collection 646), Francis Tennille Papers (Collection 795), John Brinton Land Grants (Collection 91), Thomas Davis Papers (Collection 1203), and William Hull Papers (Collection 407).

2. Benjamin Hawkins Papers, Collection 373, GHS. Hawkins (1754–1818) was an Indian agent for the Creek and other tribes in the southeastern United States.
3. Joseph Vallance Bevan Papers, Collection 71, GHS. Documents in this collection concern land speculation, Indian land cessions, and the early years of Georgia statehood.
4. Antonio J. Waring Papers, Collection 1287, GHS. Waring (1915–1964) was a specialist in Native American archaeology and was an authority on Chief William McIntosh.
5. George Michael Troup Papers, Collection 806, GHS, contain Troup's correspondence while governor of Georgia.
6. Jacob R. Brooks Papers, Collection 93, GHS. This collection contains an inventory of the Cherokee language, a history of the Cherokee nation of Georgia, and documents relevant to the removal of the Cherokee from Georgia.
7. Shaver Collection, Collection 2162, GHS. This collection contains civic records and official documents of Bryan, Effingham, Screven, Telfair, and Chatham Counties for the antebellum period.
8. Wilkes County Papers, Collection 867, GHS, pertain to legal and civic activities in early Washington.
9. Bull Family Papers, Collection 102, GHS. This collection includes documentation related to Petersburg.
10. William Lovett Papers, Collection 503, GHS, relate to business and legal affairs in LaGrange and Troup County in the 1850s.
11. Bailey Family Papers, Collection 38, GHS, contain material relevant to antebellum Hancock County and Sparta.
12. Atkins Family Papers, Collection 30, GHS, relate to the early development of Albany in the 1830s.
13. Bull Family Papers, Collection 102, GHS, contain material relevant to antebellum Athens.
14. Joseph Bryan Cummings Papers, Collection 188, GHS, contain material relevant to antebellum Augusta.
15. Hall and Deblois Papers, Collection 357, GHS, relate to cotton trading and banking activities in Columbus in the 1840s. See also Seaborn Jones Family Papers, Collection 445, GHS. Seaborn Jones (1788–1864) was a United States congressman and one of the most prominent antebellum citizens of Columbus.

CHAPTER 6

1. Richard Leake Account Book, Collection 485, GHS. Also King-Wilder Papers, Collection 465, GHS. Richard Leake planted Sea Island cotton at Jekyll Island and at Belleville Plantation, McIntosh County. Thomas Butler King married Ann Page of St. Simons Island in 1823 and together they managed Retreat Plantation there, a leader in Sea Island cotton production.
2. Spalding Family Papers, Collection 750, GHS. Thomas Spalding (1774–1851)

of Sapelo Island, McIntosh County, was perhaps the most innovative planter of the coastal region. He documented extensively his successful planting methods for Sea Island cotton and sugarcane in the *Southern Agriculturist of Charleston*, the leading farm journal of the antebellum period.

3. Fraser-Couper Papers, Collection 265, GHS. James Hamilton Couper (1794–1866) of Hopeton plantation, Glynn County, alternately planted cotton, sugarcane, and rice on his Altamaha River delta plantation, referred to as "the model plantation of the South" by the editor of the *Southern Agriculturist* in 1833.

4. Joseph Frederick Waring Papers, Collection 1275 and Houstoun-Wylly Papers, Collection 399, GHS, contain useful insights on antebellum tidewater society, particularly that associated with Savannah and with the coastal island plantations.

5. Manigault Family Papers, Collection 1290 and James Potter Papers, Collection 630, GHS. Charles Izard Manigault (1795–1874) and James Potter (1793–1862) were the two leading Savannah River rice planters, Manigault at Gowrie and East Hermitage, and Potter at Coleraine. The agricultural records of these two families are some of the most complete sources that have survived for Georgia rice plantations.

6. Eli Whitney Papers, Collection 866, GHS. Eli Whitney (1765–1825) invented his patented cotton gin while in the employ of Catherine Greene, owner of Mulberry Grove Plantation and widow of General Nathanael Greene. Whitney and his partner Phineas Miller manufactured and marketed the gins, but with little profit.

7. Robert Habersham Papers, Collection 345, GHS. Robert Habersham (1783–1870) was the most prominent cotton and rice factor in Savannah during the antebellum period. This collection is useful for its documentation of the marketing of staple commodities in Georgia and the growth of the cotton industry.

8. Wayne-Stites-Anderson Papers, Collection 846, GHS. This extensive collection contains the papers of James Moore Wayne (1790–1867), a prominent Savannah jurist and associate justice of the United States Supreme Court; Richard M. Stites (1777–1813), a Savannah lawyer; and Jefferson R. Anderson (1861–1950), a Savannah lawyer. The collection is notable for its extensive documentation of the business, legal, and agricultural affairs of Savannah during the antebellum period. See also Keith Read Collection, Collection 648, GHS, one of the most extensive collections in the United States relating to the mercantile, maritime, commercial, and agricultural activities in Savannah and its environs during the antebellum period. See also Gordon Family Papers, Collection 318, GHS. William Washington Gordon (1796–1842) of Savannah was the founder and first president of the Central of Georgia Railroad Company.

9. Kollock Family Papers, Collection 470, GHS. Covers the social, political, and business life of the planter class of Savannah during the antebellum period. See also Marmaduke Hamilton and Delores Boisfeuillet Floyd

Papers, Collection 1308, GHS, for antebellum coastal Georgia agriculture, tabby architecture, and various other aspects of tidewater life. Georgia Historical Society Internal Papers, Collection 1361AD, GHS, provides a glimpse of antebellum Savannah society, including the founding of the society in 1839 and the establishment of the society's permanent home at Hodgson Hall in 1876.

10. Joseph Bryan Cummings Papers, Collection 188, GHS, contain considerable documentation relating to antebellum and Civil War Augusta. See also Richmond County Records, Collection 659, GHS.

11. Central of Georgia Railway Company Collection, Collections 1359 and 1362, GHS.

12. E.T. Fairbanks and Company Papers, Collection 245, GHS. Contains business papers, travel accounts, and extensive documents relating to economic conditions in antebellum Augusta, Macon, Columbus, Athens, Savannah, Charleston, South Carolina, and Apalachicola, Florida.

13. John Macpherson Berrien Papers, Collection 67, GHS. John M. Berrien (1781–1856) was Attorney General of the United States under President Andrew Jackson and a prominent Savannah lawyer. This collection contains documentation on the economic, political, and legal affairs of antebellum Georgia.

CHAPTER 7

1. McDonald-Lawrence Papers, Collection 522, GHS. This collection contains letters and documents relating to states' rights issues and events associated with Georgia's secession from the Union. See also the Francis Bartow Papers, Collection 1156, GHS.

2. Robert Augustus Toombs Papers, Collection 804, GHS.

3. Confederate States of America Army Papers, Collection 169, GHS, contain extensive financial and quartermaster records that provide detail on the material needs of the Confederate Army as they related to the manufacturing efforts on the home front.

CHAPTER 8

1. Lafayette McLaws Photographs, Collection VM 2087 and Oglethorpe Light Infantry Papers, Collection 596, GHS. These collections document the early months of the war in coastal Georgia and the difficulties of protecting the coast from the Union naval blockade. Lafayette McLaws (1821–1897) was a major general in the Confederate Army. He participated in several battles and campaigns, including the defense of Savannah in 1864.

2. Charles Hart Olmstead Papers, Collection 599, GHS. Olmstead (1837–1926) was a native of Savannah, served with distinction in the Civil War, and was a strong supporter of the Georgia Historical Society in the late nineteenth and

early twentieth centuries. His memoirs, edited by Lilla Mills Hawes, were published by the GHS in 1964 as volume 14 in its Collections series.

3. William Daniel Dixon Journal, Collection 1620, GHS, contains observations on military activities in the Savannah area from 1861–1863. Dixon served in the Savannah Republican Blues, which saw duty at Fort McAllister during the period of the Union naval attacks.

4. Henry F. Willink Jr. Papers, Collection 872, GHS.

5. Mills Bee Lane IV Papers, Collection 1291, GHS, contain contemporary accounts of life in Savannah during the war.

6. Confederate States of America Army Papers, Financial and Quartermaster Records, Collection 169, GHS.

7. Confederate States of America Navy Papers, Collection 170, GHS.

8. Claudius C. Wilson Papers, Collection 874, GHS, contain accounts of the Chickamauga campaign.

9. Georgia Volunteer Infantry, 47th Regiment Papers, Collection 296 and A.E. Sinks Papers, Collection 732, GHS. Contain first-hand accounts of the fighting around Atlanta in 1864. The best source for the details of the entire campaign are contained in the indispensable Civil War military collection, *The War of the Rebellion: A Compilation of the Official Records of the Union and Confederate Armies*, 130 volumes. Washington, D.C., 1880–1901. The Atlanta Campaign is covered in Series I, vol. 38, parts 1–5.

10. George Wayne Anderson Papers, Collection 7, GHS.

11. Alexander Atkinson Lawrence Collection, No. 2019, GHS, is the outstanding source for data on the Savannah campaign and Sherman's occupation of the city. Also see Edwin Rhodes Papers, Collection 1065, GHS.

12. *The War of The Rebellion: Official Records*. Series I, vol. 49; Maxine Turner. *Navy Gray: A Story of the Confederate Navy on the Chattahoochee and Apalachicola Rivers*. Tuscaloosa: University of Alabama Press, 1988.

13. Manuscript data on events and activities associated with the Reconstruction period in Georgia, as well as postwar adjustments on the Georgia coast, are contained in Henry Rozier Casey Scrapbook, Collection 124, GHS, William Wiseham Paine Papers, Collection 603, GHS, and Richard J. Adams Papers, Collection 1, GHS.

CHAPTER 9

1. Cohen-Hunter Papers, Collection 161, GHS. The most lucid account of Atlanta's postbellum rise as one of the South's primary cities is Don H. Doyle's *New Men, New Cities, New South*. Chapel Hill: University of North Carolina Press, 1990.

2. The Race Question Scrapbook, 1880–1900, Collection 1568, GHS, contains newspaper articles and other documents relating to postbellum racial issues in Georgia.

3. Hilton Papers, Collection 387, GHS, document the rise and fall of the pine

timber sawmilling industry at Darien, Belfast, St. Simons, and Savannah from 1870 to 1920.

4. The available documentation on the southeast Georgia naval stores industry in the late nineteenth century is extensive. See Thomas Gamble Scrapbooks, Collection 271; John Avery Gere Carson Papers, Collection 123; A.S. Carr Collection, VM 1584; and Naval Stores Collection, Collection 2022, all GHS.

5. Savannah Cotton Exchange Records, Collection 686, GHS, covering the years 1885–1930.

6. Willie Swoll Sawyer Papers, Collection 713, GHS, document timbering and sawmilling activity in south Georgia during the postbellum period. The best accounts of the economic development of this region are contained in the annual issues of the *Journal of Southwest Georgia History*, 1983–1996.

7. Charles Colcock Jones Jr. Papers, Collection 438, GHS. Contain extensive materials relating to arts, education, and culture in Georgia during the postbellum period, in addition to correspondence relevant to the Georgia Historical Society in the latter half of the nineteenth century.

CHAPTER 10

1. Pleasant A. Stovall Papers, Collection 1021, GHS, contain documentation relating to legislative affairs in Georgia from 1900 to 1915. A useful and illuminating documentary anthology of politics and race relations in Georgia during the period 1870 to 1910 is Mills Lane, ed., *Standing Upon the Mouth of a Volcano, New South Georgia, A Documentary History*. Savannah: The Beehive Foundation, 1993.

2. The photographic archives of the Georgia Historical Society are a rich resource for visual images of life in early twentieth-century Georgia, including many period views of Georgia textile mill towns. Some of the best images are contained in "Tour of Georgia Photo Album," Collection VM1626, for images of Georgia places for the period 1910–1926; GHS Postcard Collection, Collection 1361PC, for images *c.* 1890 to 1930; and GHS Photograph Collection, Collection 1361SG, containing stereographic views of Georgia for the period 1860 to 1920.

3. One of the most informative sources for documented material on labor issues during the period 1890 to 1930 is "Labor in Georgia." *Georgia Historical Quarterly*. Special issue, Volume 81. (Summer 1997).

4. Capeci, Dominic J. Jr. and Jack C. Knight. "W.E.B. Du Bois's Southern Front: Georgia 'Race Men' and the Niagara Movement, 1906–1907." *Georgia Historical Quarterly*. Volume 83. (Fall 1999).

5. John M. Slaton Family Papers, Collection VM1639, GHS.

6. Brundage, W. Fitzhugh. *Lynching in the New South: Georgia and Virginia, 1880–1930*. Champaign-Urbana: University of Illinois Press, 1993.

CHAPTER 11

1. U.S. Department of Agriculture, Agricultural Drainage in Georgia, Bulletin 32, Geological Survey of Georgia, Atlanta, 1917.
2. Writers Program of the WPA in Georgia. *Georgia: A Guide to Its Towns and Countryside*. Athens: University of Georgia Press, 1940.
3. Conkin, Paul K. "It All Happened in Pine Mountain Valley." *Georgia Historical Quarterly*. 47 (1963).
4. Ibid.
5. Cobb, James C. "Not Gone, But Forgotten: Eugene Talmadge and the 1938 Purge Campaign." *Georgia Historical Quarterly*. 59 (1975).
6. Coleman, Kenneth and Charles Stephen Gurr, eds. *Dictionary of Georgia Biography*. Volume 2. Athens: University of Georgia Press, 1983.

CHAPTER 12

1. Lillian Gray Porter Papers, Collection 2139, GHS, contain World War II correspondence and other documents of the United States Army Corps of Engineers, Savannah District.
2. U.S.S. *Florence Martus* Logbooks, Collection 2013, and U.S.S. *Juliette Low* Logbooks, Collection 2014, GHS. These are operational logs of two Liberty ships built by Southeastern Shipyard at Savannah during World War II.
3. John Helm Maclean Papers, Collection 535, GHS, contain documents and letters relating to Eugene Talmadge's terms as Georgia governor, as well as detail on the 1942 gubernatorial campaign between Talmadge and Ellis Arnall.
4. Cordray-Foltz Collection, Collection 1360, GHS, contains a large number of visual images of industrial and business activity in Savannah and Chatham County during the 1940s and 1950s. See also GHS General Photograph Collection, 1361PH, for photographs of locales and events throughout Georgia.
5. Thora O. Kimsey and Sonja O. Kinard. *Memories of the Marshes of Glynn: World War II*. Brunswick: n.p., 1999.

Selected Bibliography

Primary Sources: Manuscripts

Numerous manuscript collections contained among the archival holdings of the Georgia Historical Society were consulted during the research for large segments of this volume. Specific collections and documents are cited in the Endnotes.

Books and Periodicals

Abbot, W.W. *The Colonial Governors of Georgia*. Chapel Hill, NC: University of North Carolina Press, 1959.

Bailey, Anne J. and Walter J. Fraser Jr. *Portraits of Conflict: A Photographic History of Georgia in the Civil War*. Fayetteville, AR: University of Arkansas Press, 1997.

Boney, F.N. *A Pictorial History of the University of Georgia*. Athens: University of Georgia Press, 2000 edition.

Bonner, James C. *A History of Georgia Agriculture, 1732–1860*. Athens: University of Georgia Press, 1964.

Bragg, William Harris. *DeRenne: Three Generations of a Georgia Family*. Athens: University of Georgia Press, 1999.

Brundage, W. Fitzhugh. *Lynching in the New South: Georgia and Virginia, 1880–1930*. Champaign, IL: University of Illinois Press, 1993.

Bryant, Pat and Ingrid Shields. *Georgia Counties: Their Changing Boundaries*. Atlanta: Georgia Department of Archives and History, 1983.

Cadle, Farris W. *Georgia Land Surveying History and Law*. Athens: University of Georgia Press, 1991.

Candler, Allen D., ed. *The Colonial Records of the State of Georgia*. 25 vols. Athens and Atlanta: Franklin Printing and Publishing Co., 1904–1916.

Carter, Jimmy. *Turning Point: A Candidate, A State and A Nation Come of Age*. New York: Times Books, 1994.

Cashin, Edward J. *The Story of Augusta*. Spartanburg, SC: Reprint Co., 1991.

———. *Lachlan McGillivray, Indian Trader: The Shaping of the Southern Colonial Frontier*. Athens: University of Georgia Press, 1992.

———. *William Bartram and the American Revolution on the Southern Frontier*. Columbia, SC: University of South Carolina Press, 2000.

Castel, Albert. *Decision in the West: The Atlanta Campaign of 1864*. Lawrence, KS:

University Press of Kansas, 1992.

Cimbala, Paul A. *Under the Guardianship of the Nation: The Freedman's Bureau and the Reconstruction of Georgia.* Athens: University of Georgia Press, 1997.

Coleman, Kenneth. *The American Revolution in Georgia, 1763–1789.* Athens: University of Georgia Press, 1958.

———. *Colonial Georgia: A History.* New York: Charles Scribner's Sons, 1976.

———, ed. *A History of Georgia.* Athens: University of Georgia Press, Second edition, 1991.

Coleman, Kenneth and Charles Stephen Gurr, eds. *Dictionary of Georgia Biography,* 2 vols. Athens: University of Georgia Press, 1983.

Davis, Harold. *The Fledgling Province: Social and Cultural Life in Colonial Georgia, 1733–1776.* Chapel Hill, NC: University of North Carolina Press, 1976

Davis, Robert S. Jr. *Cotton, Fire & Dreams: The Robert Findlay Iron Works and Heavy Industry in Macon, Georgia, 1839–1912.* Macon: Mercer University Press, 1998.

Doyle, Don H. *New Men, New Cities, New South.* Chapel Hill, NC: University of North Carolina Press, 1990.

Federal Writers Project. *Georgia: A Guide to Its Towns and Countryside.* Athens: University of Georgia Press, 1940.

Garrett, Franklin M. *Atlanta & Environs: A Chronicle of Its People and Events.* Atlanta: Lewis Historical Publishing, 1954.

Georgia Historical Quarterly. Various issues, 1917–2002.

Georgia Writers Project. *Drums and Shadows: Survival Studies Among the Georgia Coastal Negroes.* Athens: University of Georgia Press, 1940.

Hemperley, Marion R. and Edwin L. Jackson. *Georgia's Boundaries: The Shaping of a State.* Athens: Carl Vinson Institute of Government, 1993.

Hodler, Thomas W. and Howard R. Schretter, eds. *The Atlas of Georgia.* Athens: Institute of Community and Area Development, 1986.

Hoffmann, Paul E. *A New Andalucia and a Way to the Orient: The American Southeast During the Sixteenth Century.* Baton Rouge, LA: Louisiana State University Press, 1990.

Inscoe, John C. and Numan V. Bartley, eds. *Georgia in Black & White: Explorations in the Race Relations of a Southern State, 1865–1950.* Athens: University of Georgia Press, 1994.

Journal of Southwest Georgia History. Various issues, 1983–1996.

Kimsey, Thora Olsen and Sonja Olsen Kinard. *Memories of the Marshes of Glynn: World War II.* Brunswick: n.p., 1999.

Knight, Lucien Lamar. *A Standard History of Georgia and Georgians,* 6 vols. Atlanta: Lewis Publishing, 1917.

Lane, Mills B., ed. *General Oglethorpe's Georgia: Colonial Letters, 1733–1743,* 2 vols. Savannah: The Beehive Foundation, 1990.

———. *The People of Georgia.* Savannah, GA: The Beehive Foundation, 1992.

———. *Standing on the Mouth of a Volcano: New South Georgia, A Documentary History.* Savannah, GA: The Beehive Foundation, 1993.

Lawrence, Alexander A. *Storm Over Savannah*. Athens: University of Georgia Press, 1951.

———. *A Present for Mr. Lincoln: The Story of Savannah from Secession to Sherman*. Macon: Ardivan Press, 1961.

Memoirs of Georgia, Containing Historical Accounts of the State's Civil, Military, Industrial and Professional Interests and Personal Sketches of Many of Its People. Atlanta: Southern Historical Association, 1895.

Mohr, Clarence L. *On the Threshold of Freedom: Masters and Slaves in Civil War Georgia*. Athens: University of Georgia Press, 1986.

Newman, Harvey K. *Southern Hospitality: Tourism and the Growth of Atlanta*. Tuscaloosa, AL: University of Alabama Press, 1999.

Orser, Charles E. *The Material Basis of the Postbellum Tenant Plantation*. Athens: University of Georgia Press, 1988.

Russell, Preston and Barbara Hines. *Savannah: A History of Her People Since 1733*. Savannah: Frederic C. Beil, 1992.

Scaife, William R. *The Campaign for Atlanta*. Saline, MI: McNaughton & Gunn, 1993.

Sears, Joan Niles. *The First One Hundred Years of Town Planning in Georgia*. Atlanta: Cherokee Publishing, 1979.

Spalding, Phinizy B. *Oglethorpe in America*. Chicago, IL: University of Chicago Press, 1977.

Stewart, Mart A. *"What Nature Suffers to Groe": Life, Labor and Landscape on the Georgia Coast, 1680–1920*. Athens: University of Georgia Press, 1996.

Sullivan, Buddy. *Early Days on the Georgia Tidewater*. Darien: Darien Printing, sixth edition, 2001.

Tuck, Stephen G.N. *Beyond Atlanta: The Struggle for Racial Equality in Georgia, 1940–1980*. Athens: University of Georgia Press, 2001.

Turner, Maxine. *Navy Gray: A Story of the Confederate Navy on the Chattahoochee and Apalachicola Rivers*. Tuscaloosa, AL: University of Alabama Press, 1988.

U.S. War Department. *The War of the Rebellion: Official Records of the Union and Confederate Armies*. Washington, D.C., 130 vols., 1880–1901. Used in the preparation of this book were: vol. 14 (operations in coastal Georgia, 1861–1863); vol. 38, parts 1–5 (operations associated with the Atlanta Campaign, May–September 1864); vol. 44 (the March to the Sea and operations at Savannah, fall 1864); and vol. 49 (Wilson's raid in west-central Georgia, April–May 1865).

Utley, Francis Lee and Marion R. Hemperley, eds. *Placenames of Georgia: Essays of John H. Goff*. Athens: University of Georgia Press, 1975.

Wetherington, Mark V. *The New South Comes to Wiregrass Georgia, 1860–1910*. Knoxville, TN: University of Tennessee Press, 1994.

White, George. *Historical Collections of Georgia*. New York: Pudney and Russell, 1854.

Worsley, Etta Blanchard. *Columbus on the Chattahoochee*. Columbus: Columbus Office Supply, 1951.

INDEX